FIRST EDITION

Readings in Art Appreciation

EDITED BY ANDREW SVEDLOW

UNIVERSITY OF NORTHERN COLORADO

Bassim Hamadeh, CEO and Publisher

Kassie Graves, Director of Acquisitions

Jamie Giganti, Senior Managing Editor

Miguel Macias, Graphic Designer

Kristina Stolte, Senior Field Acquisitions Editor

Sean Adams, Project Editor

Alisa Muñoz, Licensing Coordinator

Alia Bales, Associate Production Editor

Printed in the United States of America

ISBN: 978-1-5165-0976-8(pbk) /978-1-5165-0977-5(br)

cognella | ACADEMIC PUBLISHING

CONTENTS

Foreword

It is no easy task to choose readings in art appreciation that act both as a survey of the field and as a guide to particular time periods and places in the history of the visual arts. With a modicum of wisdom and a guiding principle that focuses on the breadth of global artistic pursuits, and the depth of perception as manifested in these readings, an anthology of relevance and reward has been created.

The intent of this selection of essays, writings, and thoughtful commentary is to provide a deep grasp of the range of subject matter that comprises the topic of art appreciation. While not necessarily an overt inquiry into the meaning of art appreciation, each selection provides insight into significant aspects of particular facets of the history and value of the visual arts. Each of these gracefully articulated treatises evokes the nature of art and the context in which such products of humanity may be appreciated.

It is difficult to set parameters around art appreciation and to define it as a distinct discipline. While explicitly about the values manifested in a particular time and place through the material culture of a society, it is also a field of inquiry that relies on the philosophy of art, the history of art, the materials and methods of practitioners, as well as art criticism. Therefore, it is not confined to any one perspective or research methodology in its pursuit of sharing the visual arts with audiences interested in understanding art in the world and its significance to individual appreciators.

Art appreciation is much more than the idiom "beauty is in the eye of the beholder." To appreciate ancient art, classical architecture, Chinese landscape painting, or an Andy Warhol silk screen of a soup can, is to look beyond the surface of these objects' visual presentation and to grasp their intended meaning within the context of their historical time and place. Art appreciation is, at times, about beauty and what different cultures and societies have valued and cherished as beautiful. But it is also an intellectual and

sometimes dispassionate probing into what underscoring world views held by those societies and cultures were as underpinnings to those concepts of ideal beauty.

One may peruse these readings in order or skip through the selections randomly and still take away a substantial understanding of the place visual arts hold in the world and in one's life. However, it is the intention of the editor to relate the gamut of art appreciation through a chronological approach that takes the reader on a journey from the earliest creative intellectual pursuits of humanity to more current expressive arts of the twenty first century.

Andrew Jay Svedlow,
Ph.D.

Introduction

This text has been brought together in order to provide a reader in art appreciation that may serve as a template for understanding the visual arts and to encourage lifelong learning as applied to the history and global traditions of the plastic arts. Selections from aesthetics and the philosophy of art were chosen to give a background about what has been art and what should be considered important about these material products of the human imagination. There is no one effective or definitive method to interpret what's important about art. Still, some of the readings presented here do critically analyze the particulars of specific artworks in pursuit of a universal understanding of the broader realm of art and art history.

The chronological format of the selected readings should act as a travel guide to historical examples of art from around the globe. Like an excellent tour guide, the readings point out highlights of the places visited, the people who have populated these specific places, and the people who have made the great wonders and beautiful objects experienced along the way possible. The essays included in this book serve as pithy introductions to great art, but they do not serve as the total authoritative writing on the subject. It is hoped that each reading will serve as a stepping-stone to further inquiry. Thus, a resource compendium is included as a guide to additional study.

The readings were chosen for the strength of their writing and insights into art and art appreciation, as well as for the stature, professional acumen, and historical significance of the authors themselves. Additionally, the editor has added his own essays to round out the body of work offered.

Whether a student enrolled in their first art appreciation or art history course, or a seasoned learner interested in a unique approach to the appreciation of the visual arts, this book holds a wealth of material to delve into. The individual interested in practicing

art appreciation will need to investigate the material world through a range of established disciplines, such as philosophy, biography, history, archaeology, anthropology, and art history, as well as critical theory and art criticism. Art appreciation does not have an extensive body of literature specifically defined as art appreciation. The historian interested in ancient Greek architecture will no doubt provide important information about the Greek ideal of beauty and the proportions of an ideal building, as well as a valued perspective that details the Greek sense of beauty as being a balanced, harmonious, and edifying structure. The cultural anthropologist interested in the artifacts of a culture built on centuries of perennial practices will expound upon the elegance of sculptural depictions of ancestors. The philosopher will ask pertinent questions about what is beautiful and why we value certain objects over others. The archaeologist will provide us with evidence of early human activities in places such as the caves of Lascaux, and the biographer will give us insight into the life styles of celebrity artists of the twentieth century.

The assumption here is that any academic discipline that seeks to explain the creative products of the human endeavor will bolster our appreciation of those objects and edifices, those ideas and imaginative wanderings. Therefore, this book attempts to fulfill a multitude of demands on appreciators of art. The reader will encounter rigorous and comprehensive interpretations of art that will serve as primers for art appreciators of all ilks.

The fifteen chapters are devoted to art created during the past 20,000 years of human history from Europe, Asia, Africa, Australia, and North and South America. The basic question answered by these disparate essays is, "Why are these objects important?" The answers are as varied as the art itself. Creativity is basic to the human condition, whether it manifests itself as the tomb of an Egyptian Pharaoh or as an Impressionist painting of water lilies. The challenge posed by this book is more than the sharing of knowledge about objects. Rather, it is acquiring an understanding of the values of a time and place as manifested in those objects and how that understanding impacts and informs our lives today.

Caves and Art

Initiation and Transcendence

By L.G. Freeman

Certain precincts in Paleolithic sites with or without decorations are truly sanc-tuaries, including cases from Cueva Morín, the Cueva del Juyo, and the Great Ceiling at Altamira. The cave and its decorations, in Altamira, provides a more extensive demonstration of its uniqueness and the propriety of calling it a sanctuary in its integrity. In its decorations, the Great Ceiling bears a symbolic relationship to the depictions in the Final Gallery of the cave (also called the Cola de Caballo) that is so striking that it can only have been intentional. The central galleries at Altamira seem to serve as a sort of symbolic bridge between the decoratively richer galleries near the vestibule and the final recesses of the cavern. What is more, some of these details suggest that the Altamira sanctuary was the locus of periodic rites of transition or initiation. Before we can evalu-ate this suggestion, it will be necessary to complete the description of the galleries of Altamira and their depictions (Freeman and González Echegaray 2001).

ALTAMIRA'S CENTRAL GALLERIES

As one goes beyond the Great Ceiling into the central galleries of the cave, finger-engraved meanders appear on the ceiling. Another set of meanders was part of a fallen frieze further on, where it may perhaps mark a break in the continuity of depicted subject matter. Animals in this area are represented by finger engravings, by engraving with a sharp implement, or by painting, and there seems to be no difference in the selection of species represented in each technique. The series of animal depictions begins with digital engravings of wild oxen, followed by the true engraving of a hind. Engraved horses and deer and one large bison occupy the next gallery in the sequence. Black horses are followed by the red scalariforms of the "Rincón de los Tectiformes"; its end is marked by a large patch of red paint. Along the sides of the main gallery there were friezes (one of which is now partly collapsed), with engravings of horses, deer (stags as well as hinds), an anthropomorph, and more meanders.

Further on, when the corridor turns sharply, engravings of deer vanish as if by magic, not to reappear until the Cola de Caballo. We find engraved figures of wild oxen and goats, and black drawings of horses and bison, but no deer. Black ibex are added to those animals as we pass along the next gallery, when at last the hind also reappears, but only as a single head in black outline. Black horses are found with the first enigmatic black marks (like those in the walls of the Final Gallery) and along the irregular wall we find the first "masks," in this case less well defined than they are in the Cola de Caballo. In these intermediate galleries, the figures and their relationships correspond more and more closely to the symbols and organization of the Final Gallery as we progress in the direction of that gallery from the Great Ceiling.

ALTAMIRA'S FINAL GALLERY: THE COLA DE CABALLO

When we began our part in the 1980s reevaluation of Altamira and its depictions, we chose to invest a great deal of effort in a reexamination of the Final Gallery of the cave. (The methods we employed are described in great detail, with our conclusions, in an earlier report [Freeman et al. 1987].) This gallery, also called the "Cola de Caballo" from its fancied resemblance to that appendage, has a number of characteristics that make it an ideal laboratory for the testing of recording methods and the development of analytical techniques concerning the importance of positioning and relationship in the organization of Paleolithic art. It could be studied as an "isolate" (though we now know that it is not unrelated to other parts of the cave), and it is small enough (just 70 meters long, usually less than 2 meters wide, and sometimes even narrower, and from less than a meter to about 2 meters in height) so that it could be examined completely in a reasonable time. An adult can usually touch the walls on either side without having to move from the middle of the track. In addition to these spatial constraints, the

gallery is richly decorated, with fingertip meanders, deep and fine-line engraving, and black drawings, some representing animals, others depicting complex geometric figures, and others that are just "marks." Its size and the shape of its corridors naturally constrained the ways the Paleolithic artist could place the decorations, as well as the ways they would later be viewed or studied. The gallery makes many sharp bends that divide its topography into clearly distinct sections. The walls and ceiling of the gallery are highly irregular, covered with projections and crevices that provide a large number of surfaces suitable for decoration, and these irregularities keep many of the figures from being seen from anywhere but one strategic viewpoint. These characteristics make it possible to deduce where the Stone Age artist or viewer stood (or crouched, or lay) to produce or see such figures, and in what direction he or she must have been looking at the time. Since there is only one way into the gallery, and one way out following the same track, we can even establish the most probable order in which most of the figures were intended to be seen, to determine which were seen entering and which were only visible on the return trip. Of course, this is much harder, usually impossible, for larger, more open spaces. Our first step was to produce an accurate map of the Final Gallery, locating on it each and every figure we detected.

The twists, bends, and irregularities of this gallery subdivide it into six distinct segments or corridors, that we have given names. With one exception (the "Empty Corridor") each of them contains decorations, including a total of 74 masses of undecipherable charcoal lines and patches. The other depictions are one positive handprint in black, two patches of finger meanders (one that is an extension of the meanders at the entry into the first five meters of the first corridor), several black tectiforms, several engravings including both geometrics and the figures of five bison, eighteen deer, two horses, and three supposed "goats," as well as three black outline drawings, all of which seem to portray horses. The positive handprint, near the end of the first patch of "macaroni," is that of a youngster's left hand, which from its outline may have worn a glove. There are also some indeterminate figures that may be clumsy or unfinished attempts to represent unidentifiable animals. One of the fine-line engravings, a bison, had been partly completed by the addition of black lines to form its haunch and foreleg, suggesting that the engravings and black line drawings in this gallery are most probably contemporaneous. A series of large projections from either wall of the Final Gallery, uncannily suggestive of the heads of humans or bison, has been minimally altered by engraving, pecking, or the addition of black lines, to enhance the resemblance. These are the so-called masks at Altamira. So far, nine certain masks are known from the Gallery.

The Empty Corridor splits these representations into two series. The two galleries nearer the entry are the Bison Gallery, where all three engraved animals are bison, and the Low Gallery, where there are four engraved animals on the ceiling, all stags, and two black outlines of horses, one on the right wall, the other on a block projecting from the floor. No engraved horses appear between the entry and the Empty Corridor. The Low Gallery ends with an engraved "geometric" figure on the ceiling, and near it, in a lateral fissure on the left wall of the corridor, there are more finger-engraved meanders.

Beyond the Empty Corridor comes a complex corridor consisting of our Gallery of Tectiforms and a wider room at its end called the Chamber of Masks. The former contains two groups of black tectiforms, each accompanied by spider-like figures (circular or oval figures with lines radiating outward) next to recesses in the right wall of the corridor, and a third engraved geometric a few meters farther on. Aside from two horses, one of which is among the finest engravings in the cave, the other engraved figures in this unit are three bison, including a pair of animals shown engaging in stereotyped breeding ritual, the female mounting the male. The last corridor is the Cervid Gallery. It becomes so low and narrow that one must lie flat to wriggle through it until it finally becomes impassible. There are fourteen figures of deer, including two stags and twelve hinds, and three other animals interpreted as goats, though they may be yearling stags instead. It is important to note that in each series, the one before and that after the Empty Corridor, representations of bison come first, with deer present only in the innermost part of each.

FIGURE DISTRIBUTION IN THE FINAL GALLERY

There is much more evidence, if that were needed, that the distribution of figures in the Final Gallery is organized rather than haphazard, and that their placement corresponds to a carefully executed plan followed by all the artists. The divisions we detected evidently provided the framework for this symbolic pattern. Even the apparently random black marks obey its dictates. In the first part of the Final Gallery, there are about twice as many of these patches of linear marks on the left wall as on the right (20 as opposed to 12). Beyond the Empty Corridor, this lateral distribution is reversed, with about twice as many on the right (26) as on the left (16). The difference is statistically significant: the likelihood that the reversal of proportions is accidental is less than 0.05 (less likely than one chance in twenty). There are so many of them, and they are often so far from the few black drawings, that the explanation that the black marks may result from the artists' sharpening their charcoal crayons as they worked is also unreasonable, and another alternative, that they were used to blaze a trail to be followed, is ridiculous for a corridor where there is only one possible route in and out. Other practical reasons for the distributions have been considered, and all rejected, leaving the conclusion that their organization is simply a reflection of the intentional symbolic organization of space. Other evidence for lateral differentiation comes from the placement of the engraved bison and the painted geometrics, all on the right wall of the Gallery. All but one of the hinds' heads are also on the right wall of the Gallery, an apparent reflection of the fact that these figures occupied a symbolic position that was somehow complementary to that of the bison.

However, the most revealing evidence of deliberate organization of the decorations is the differential distribution of engravings of bison on the one hand and deer on the other. In corridors where bison are found, there are never any deer, and (of course) where there are deer

there are no bison. It is remarkable to us that this mutual exclusion, which seems so obvious, was not detected before. It is all that is needed to show that, in the Final Gallery, cervids and bison stand symbolically in equivalent positions in a system of complementary opposition. Contrary to Leroi-Gourhan's interpretation (1964), the ubiquitous horse does not seem to occupy any particular place in this system. Figures of horses are represented in every technical style known in the site: polychromes, red outlines, black outlines, and engravings. Since horses are found next to both the animals that are at the poles of the complementary opposition, it is unlikely that they are themselves part of either group more than the other.

Other details of the size, positioning, and distribution of the representations help complete this interpretation. First of all, while the density of depictions of deer increases as we go deeper into the gallery, bison are if anything more numerous toward the cave entry. This difference of focus is underlined by the fact that all but one of the bison actually face the entry, while all but three of the deer face into the Final Gallery. All the engraved bison without exception are whole animals, but only six of the deer (five of them males) are whole: the other twelve are represented by heads or heads and necks alone. The bison are represented as proportionally larger in scale than the deer: only seven of the deer might be called "large" if we are generous in our usage, but all six of the bison are "large" by the same standard. The degree of aggregation represented also differentiates the two species. Except for one case (a pair of bison engaged in pre-copulatory behavior, the female mounting the male), individual engravings of bison are always some meters distant from each other (a minimum of 2.5 meters, an average of 11). Engraved deer, on the other hand, always appear in groups. True, the two major concentrations are separated by more than 30 meters. But within either concentration, that in the Low Gallery or that in the Cervid Gallery, the average distance between individual engravings on the same wall is just over 1 meter, and the closest non-superimposed figures actually touch. In the Cervid Gallery, the distance between any engraved deer and another on the opposite wall may be as little as 1 meter and is never greater than a meter and a half. These observations all reinforce the interpretation of bison and deer as symbolically related by the principle of complementary opposition.

Possible correlates of the symbolic opposition of deer and bison that would have been meaningful to prehistoric hunters are not hard to find. The fact that representations of deer far outnumber those of bison is in accord with the archeological evidence from Altamira's Paleolithic levels, where the most abundant mammal bones are those of red deer. Deer were probably a more frequent prey, and a more frequent dietary item, than were bison (and deer were certainly more common than bison in the landscape). Deer and bison contrast markedly in behavior, as well. Deer remain hidden as much as possible, do not move about much during the day, and (except during the rut) are timid, skittish, and difficult to approach. Bison, on the other hand, are ordinarily highly visible animals, and are active during the day. Deer fall prey to wolves and other large predators quite frequently, while adult bison are such large, powerful creatures that herds are relatively untroubled by non-human predators. Descriptions of techniques used in the bison hunt by Plains Indians before the introduction

of the horse and firearms indicate that the animals allowed stealthy hunters (sometimes disguised in wolf- or deerskins) to approach nearly within arm's reach of them before moving away. (Hunters armed with spears or bows sometimes approached the herd concealed behind horses, when they had them.) There was in fact a quite peculiar relationship between these majestic beasts and their human hunters, involving aspects of prey behavior and techniques and organization of the hunt, that clearly differentiate deer from bison as subjects for physical, mental, and cultural manipulation. The analogical relationship of people and bison in the art of the Final Gallery suggests that people thought of themselves, as well as the bison, as essentially unthreatened, dominant creatures of their kind in a usually predictable and benevolent environment.

THE MASKS IN THE FINAL GALLERY

There is one other kind of decoration in the Final Gallery, the eerie, minimally retouched natural projections that are conventionally called "masks." They are in many ways the most remarkable of the decorations in the Final Gallery. These are natural head-like projections from the cave wall that resemble face-on or profile heads of men or animals. Each of them has been deliberately modified to make their naturally suggestive appearance still more evocative, just as was the case for the face in the sanctuary at el Juyo. In the course of our investigations, we discovered six of these figures, which when added to the three already known raises the total to nine. The presence of masks is not restricted to Altamira among Cantabrian sites. There is a particularly fine example of a large mask representing the profile of a bison in the cave of Castillo. A smaller, frontally viewed face of a small horned animal was also found in the same site (Alcalde del Río, Breuil, and Sierra 1912: esp. fig. 144, lams. 62, 85, 86), next to what may be yet a third such figure.

Most of the masks at Altamira are clearly intended to represent bison. One is the frontal view of a human face. There are also three that while apparently representing bison also suggest human features, or, in one case, represent a hybrid figure that from one viewpoint is a bison, but becomes very man-like when viewed from a different perspective. The conclusion is inescapable that the artists intended to represent a transformational series, including figures that are bison in every respect, figures that are wholly human, and hybrid figures that establish a symbolic equivalence between the two species.

Masks are related in both subject matter and frequency to other depictions in the Final Gallery. The relationship between the engraved whole bison and the bison masks is in many ways analogous to the relationship between whole engraved deer and engravings of deer heads. If the masks are included in the count of bison figures, however, the density of depictions of bison increases from the Bison Gallery to the Chamber of the Masks, just as the deer increase from the Low Gallery to the Cervid Gallery. Beyond the Empty Corridor, the

ratio of heads to whole deer is 9 to 5, while the ratio of masks to whole bison is 5 to 3. The difference between the ratios is negligible. Near identity in proportions in this case confirms the postulated correspondence, leading us to conclude that consciously or not, the Paleolithic artists intended these figures to be compared, weighing one against the other.

But there are also major differences between the series "whole deer + deer heads" and "whole bison + bison masks." All the masks are very much larger than the heads of the engraved bison, but that is only true for a minority (three of twelve) of the deer heads. While six of the nine masks are on the left wall, all six engraved bison are on the right, as are all but one of the heads in the Cervid Gallery. These differences are statistically significant, and there is a very small probability of their being due to chance. So, while the bison + mask group is intended to be seen as somehow related to the engraved deer head + whole deer group, the relationship indicated is not one of equivalence. Neither the sequences nor the species are intended to be seen as interchangeable. The difference becomes clearer when the mask distribution is examined more closely.

THE FINAL GALLERY: EQUIVALENCE AND TRANSCENDENCE

The largest concentration of the masks (four) is found in the Mask Chamber. This is the room where the figurative depiction of bison reproduction in the Final Gallery is located. It is also the room in which the masks make the clearest statement of the equivalence of humans and bison. In that sense, the Mask Chamber is a focal part of the Final Gallery—the locus of a most important condensation of fundamental symbolic values. These symbolic statements are distinctly separated from the chamber filled with cervids. They embody aspects of belief that differentiate bison from deer.

The positions of the remaining masks indicate that they also serve other important symbolic functions. Those five masks are strategically sited at liminal points along the Final Gallery where there is a fundamental change in the nature of the decorations, as if they were the guardians of "gates" or portals through which one passed as one symbolic assertion was completed and another began. Most often, the masks at these portals are all but hidden from view until the visitor is right atop them, when they suddenly spring into the peripheries of the visual field in a way that can be startling even to the viewer who is familiar with the experience. All the "Mask Gates" but one are marked by a single mask. The other, the first gate one sees on entering and the last on leaving, is flanked by a pair of masks, one on either side of the corridor, but even in this case, only one was intended to be seen at a time. The one seen on entering is wholly a bison. The one seen on leaving is a bison-human hybrid. The masks on the right wall invariably face the entering visitor, and those on the left the exiting viewer. The visitor who passes through the Final Gallery viewing all its decorations in the most efficient

manner, without stopping to retrace steps or turning to look about, will in every case but one see the masks on his or her right—the exception can be seen from both directions.

In the case of the engraved heads of deer, a part animal, less than a complete deer, is used to evoke the animal as a whole in a sort of graphic synecdoche. In contrast, some of the masks suggest hybrid beings, part-human, part-bison, that are something surpassing a whole animal: strange and complex "supernatural"[1] entities whose nature transcends that of either humans or bison. All three of the masks on the right side entering are simply bison, and none really suggests a human visage. But the very next mask, the first one the visitor sees on turning back through the Mask Chamber, is a purely human visage. It takes no overdeveloped imagination to see in the long, saturnine mask that next appears a suggestion of blended human and bovine features. The two profiles that follow are simply bison, but the next, though fundamentally bovine, once more looks oddly human. The last mask one sees on exiting is the most extreme example of a hybrid visage in Altamira. It behaves almost as an optical illusion. Without any voluntary effort on the viewer's part, it shifts back and forth between its human and animal aspects. Seen in sequence, the masks present a gradual transition from depictions that are simply bison or purely human to representations of hybrids blending bison and human natures, suggestive of the symbolic metamorphosis of the former into the latter, and a metaphoric equation of these two very different beings.

Significantly, the equivalence of humans and bison is also suggested by figures in other decorated caves. A vertical red bison at Castillo is one example, and the "calligraphic" black bison at La Pasiega another that is even more remarkably human. Figures of hybrid men-bison are also known from France. There are two examples in the Sanctuary at Trois Frères, one of them the well-known semi-human, bison-headed figure, said to be playing a flute or musical bow. The most remarkable figure of the kind in Spain is the vertical bison/man modeled by the natural relief of a stalagmitic column at Castillo. This figure has a bison's head and body, supported by human legs and feet (Ripoll Perelló 1971–1972). The column is crowned by the roughly sculpted head of another bison, made by enhancing a naturally evocative formation.

THE COHESIVENESS OF SYMBOLS AT ALTAMIRA

It is evident when all the evidence is reviewed that the compositions at Altamira, engravings as well as paintings, polychromes included, form a single interrelated whole that represents similar concerns in different ways. Once the figures are correctly identified and the structure that underlies their placement and their relationships is understood, the unifying integrity of the whole can be seen. We found exactly the same subjects—deer, bison, horses, ibex, anthropomorphs, and geometric figures—represented both on the Great Ceiling closest to the cave's entry and the Final Gallery in its deepest recesses. The same animals are found in

the central galleries, and those galleries make a structured symbolic transition between the galleries at the two ends of the decorated space.

The same curious scene of an excited cow mounting a bison bull is repeated both on the Great Ceiling and in an engraving in the Final Gallery. The use of a virtually identical design, with both animals sharing a single pair of hind legs, to repeat this unusual subject matter in different media is enough by itself to show that the procreation of the bison herds was as much a concern of the engravers of the Final Gallery as of the painters who made the polychromes on the Great Ceiling. Cervid reproduction is another theme uniting the two galleries, as is evident from the association of antlered stags and antlerless hinds in the Cervid Gallery and in the Great Ceiling's engraved series. The human-bison relationship so clearly seen in the masks of the Final Gallery is also present in muted form in the man-like face of an engraved bison on the Great Ceiling.

A single set of structural principles was applied to the symbolic organization of the two galleries in precisely complementary and opposite ways.[2] While the species and themes represented are continuous between the Great Hall and the Cola de Caballo, and the organization of symbols in both areas obeys the same underlying structural principles, the application of those principles in one gallery consistently yields inverted transformations of the placement and relationships of figures in the other. The Great Ceiling gets its name from the fact that its famous polychrome decorations are all on its ceiling. Most of the important figures in the Final Gallery, in contrast, are on its walls, with few on the ceiling. The most numerous and striking figures in the Final Gallery are its engravings; it is painted figures that dominate the Great Ceiling. The decorated area on the Great Ceiling is undivided space, whose two major compositions, the paintings (principally bison) and the engravings (principally deer), are superimposed on each other without separation. The Final Gallery, on the other hand, is split into two major segments, each with subdivisions, and the bison and deer themes are segregated and occupy alternate galleries. The polychrome composition contains just one hind and several bison, while the Final Gallery, like the engravings on the Great Ceiling, has many hinds and few bison. The polychrome hind is disproportionately large compared to the bison, while the bison in the Final Gallery are much larger than the deer. In the Final Gallery, there are several large heads (the masks), while on the Great Ceiling there is but one each in the paintings and the engraved series. Complete polychromes on the Great Ceiling are often three-dimensional (from the natural irregularities over which they were painted), while the large painted head is flat; in the Final Gallery, the heads are three-dimensional projections, and the whole animals are flat. Further contrasts are numerous, but the enumeration of data that all point to the same conclusion would serve no purpose other than to burden the reader with redundancies.

It is also true that there are systematic similarities and contrasts between the engraved symbols on the Great Ceiling, on the one hand, and its paintings on the other. They do not coincide exactly with the comparisons and contrasts we have made of the figures in different galleries. In fact, one can find enough points of contrast between the engravings on the Great

Ceiling and those in the Final Gallery considered by themselves to show that the two sets of figures were also intended to embody the same pervasive set of concerns in contrastive and complementary ways.

All the evidence we have reviewed indicates that the decorations in all Altamira's galleries were produced and arranged according to a single uniform program of symbolic organization. This program involves such a complicated and multi-faceted interplay of parallels in subject matter and relational oppositions, and its application was so pervasive and time-consuming for those who produced it, that it can scarcely be accidental. (Incidentally, in my opinion, that implies that the different compositions I have discussed, in all the galleries, must be broadly of the same age.) The remarkable extent and consistency of interrelationships between the major compositions in Altamira's decorated galleries clearly show the importance of the symbols employed to the cultural system of the artists, support the identification of Altamira as a sanctuary or set of interrelated sanctuaries, and reveal the operation of sophisticated, insightful, and playful human minds capable of tours-de-force of symbolic construction and cultural complexity rivaling those of any living human group.

SPECULATIONS: ALTAMIRA AND INITIATION

The observations presented in the preceding interpretation, including, I submit, the identification of Altamira as a sanctuary, have a sound basis in the data, and can be empirically demonstrated. While it is possible to carry interpretation further, I realize that to do so involves a great deal of speculation. In this case, by speculation I mean logically constrained conjecture, *not* the free play of imagination. The facts in the case of Altamira permit plausible inference that leads to interesting suggestions. I caution the reader that conjecture is not fact, and assertion is not proof. While my conjectural interpretation may in fact be correct, it may also be wrong, and alternate interpretations I have not considered may fit the data equally well.

I have said that the idea that Altamira was a prehistoric sanctuary is justified. There are many kinds of sanctuaries that serve different purposes. The themes represented by Altamira's decorations indicate some dimensions of its purpose, while the correspondence of the characteristics of the Final Gallery to those of some sacred sites used for initiation ceremonies—rites of transition and transformation—in historic times suggests that it too may have served similarly.

The masks of the Final Gallery, hidden away deep in the bowels of the cave, depict a transformation or intergradation between humans and bison, suggesting that, for the artists, the two were somehow equivalent. In the same gallery they represented deer (which, to judge from their frequency in the Magdalenian level, were the principal prey of the hunters) as

more abundant but at the same time markedly smaller than either the masks or the engraved bison, emphasizing the symbolic preeminence of the latter over the deer.

On the contrary, in the most accessible composition, and the nearest to the light of day and to the space used for the ordinary activities of daily living, the polychrome figures of bison are much more abundant than are those of deer. At the same time, the bison are drawn at a relatively smaller scale than the painted deer. Significantly, the closer they approach the large hind, the smaller the polychrome bison become. And there is a group of much smaller black outlines of bison near her figure, one just below her neck.

It seems possible that the artists, decorating the most visible part of the cave, tried to emphasize the special importance of the hind relative to humans and bison by painting her at an exaggerated scale and associating her with engraved "orants." Perhaps it would not have been advisable to show disdain for deer, a principal mainstay of human subsistence, despite the fact that they were comparatively easier than the bison to capture and kill. Perhaps, in order to counterbalance any suggestion of disdain that might be inferred from the treatment of deer in the Final Gallery, to avoid insulting so important a subsistence resource, and to ensure that deer would continue to sacrifice themselves to the needs of humans, the artists symbolically expressed reverence for and supplication of the large hind as a representative or embodiment of all deer in general. No such symbolic compensation was needed in the case of the bison. The artists had already convincingly incorporated their belief in the equality of humans and bison by means of the symbolism of the masks in the Final Gallery.

The Magdalenian artists at Altamira seem to have declared in the polychromes on the Great Ceiling and the masks of the Final Gallery some of their society's fundamental beliefs concerning the relations between humans and the natural environment. If the Final Gallery expresses the wisdom of a community by means of figures whose attitudes and arrangement correspond to definite principles of symbolic organization, the Great Hall recombines the same symbols in accordance with a new and complementary structure, to reveal another side of the same message.

The animal world as revealed at Altamira is divided into two principal groups. One is that of the large, powerful bison, animals that aside from human beings had almost no effective mortal enemies in nature. The bison are contrasted to the timid and vulnerable deer. In a stable, rich, nurturing environment, a perceived equivalence between the sturdy, brave, and carefree bison on the one hand and human beings on the other would be quite understandable. As the bison did in their proper domain, humans reigned in their own.

The polychromes, executed on the Great Ceiling so close to the light of day, express their message with simplicity, clarity, and power, and their content is not hard to decipher. But their message is incomplete. In the shifting shadows of a dark and twisted gallery lay hidden their secret conclusion. That conclusion is only revealed to those who follow a narrow and arduous path, finally creeping along on their bellies, until finally they arrive in the very innermost entrails of the grotto, from which the only possible way out is to return along the selfsame constricted path. Their secret is a simple but profound equivalence: bisons and humans are

each the shadow of the other. The multiplication of the bison herds signifies the florescence and increase of the society of humans.

The characteristics of this obligatory itinerary and its hidden message suggest that Altamira was the locus of prehistoric rites of initiation. Following a narrow and menacing path, the novice was eventually swallowed up in the deepest bowels of the earth and lay there nearly helpless and immobile. Only after contracting to turn in the smallest possible space to force a way back out the womb of the earth was it possible to emerge again, first to a wider gallery where ritual practitioners could explain the hidden message of the depictions to the initiates, then to daylight, symbolically reborn, but transformed by the revelation bestowed in the process of symbolic death and rebirth.

Symbolic indications of transformation and transcendence characterize the three sanctuaries that I have discussed. I have indicated that the treatment of the Early Aurignacian burials and the mortuary precinct at Cueva Morín suggests a concern for the neutralization and placation of the possibly threatening physical remains of the deceased by means of mortuary rituals, and the transition of the dead by such means to a new social status, still as members of the ongoing social group. At the Cueva del Juyo, whatever the exact nature of the rituals there performed, the sanctuary shows a preoccupation with both the change of seasons—the regular periodic diminution of day length, the annual regression of the sun from the time of its longest and most beneficent appearance—and the fusion of the two sides of humanity and the natural world: their more "natural," uncontrollable, instinctive, and bestial side symbolized by the large cat that is the head's proper left side, and the more "cultural," controlled, and benign side, symbolized by the bearded human that is its proper left. At Altamira, it is a symbolic equivalence of bison and people that is indicated by the mask series in the Final Gallery. In all these cases, a fusion of "opposites" that transcends what we can observe in nature is indicated. The late Mircea Eliade called such reconciliations of opposed principles a characteristic of the oldest and most widespread symbols of the "paradoxical state of the totality, the perfection, and, consequently, the sacredness of God" (Eliade, 1971: 146; see also 1979). While we need not believe that all that is implicit in this affirmation can be applied to the Paleolithic evidence, the fact that it comes from such a respected authority on the history of religious systems reinforces our interpretations.

The conclusions concerning relationships between the depictions presented in the previous chapter as certain are susceptible to validation and proof. We do not pretend that the more speculative aspects of our interpretation are necessarily correct, or that they are less imaginative than those of Henri Breuil, Max Raphael, or André Leroi-Gourhan: in fact, our interpretation shares some particulars with each of theirs. But because it is based on a minute examination of the cave and its compositions in their manifold details, it is more consistent with all the data, and explains more of the characteristics of Altamira and its decorations than did they, and at the same time it is in better agreement with what we know of ecology, ethology, psychology, and socio-cultural anthropology, and all that we know of the history of symbols.

NOTES

1. By the term "supernatural" I mean here that the figures go beyond any possible experience of the natural world. I do not mean the term to be understood as it is in ordinary everyday usage, with its accompanying baggage of meaning and emotion.

2. I did not approach the study of the Altamira figures using the theoretical framework of French "Structural Analysis," as exemplified by the work of Claude Lévi-Strauss (esp. *Anthropologie structurale,* 1958). Though my stance is not by any means "anti-theoretical," I believe that a slavish and overly rigid adherence to any theoretical viewpoint can or must lead to distortions of or falsifications of the data studied, or (at very least) to the imposition of an inappropriate and subjective interpretive scheme on them. The relationships of complementary opposition described here in fact suggested themselves as our investigations of the cave and its depictions progressed.

REFERENCES

Alcalde del Río, H., H. Breuil, and L. Sierra. 1912. *Les Cavernes de la région Cantabrique.* Monaco, Vve. A. Chêne.

Eliade, M. 1971. *The Forge and the Crucible.* New York, Harper and Row.

———. 1979. *The Two and the One.* Chicago, University of Chicago Press.

Freeman, L., and J. González Echegaray. 2001. *La Grotte d'Altamira.* Editions du Seuil, La Mai-son des Roches.

Freeman, L., J. González Echegaray, F. Bernaldo de Quirós, and J. Ogden. 1987. *Altamira Revisited and Other Essays on Early Art.* Santander, Centro de Investigaciones y Museo de Altamira.

Leroi-Gourhan, A. 1964. *Les réligions de la préhistoire.* Paris, Presses Universitaires de France.

Lévi-Strauss, C. 1958. *Anthropologie structurale.* Paris, Plon.

Ripoll Perelló, E. 1971–1972. Una figura de "hombre-bisonte" de la Cueva del Castillo. *Ampurias* 33–34: 93–110.

Architectural Art in Ancient Egypt

By Leo Hansen

When the Greek ethnographer and historian Herodotus (c. 484–425 BCE) visited Egypt in the fifth century BCE, he was awed by the number of "marvels and monuments that defy description"; he thought the Egyptians, of all the peoples in the world known to him, were the most "exceedingly pious." Even 2500 years later, Egyptian art and architecture continue to astound and amaze those who become familiar with their cryptic beauty. It is often said of Egyptian art that it remained, to a certain degree, constant over the span of three millennia. Some motifs that first appeared in the Old Kingdom (c. 2650–c. 2150 BCE)—*mastabas,* underground burial chambers with rectangular, flat-roof structures above—are visible in art in the Ptolemaic period (332–330 BCE). There is an abundance of material that is well preserved in museums around the world and in situ, in temples all along the Nile Valley. Egyptian architecture rarely exists with an absence of Egyptian art, and few surfaces on buildings escape some form of decoration.

Egyptian architectural art is visible in wall paintings and sculpture in temples; temple complexes; tombs, including underground burial chambers; and palaces. Of the latter, there are surprisingly few extant sites, in spite of the singular importance of the pharaohs and the fact

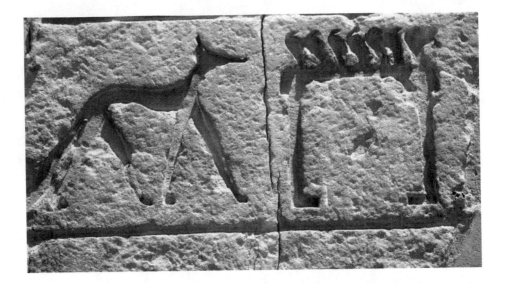

FIGURE 2-1 Mastaba of Mereruka, Saqqara, Egypt (6th Dynasty (2323–2150 BC). Mereruka was the vizier to Teti, a pharaoh who built a small pyramid nearby. Two figures are shown incised relief at the entrance to the tomb—a jackal, or the god Anubis, the guardian over tombs, and the tomb itself, protected by wasps on its roof.

that the word pharaoh can be translated as meaning great house. Like lesser domestic structures, palaces were typically built out of mud-brick, and thus were not as durable as the stone religious architecture. Still, palace interior walls were often painted and decorated.

The forms of architectural elements in ancient Egyptian architecture, especially the shafts and capitals of columns, were inspired by and modeled after the ubiquitous flora seen along the Nile—papyri, reeds, lotus flowers, and palm trees. This plant material was used for architectural elements beginning in the Prehistoric and Predynastic periods. Bundled or matted plant stems from reeds and papyri were used as support columns for huts and for early religious structures as well. This tradition is alive even today in the construction of agricultural huts.

The papyrus plant, which grows in clumps in shallow areas of riverbanks, has a long stem that flares outward at the leaf stalks, a form that was copied for columns. Papyrus-bundle columns are symbolic of the primeval landscape of Egypt. Reeds, which are used for roofing when dried, are collected in bundles. Bundled reeds exhibit a resistance to bending greater than single-stemmed plants, which explains their symbolic use for column shafts. The stem of the lotus flower grows out of shallow river bottoms, and the leaves and flowers float on the surface of the water. Both the open flower, which resembles an open segmented bowl with its petals, and the closed bud influence another type of column capital. For obvious reasons, palm trees were also used as an inspiration for capitals from the Fifth Dynasty (c. 2492–c. 2345 BCE) forward. A typical capital will have eight "fronds." The palm tree is associated with royalty, and therefore the palm capital is only used for royal architecture. A square pillar with a simple *abacus*, the square or rectangular slab immediately above the capital that supports

an architrave or beam, was also common, sometimes with the corners chamfered to create an octagon (beginning in the 11th Dynasty, c. 2125–c. 1985 BCE), or with further chamfers to create a 16-sided pillar (commencing in the 12th Dynasty, c. 1985–c. 1795 BCE).

Among the many contributions by the Egyptians to architectural history is the distinctive decoration of columns, a tradition dating back to the first monumental stone structures built during the reign of Djoser at Saqqara in the Third Dynasty (c. 2686–c. 2613 BCE). Djoser's ziggurat is the earliest Egyptian monumental work of architecture, and represents the birth of the pyramid era. Like most pyramids that would be built in the next few centuries, Djoser's pyramid complex contained ancillary shrines and halls. The entrance colonnade and the Heb-Sed court, both of which have been reconstructed, have fluted columns, which are imitative of bundles of reeds. The roof of the colonnade has round stone beams supporting stone slabs, which is a replication of a common structural technique using real palm logs, employed both in earlier religious structures and in houses.

The first evidence of columns with lotus-bud capitals is at the necropolis at Abusir, built during the Fifth Dynasty. Columns at the tomb of Ptahshepses resemble bundles of stems tied at the top of the shaft with four stone hoops. Above these are the closed lotus flower capitals, and then the abacus. At the tomb-chapel of Kheti, a regional governor at Bani Hasan from the 11th Dynasty, interior lotus bud columns have the same four stone ties that separate the "stem" from the "bud."

Open-bloom papyrus columns are first used in the 18th Dynasty (c. 1550–c. 1295 BCE) at the entrance colonnade at the Temple of Luxor. Luxor Temple is located on the east bank of the Nile River. A thin abacus is hidden from the view of a person standing adjacent to or near the column due to the splaying out of the capital.

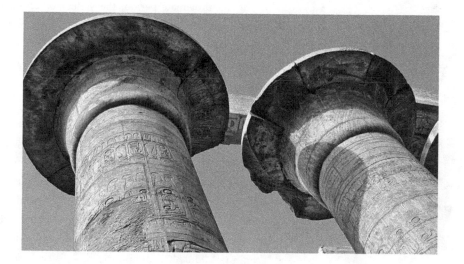

FIGURE 2.2 Open Papyrus Column, Hypostyle Hall, Great Temple of Amun, Karnak (13th c. BCE).

A so-called "tent-pole" column was used at the Festival Hall of Tuthmosis III or Men-Khephure-Re (Blessed through His Monuments) at Karnak. The columns are copies in stone of wooden poles used to support a canopy over the portable throne used by Tuthmosis in his military campaigns in the Levant. The hall itself was meant to emulate a tent structure used for festivals. The use is singular; there are no other known applications of this design.

The so-called Hathor column contains an added element above the shaft of the column: a stone cube with the face of the mother goddess Hathor on all four exposed surfaces. The oldest such column is found at the Temple of Hathor at Serabit el-Khadim, located in the Sinai Desert. The sanctuary was founded in the Fourth Dynasty; the court with the Hathor columns was built by Hatshepsut and Tuthmosis III (c. 1479–c. 1425 BCE). The Hathor column can also be found at Hatshepsut's mortuary temple at Deir el-Bahri. It is sometimes called a *sistrum* capital because of its resemblance, in form, to the ancient Egyptian musical instrument that consisted of three rods in a metal frame, which emitted a rattle sound when shaken. At the Temple Complex of Dendera (c. 332 BCE–395 CE), the Hathor block is immediately above the shaft of the column, and thus becomes the capital. Above the capital

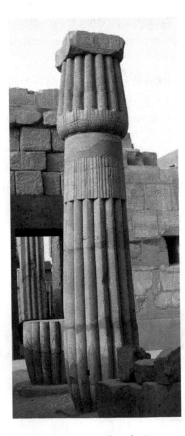

FIGURE 2.3 Closed Papyrus Column, Great Temple of Amun, Karnak (13th c. bce).(13th c. BCE).

is another cube in which the symbol of Hathor is inset within a simple geometric relief, possibly a doorway. Above this is a thin abacus and the stone architrave. At the columns for the colonnade of the first courtyard of the Temple of Isis at Philae, the Hathor block is placed above the capital, with a shorter block above, and no abacus. The goddess Hathor is shown with a human face and cow's ears. Another god seen in capital art is the dwarf god, Bes, placed on top of square pillars.

In the Ptolemaic period, the variety of capitals increased substantially. Motifs were blended to create a composite design. Additional plants were used as source material. The decoration of capitals could vary from column to column such as at the same columns mentioned above at the Temple of Isis at Philae.

All architectural elements in a temple or tomb structure were potential surfaces for art. The oldest form was bas-relief, in which the entire background was removed, leaving the intended figure or figures. Both the figure and the background were then painted. Sunk relief, in which an outline of the figure is incised into the stone and then the interior space, was molded. From the Middle Kingdom forward, walls could also be painted without first being sculpted.

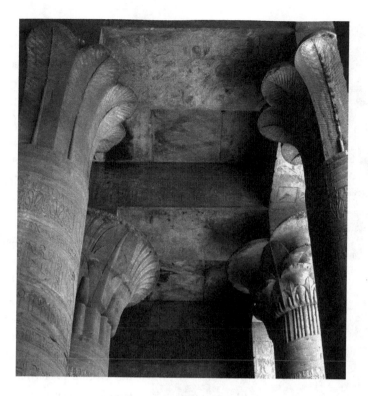

FIGURE 2.4 Palmette Column, Temple of Horis, Edfu (237–57 BCE)

Sculpture placed in monumental architecture in ancient Egypt was achieved in one of several ways. Statues were simply placed in strategic locations—separate from, but with consideration of, the structure. Statues of pharaohs often flank the opening of a *pylon*, an entrance to a temple complex formed by two large towers with inclined sides. At the Temple of Luxor, located near Thebes, the Egyptian capital during the 18th Dynasty, there are two oversized seated statues of Ramesses II, representing the thrones of Upper and Lower Egypt united under one ruler, at the First Pylon, as well as additional major sculptures of pharaohs and queens at subsequent pylons.

Between the great temple complexes at Luxor and Karnak, there was once a processional way, the so-called Avenue of the Sphinxes, which was originally built by Queen Hatshepsut in the early part of the 15th century BCE (1502–1482 BCE), and replaced by Nectanebo I (380–362 BCE) when it had fallen into disrepair. The sphinxes, a symbol of the power of the pharaoh, have the body of a lion and the head of a ram, invoking the god Amun. A small statue of the pharaoh is set between the paws of the lion, symbolizing Amun's protection of the pharaoh. During the opet festival, an annual celebration in the ancient capital of Thebes, statues of the Theban gods were transported on sacred boats carried by priests from Karnak to Luxor, symbolizing both the uniting of Amun and Amun-Re, and the renewal of the marriage

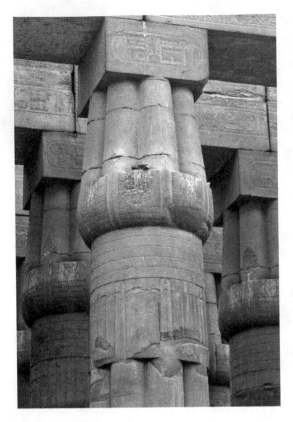

FIGURE 2.5 Closed Lotus Bud Column, Courtyard of Amenhotep III, Luxor Temple (13th c.).

between Amun and his wife Mut. Similar sphinx-lined processional ways have also been discovered at the Deir el-Bahr mortuary complex of Hatshepsut, the Temple of Seti I (c. 1294–1279 BCE), and at the Nubian Temple of Amun-Re built by Ramesses II at Wadi es-Sebua.

The second type of installation of statuary in Egyptian architecture is the Osiride pillar statue, in which a standing pharaoh figure is attached or semi-attached to, or freestanding in front of, a square or rectangular pillar. The pharaoh is shown with his arms crossed over his chest, symbolizing royal power and invoking the god Osiris. On the Osiride pillars on the upper terrace of Hatshepsut's funerary temple in Deir el-Bahri, some of the Hatshepsut statues have been reconstructed. Hatshepsut, who was the daughter of Tuthmosis I and the wife of her half brother, Tuthmosis II, served as co-regent between c. 1479 and c. 1458 BCE. At the Temple of Ramesses II, or Temple of Ramesses-Meryamun, at Abu Simbel (c. 1245), portrait statues standing in the Osiride pose line both side of the first atrium. On the ones on the right, Ramesses II wears the double crown of the united Upper and Lower Egypt. On those to the left, he wears the white crown of Lower Egypt.

A third category, titanic statuary integrated into the facades of temples, is less common, but spectacular in its effect, and thus very celebrated. Although Herodotus used the word *kolossos* when describing all Egyptian statuary in temples, the word colossus is presently used to refer to very large statues such as the Giza Sphinx. The most famous examples of these colossal images in Egyptian architecture are the so-called Colossi of Memnon, the actual Mortuary Temple of Amenhotep III (c. 1390–c. 1352 BCE) near Luxor, and the Temple of Ramesses II at Abu Simbel. From all indications, the Temple of Amenhotep III was a magnificent structure. The two seated statues of Amenhotep, now isolated, were once attached or semi-attached to a mud-brick pylon, which has disappeared. They stood 20 meters (65 feet) tall. A processional way, with crocodile-lion sphinxes, led to the pylon.

Abu Simbel is a rock-cut temple, so named because the entire structure was carved in place out of the sandstone. Two identical limestone statues of the seated pharaoh are positioned on either side of a small opening in a vertical wall in the shape of a single pylon tower. The statues are 21 meters (69 feet) tall. When the Aswan Dam was built, the temple was painstakingly relocated to a new location; the original site is now under Lake Nasser, a man-made lake.

Figures other than gods or pharaohs are seldom seen in Egyptian art. Pharaohs depicted in Egyptian architectural art can be shown in various manners: seated or standing in full portrait; standing and holding offerings to a god; seated, with hands placed flat on each thigh; in the Osiride pose, as described above; walking, with one foot forward, holding a royal staff in one hand and a mace in the other; and in the act of smiting an enemy, with one hand wielding a mace and the other grabbing the hair of the victim. This last pose is first seen on the Narmer Palette (c. 3100 BCE), a two-sided monument celebrating the unification of Upper and Lower Egypt, found at Abydos, and now on display in the Egyptian Museum. Another pose, associated with the pharaoh's resurrection in the afterlife and seen in tombs and mortuary temples, shows the king raising the Djed-pillar, a symbolic re-creation of the resurrection of Osiris in the shape of a single column with three or four short cross-members, the god's figurative spine. As a hieroglyph, it means stability. Pharaohs are often seen wearing a short

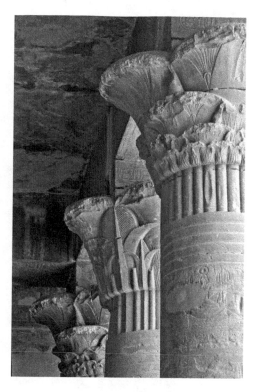

FIGURE 2.6 Lotus Column, Temple of Sobek and Horius, Kom Ombo (180–47 BCE).

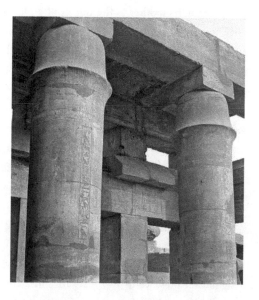

FIGURE 2.7 Tent Style Column, Festival Temple of Tuthmosis III, Karnak (15th c. BCE).

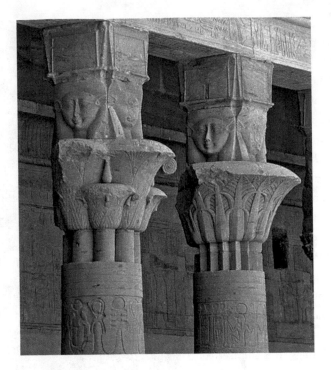

FIGURE 2.8 Hathor Column, Temple of Isis, Philae
(380–362 BCE).

skirt, belted at the waist, called a *shendyt*, and seen as stiff, not loose. In an appropriate setting, a pharaoh is sometimes shown paired with his favored wife.

A pharaoh's mother is the queen of a pharaoh; the god Amun is the father. A "divine birth" sequence can be found in tomb and temple art. The messenger god Thoth leads Amun to the bedchamber of the queen. The queen is then shown with her knees intertwined with Amun, with each holding the ankh symbol, Amun's to her mouth, the queen's to his genital area. Later scenes show the pregnant queen and the young pharaoh-to-be being presented to Amun. An *apotheosis*, or elevation, of the king to divine status, also occurred in the Roman Empire and in Mesoamerican civilizations, and in all three, the art and architecture are authentications of this transfiguration. Throughout the three millennia when Egyptian art remained relatively constant, a hierarchal scale was used for the representation of the pharaohs; they have the highest status and are generally shown at the largest scale, without regard to proportional realism.

From the very beginning of Egyptian dynastic civilization, beginning around 3100 BCE, until the Ptolemaic period, which ended in 30 BCE with the suicide of Cleopatra and the execution of Ptolemy XV Caesarion, the divinity of the pharaoh was part of the ideology, and thus a significant presence in Egyptian art and architecture. Alexander the Great, who assumed control of Egypt by defeating Darius III and the Persian army in 333 BCE, became pharaoh in 332. He crowned himself at the Siwa Oasis, a remote outpost of difficult access. He went there to

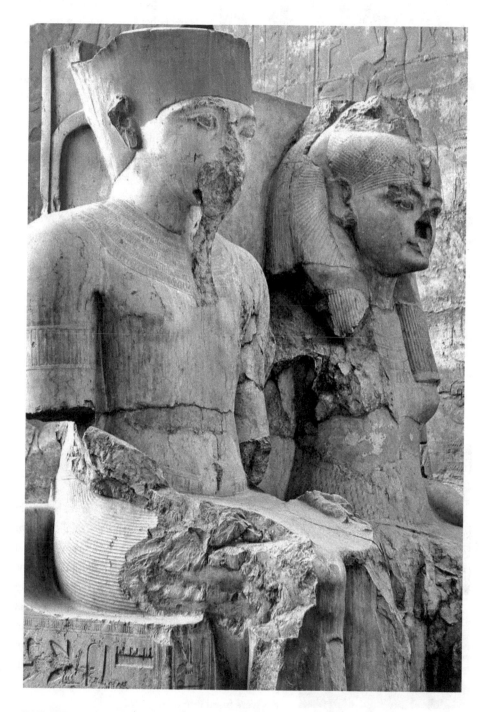

FIGURE 2.9 Luxor Temple, Egypt. Tutankhamun and his sister-queen Ankhesenpaaten, later Ankhesenamun (14th c. BCE).

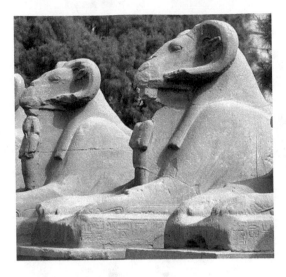

FIGURE 2.10 Sphinx, Karnak (13th c.).

consult the Siwa oracle, asking "Who is my father?" The oracle responded that his father was the sun. Thus, as the son of the sun god, Re, Alexander was deified, and his ascension to the throne of the pharaoh gained legitimacy.

During his lifetime, the pharaoh was seen as an incarnation of Horus, the falcon-headed god who wears the sun disk on his head. The disk is surrounded by a *uraeus*, a representation of a sacred serpent emblematizing the highest power. Horus is the sky god, depicted as a falcon in profile, or with wings fully spread. The eyes of Horus are the sun and the moon. After his death, the pharaoh was associated with Osiris, god of the afterworld, of fertility, and vegetation. The goal of the king in his afterlife is to become one with Osiris and thus be resurrected. In art, a pharaoh is often seen embracing Osiris; by doing so, the pharaoh is accepted by the gods and accepted into the afterlife.

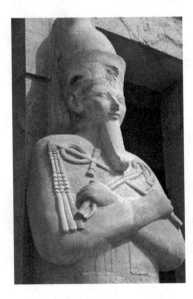

FIGURE 2.11 Osiride Column, Mortuary Temple of Hatshepsut, Deir el Bahari (mid 15th c. BCE).

EGYPTIAN MYTHOLOGY

The mythology of ancient Egypt cannot be easily understood as a single entity, but rather a collection of myths that became united due to cultural and political influences. The origins of many of the gods and myths are Predynastic, when there was still much diversity in the religious practices and beliefs of individual villages and kingdoms. Even after the unification, and continuing throughout the long history of Egyptian civilization, regions would favor or disfavor certain gods. Over time, some gods with similar characteristics were fused into one.

There were three religious texts in ancient Egypt, none of which were present at the beginning. *Pyramid texts* (Fifth–Sixth dynasties), were painted in burial

chambers and antechambers of the pyramids. *Coffin texts* (Middle Kingdom) were painted on the coffins of the deceased. *The Book of the Dead* (New Kingdom forward), papyrus scrolls that are often described as "guidebooks" for the afterlife buried in the coffin with the deceased.

In the beginning of time, there existed four coupled forces that produced chaos, collectively grouped as the Ogdoad. The Nun, partnered with Naunet, was the primeval waters. Amun, or Amon or Amen, partnered with Amaunet, was the invisible wind. Heh, partnered with Hehet, represented infinity. Kek, partnered with Keket, was darkness. Because the primeval waters were dark and slimy, frogs and snakes are sometimes used to represent the Ogdoad. Alternatively, they can be seen as baboons greeting the morning sunrise, such as at the Temple of Ramesses II at Abu Simbel, where there are 22 baboons at the top of the pylon tower.

Amun, also known as Amun-Ra, became one of the creator gods, along with Atum, who created the gods Shu and Tefenet. Khnum controlled the flooding of the Nile. Ptah, who, by his thoughts, created all other gods.

The Nine Gods of Heliopolis, or the Ennead, are the most popular gods of ancient Egypt. As a whole, they conceptually resemble the 12 Greek gods of Olympus. The dual-sex god Ra-Atum produced semen from self-stimulation, put it in his mouth, and spat out Shu (air) and Tefenet (moisture). They produced Geb (Earth) and Nut (sky), who gave birth to two pairs of twins—the elder Osiris and Isis, and the younger Seth and Nephthys. Osiris and Isis fell in love in the womb of Nut. Nephthys, however, did not like her twin brother, Seth. Shu is depicted in art as a lion-headed man, or a man with a feather on his head. His wife, Tefenet or Tefnut, is shown with a lioness head or as a cobra. Nut is a very popular figure in Egyptian art, seen nude arched over the earth, or a cow painted with stars.

FIGURE 2.12 The goddess Hathor, Temple of Sobek and Horius, Kom Ombo (180–47 BCE). Hathor is the goddess associated with fertility, femininity, music, joy, and love.

Evolution and Development
of Greek Sculpture

By William H. McNeill

A mong the Greeks sculpture began as a means for propitiating supernatural powers. Later the art served to glorify athletes and other men whose deeds deserved to be remembered. After about 400 B.C. to surprise the beholder with some novel effect became an end in itself. In the late Roman empire, however, the celebration of the power of political rulers was the main surviving role for sculpture.

William H. McNeill, "Evolution and Development of Greek Sculpture / Leaders of Antiquity," History of Western Civilization: A Handbook, pp. 119-128. Copyright © 1986 by University of Chicago Press. Reprinted with permission.

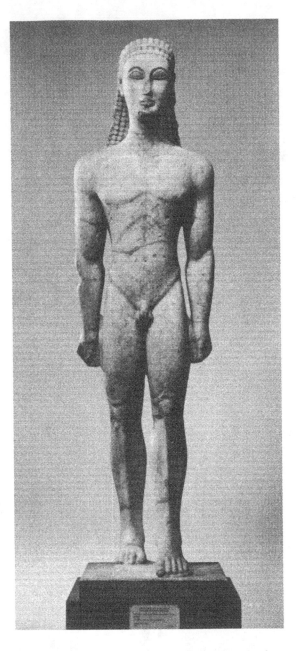

FIGURE 3.1 Kouros, or Figure of a Standing Youth 615–600 ᴮᶜ (The Metropolitan Museum of Art Fletcher Fund, 1932)

This naked statue is typical of the archaic period. The stiffness of expression and rigidity of position indicate the sculptor's limited knowledge of the complexity of the human form. Although the sculptor fell short of naturalistic accuracy, he achieved an effective representation of a man-like god, naively yet powerfully conceived.

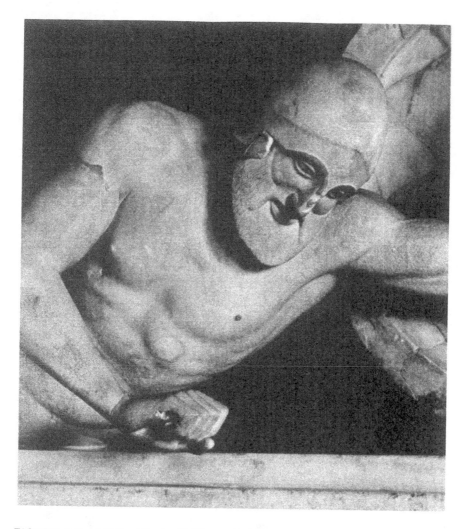

FIGURE 3.2 A Fallen Warrior Holding a Shield 500–480 B.C. Glyptothek, Munich
(Hirmer Verlag München)

The Fallen Warrior, an example of the late archaic style, once stood in the pediment of the
Temple of Aphaia in Aigina and was part of a group probably representing an incident from
the Trojan War. In comparison with the kouros, the Fallen Warrior shows a naturalistic
treatment of the body and a more realistic rendering of the muscular surfaces. Archaic
conventions, however, persist in the handling of the face.

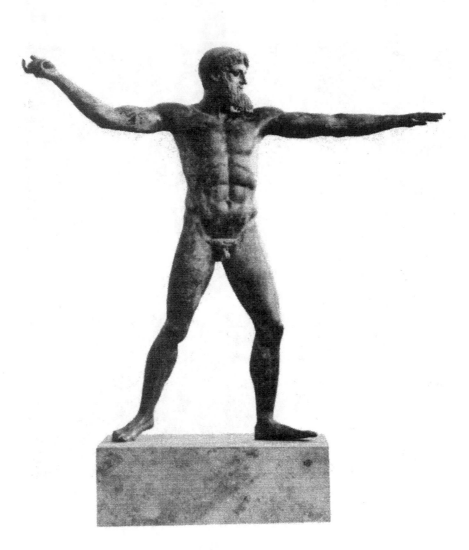

FIGURE 3.3 Poseidon or Zeus of Artemesium 460 B.C. Bronze Original In National Museum, Athens

(Hirmer Verlag München)

In the Poseidon all traces of stiffness of body surfaces and rigidity in position are now gone. In contrast to the Fallen Warrior, the face shows successful naturalistic treatment. The surfaces of the face are carefully modelled, while the deep furrows of the beard look like real hair. Yet despite naturalistic details, the Poseidon represents an idealized concept of beauty, without any real human counterpart. This statue was recovered from the sea where it had been deposited by a shipwreck. Who made it is unknown, but stylistic details show that it was designed and cast in Athens about the time Pericles assumed control of the city's public life.

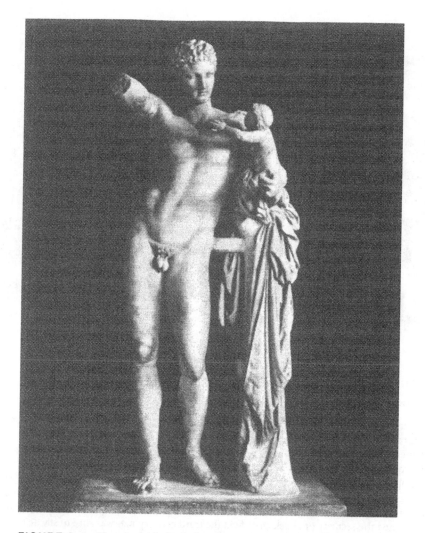

FIGURE 3.4 Hermes with the Infant Dionysos, Praxiteles 350–330 B.C.
Olympia Museum

(Alinari Art Reference Bureau)

In the fourth century B.C. their growing technical virtuosity allowed Greek
sculptors to make more and more realistic statues. This is illustrated by this work
of Praxiteles, a famous sculptor in his own day, who manages to suggest the
softness of human flesh by subtle modelling of the marble surface. Yet this ex-
traordinary mastery of technique had its cost. Praxiteles' Hermes lacks the
majesty and awe appropriate to a god. We see instead a handsome, slightly self-
conscious young man. But in Praxiteles' time the Greeks had already lost faith in
the gods of Olympus anyway, so that the reduction of divinity to a merely
decorative level fitted the intellectual climate of the age.

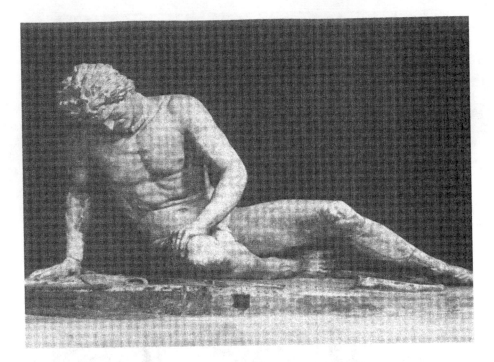

FIGURE 3.5 Dying Gaul Circa 240 B.C. Capitolina Museum, Rome

(Alinari Art Reference Bureau)

Hellenistic sculpture continued the tradition of highly realistic treatment of the human form. In contrast to artists of earlier periods, however, Hellenistic sculptors often introduced a dramatic element into their works. This statue, for instance, emphasized realistic details, but the sculptor strove for a heightened effect by portraying a defeated barbarian warrior on the point of death, attempting, with all his remaining strength, to rise from the ground and regain his feet while his life's blood oozed from the wound in his side. The sculptor thus sacrificed timelessness and monumentality for shock value, since even a pang of sympathy for the rude invaders who briefly frightened the security of Greek city life in the third century B.C. was sure to startle the slightly jaded Hellenistic gentlemen for whose taste such work was designed.

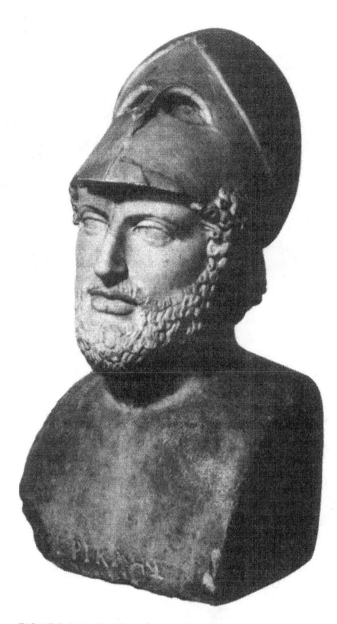

FIGURE 3.6 Pericles, after Kresilas Circa 440 B.C.

(British Museum)

The bust shows Pericles as *strategos* wearing a helmet on the back of his head. We cannot tell how much Pericles really looked like this bust. Although it was carved during his lifetime, the sculptor may have portrayed an idealized image of the wise and farseeing military leader and statesman rather than the idiosyncracies of Pericles' real features.

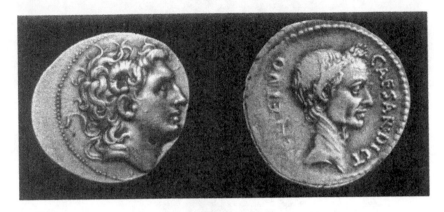

FIGURE 3.7 Alexander the Great Silver Tetradrachme, 306–281 B.C.

(Courtesy Museum of Fine Arts, Boston)

This coin aims at conveying the idea of Alexander as ruler and divinity rather than as an individual personality. The horn visible amidst his curly hair was a symbol of divine power and status. By issuing such a coin, Lysimachus, one of the generals who disputed Alexander's empire after the king's death, was laying claim to legitimate succession to the Macedonian conqueror.

Julius Caesar
(*Charakterkoepfe de We/tgeschichte /*

Kurt Lange Piper Verlag MCinchen)

The Roman fondness for realistic portraiture is demonstrated by this convincing like-ness of Julius Caesar.

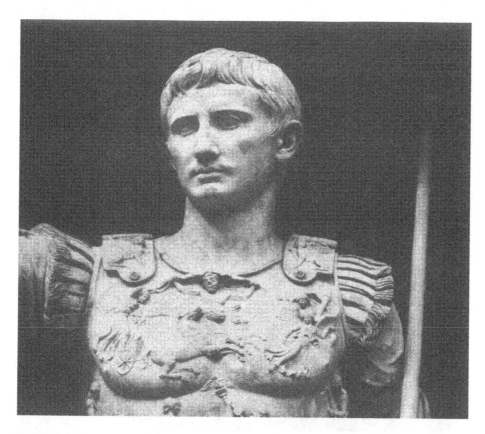

FIGURE 3.8 Augustus Addressing His Troops 15 B.C. Vatican Museum, Vatican City

(Anderson Art Reference Bureau)

This statue of the Emperor Augustus addressing his troops deliberately and consciously harked back to old times. The details on the breastplate, for example, portray incidents from early Roman history, and the artistic style used in making the statue imitated fifth century work (a full four hundred years before Augustus' time) when Greek sculptors had attained a lofty idealism—"above the battle"—in their portraits of the gods. The anonymous Greek who made this statue was a skilful imitator indeed, and far outdid Augustus himself, who restored a republican facade—but only a facade—to the Roman body politic.

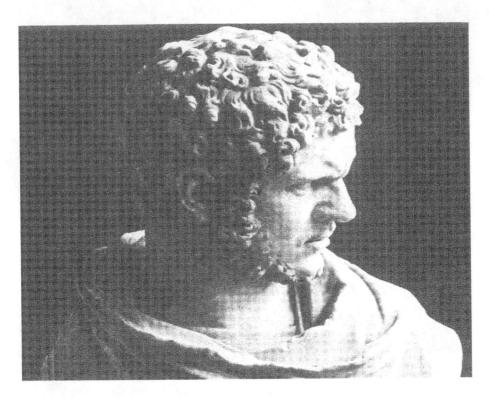

FIGURE 3.9 Caracalla *Circa* A.D. 215

(Art Museum, Princeton University)

The sculptor who made this bust of the Emperor Caracalla was fully in command of Hellenistic techniques for surprising the viewer and conveying heightened, dramatic effects. The self-conscious restraint and archaizing of Augustus' day had been rejected, just as in politics Caracalla used his imperial office to give free rein to his violent and sensuous impulses.

FIGURE 3.10 Constantine Circa a.d. 313 Capitoline Museum, Rome

(Hirmer Verlag München)

The disasters that struck the Roman empire in the third century A.D. are here tellingly recorded in stone. The sculptor had lost the high skills of earlier ages; realism, detail, technical mastery of the medium all have vanished. Yet the staring, strained expression so awkwardly conferred upon the Emperor Constantine manages for all its clumsiness to suggest a striving after transcendental truth—an effort to catch sight of another and better world than this. In such a climate of thought, Christianity throve.

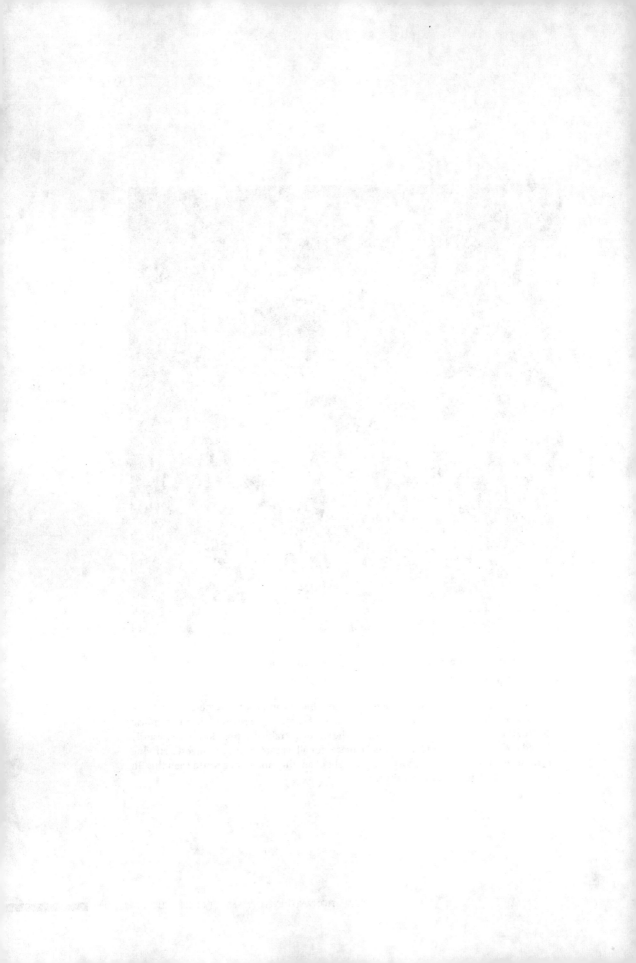

The Arts of China

By Andrew Jay Svedlow

C hinese cultural history stems back in time at least 5000 years and has antecedents as far back as the last ice age, over 10,000 years ago. Recognizable iconography and aesthetic principles are often viewed chronologically and linked to the dynastic history of China. From the earliest Shang Dynasty bronzes to the last dynasty in Chinese history, the Qing, threads of traditional symbolism, design motifs, and materials and methods can be woven together to create a tapestry of Chinese cultural and artistic history.

The vast and diverse geography that is China has been the home to unique ethnic groups, competing political and military factions, disparate languages, unique regional cuisines, persistent symbols of the ruling classes, as well as folk art forms that vary as much as the terrain. From the Gobi desert to the sprawling mega urban centers on the coast line, from the frozen northern tundra to the tropical rice fields of southern China, the peoples of China have produced a rich and highly sophisticated art history that expresses the values of the people who created or commissioned these artworks and artifacts.

In many respects, it is the geography of China that has been the shaper of its culture. With the Pacific Ocean as its natural eastern border, western China bounded by the Himalaya Mountains and the Tibetan plateau, and to the north, the grasslands of Mongolia and the forests of Manchuria, and the nations of tropical Southeast Asia at the southern border, there is no lack of climatic and environmental diversity and challenges linking the evolution of Chinese culture to its place. The core of Chinese civilization and the litany of its political history as seen in its dynastic narrative can be found in the great water shed regions of its main rivers and their tributaries. The Yellow River in the north begins in Tibet and enters the sea near the Shandong Peninsula. The Yangzi River also originates in Tibet and flows through Sichuan, entering the Pacific near Shanghai. Both these monumental rivers have been central to the foundation of China's civilization.

Historically, most of China's population was rural and agricultural. From the wheat fields of the northern regions of China, to the infinite rice fields of central and southern China, the major historical ethnic groups have cultivated and terra formed the land for thousands of years. The majority ethnic group in China is the Han, whose civilization arose in the fertile valleys of the Yangzi River. The Han account for the considerable majority of people in China,

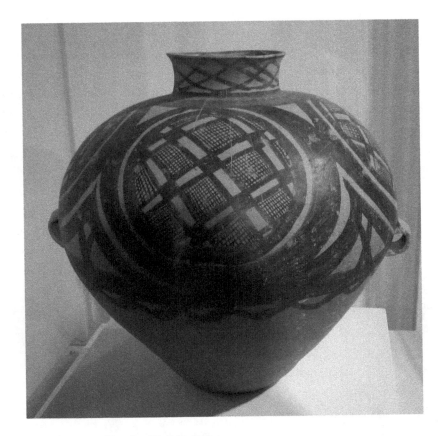

FIGURE 4.1 Yangshan Neolithic Pottery

and the Manchu, Uyghur, Tibetans, and Mongolians are the largest of the ethnic minorities in the country today.

The earliest excavated pottery in China is known as the Yangshan neolithic culture. This reddish earthenware with black designs has been found in the middle of the length of the Yellow River. Basically at the same time, along the Shandong coastal region, the Longshan culture was using a potter's wheel to create its thick, hard, black, burnished pottery.

Beginning about 2205 years before the Common Era, the Xia dynasty began to produce sets of ritual bronze objects that have been found in funereal sites, and which might be associated with ancestral worship. The competing clans of this early period in Chinese history may have come under the strong rule of one of these warring factions to dominate as the Xia Dynasty.

The Shang dynasty began about 3,500 years ago and its people lived and thrived along the Yellow River near present day Anyang. Some consider this region as the cradle of Chinese civilization. It is during this time period that ancient Chinese written characters are found on oracle bones and where elaborate bronze vessels are found in Shang tombs. The oracle bones were commonly the shoulder blades of cattle or the plastrons of turtles and were most likely used to divine weather and crop forecasts. The bones were written on and then cracked using a heat source in order to seek the advice of ancestors on behalf of the ruling king. The diviners would read these cracked bones and write out their answers for the ruler. The Shang maintained records of these oracle bone readings. The script on the oracle bones from this

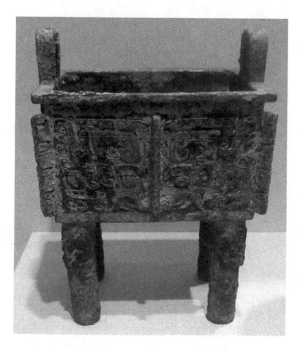

FIGURE 4.2 Shang Bronze,

period can be considered the earliest example of written Chinese. Shang bronze vessels come in a range of sizes and shapes. One dominant motif is the Tao *tie* or animal mask.

This design persisted throughout Chinese history. The bronzes were cast in clay molds. Many of these funereal bronzes were found at Sanxiangdui, an archaeological site near Chengdu stemming back about 3,200 years ago. Besides the bronze vessels, other implements and adornments in gold, jade, amber, and ivory have been recovered. It appears that many of these artifacts were part of sacrificial offerings to the Shang ancestors. As metallurgy advanced during the Shang period, the people of the Shang were taxed in order to underwrite the production of these beautiful and ritual objects.

Chronologically following the Shang dynasty is the Zhou dynasty (1027–221 BCE). The Zhou lived on the western boundary of the former Shang Empire. The first of the Zhou rulers unified the disparate clans in the region in order to defeat the Shang. King Wen led this rebellion in 1050 BCE. Wen's son, King Wu led the military coalition and took the capital city Anyang away from the Shang in 1045 BCE. Wu was still a young lad when the rebellion began and his kingship became solidified, and it was his uncle, the Duke of Zhou, who truly ruled as regent. At this time in Chinese history, the concept of the "mandate of heaven" was adopted as the principle by which the Zhou and all future dynasties would validate their authority. This mandate gave emperors the right to maintain order and balance in the empire. As part of this

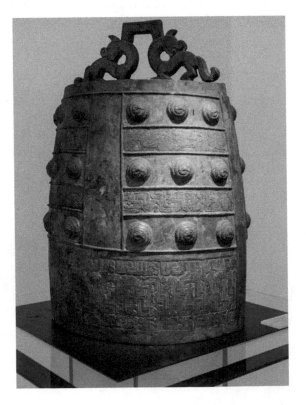

FIGURE 4.3 Zhou Dynasty Bronze Bell

Zhou belief system, the image of Tian, or heaven, became central to building of a value system that made the mandate of heaven the basic tenet for political rule in China. The Zhou located their capital in the city of Chang'an, present day Xian on the Wei River.

The new capital was laid out as a squared walled city, which would become the prototype for future Chinese capitals. The Zhou Empire expanded beyond the realm of the Shang, south of the Yangzi River. In Zhou tombs, bronze bells that reveal a highly sophisticated metallurgical practice, and protoporcelain pottery have been excavated.

The earliest documented chronicle of Chinese history was written in the 8th century BCE during the spring and autumn periods. These Spring and Autumn Chronicles were produced in the state of Lu, and may have been written by Kung Fu Tsu (Confucius). Not long after this period in Chinese history the Warring States Period (403–221 BCE) began, and the country devolved into competing fiefdoms. At this time, despite competing forces abounding across the territories, a new class of administrators, known as *shi*, evolved and became the political and bureaucratic elites. This bureaucracy set the stage for the Confucian system of roles and rewards that metastasized in Chinese society until the close of the Qing Dynasty in 1911.

In 221 BCE Emperor Shi Huang Di unified the country under his total dictatorship and created the Qin Dynasty. Known for many wonderful archaeological treasures and the beginnings of the building of the Great Wall, the Qin Dynasty lasted only twenty-one years. Many

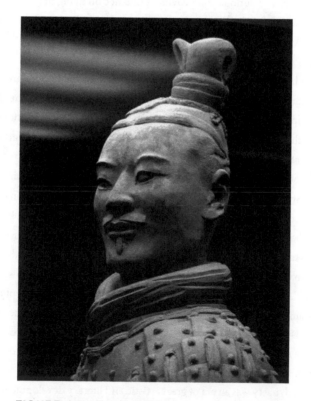

FIGURE 4.4 Terracotta Warrior

aspects of the Chinese economy and social institutions were standardized during this period. Under the Emperor's stern rule, currency was standardized, the width of cart axles was standardized, and the military was trained to a high degree of superiority. Perhaps best known for the 8,000 or so Terracotta Warriors excavated from the tomb complex for Shi Huang Di, the Qin Emperor's own imperial tomb has yet to be located.

As with all art histories, there are the Big History stories and the Small History stories. Of course, the Chinese dynastic roll call is the Big History of Chinese art. The Small or Social history of China begins about 10,000 years ago with the domestication of rice in what is now Jiangxi Provence in central China. Agricultural life developed over the centuries and settled into the village life that is still part of rural China. Spreading out from this fertile rice cultivation basin to the four corners of the Chinese landscape, over fifty national minorities still make up the billion plus population of China. One key element that has tied these nationalities and distinct linguistic groups together is a system of writing that cuts across all of those internal borders.

During the Warring States period a vibrant development of intellectual thought manifested itself in two world views that have been persistent in Chinese culture: Confucianism and Daoism. Confucianism basically outlines the means by which people can live together in harmony through the practice and maintenance of rituals and systems of relationships. Daoism has a naturalistic outlook and provides guidance on living the right way.

In Confucianism, the family stands as a microcosm of how all relationships work. Detailed in the Analytics by Kung Fu Tsu, there are five significant relationships: ruler to subject, father to son, husband to wife, elder to younger brother, and friend to friend. Each of these pairings has a superior side and an inferior side, and each, therefore, has obligations and responsibilities that form the basis of the relationship. By following the rituals and rules of the relationships, each side may fulfill their role. These concepts of relationships, and later the gentleman scholar ideal of Confucianism, will play a role in the visual arts as these ideals are manifested in the great landscape paintings of the Song Dynasty.

After the fall of the Qin Dynasty, the next powerful unifying force in China was the leaders of the Han Dynasty (206 BCE–220 CE). At this time, the Han were invested in trade with travelers that came from as far away as present day Turkey, through what would become known as the Silk Road. The Han also adopted a Confucian system of government and civil service that would become a solidified element of Chinese political life. Also during this dynasty, Buddhism was introduced to China from northern India and the iconography of Buddhism would become normalized in Chinese art and architecture. Han tombs contained ceramic replications of whole villages, farm animals, and musicians and other performers, all in much reduced scale.

As the Han Dynasty began to wane, competing forces once again threw the nation into warring states for centuries. In 618 CE the Tang dynasty emerged as the dominant and most dynamic force in setting an equilibrium across the growing territory that would become its empire. The Tang dynasty was an era of great artistic and literary development and sophistication. Considered by some to be the greatest artistic dynasty in Chinese history, the Tang capitol in

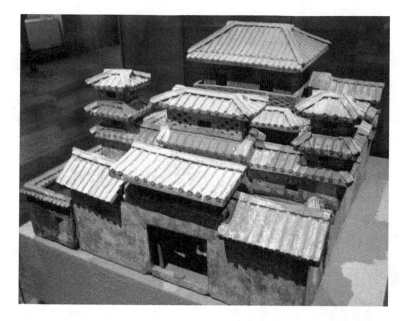

FIGURE 4.5 Han Dynasty Tomb ware

Chang'an, present day Xian, was the cultural and population center of Asia. Whether in landscape painting, sculpture, multi-colored glazed ceramics, figurative portrait painting, or poetry, the Tang produced a wealth of beautiful objects. At the same time as this burst of artistic energy was sweeping across the kingdom, Buddhism also became a prevailing religious practice among all classes of people. Artworks and architecture devoted to Buddhist themes and places for devotion proliferated across the landscape. Along with Buddhist thought, Confucianism was studied as the fundamental arena of classical learning.

The next major shift in Chinese dynastic history came with the troubled but artistically rich Song

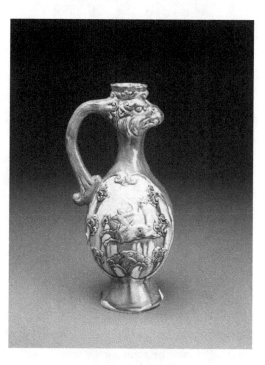

FIGURE 4.6 Tang Dynasty ceramic

dynasty, which was the controlling paradigm from 960 until 1270 CE. The capital moved from Chang'an to Bianling, present day Kaifeng, and advances in agriculture and commerce made

the Song wealthy. This wealth was used to support the arts, which flourished during this time period. The Song Dynasty is customarily divided into the Northern Song (960–1127 CE) and the Southern Song (1127–1279 CE). The art of the Northern Song is seen as a manifestation of the values expressed in Confucianism. Landscape paintings with formal compositions, much like the formalism of Confucianism, dominate the artistic conventions of this time. Both hanging scrolls and paintings on paper and silk fans led the visual expressions of the time. It is at this time that the ceramic arts took on a particularly refined turn. The elegant glazed porcelain of the Song is still highly prized today.

The Southern Song were known for their large hanging scroll landscape paintings. Perhaps the most influential painter of this time period was Xia Gui, whose monochromatic ink paintings are emblematic of Chinese landscape painting to this very day.

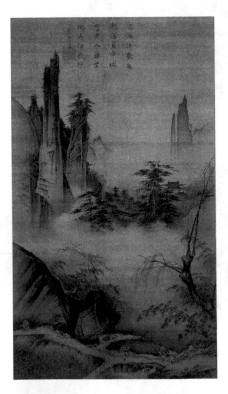

FIGURE 4.7 Sung Dynasty painting by Ma Yuan

Eventually, the Song military weakened in the face of multiple incursions by tribes from the north and west. They eventually fell to the Mongol warriors, harkening the rule of China by the first foreign emperors.

Known as the Yuan Dynasty (1260–1368 CE), the Mongols established their capital in Beijing, or Northern Capital. The artwork produced under the Yuan focused on the imperial court and included attention to architecture, gardens, colorful paintings, jade, lacquer, ceramics, and silk. As a continued development of painting and calligraphy from the Song period, a taste for smaller scale paintings that more intimately connected the artists with his audience dominated. This literati painting style, perfected in the Southern Song dynasty, has a soulful and transcendent quality.

In 1368, the over stretched Mongolian empire and the decline of the Yuan Dynasty in China saw the establishment of an ethnic Han controlled dynasty, named Ming. Ming military leaders and their armies drove the Mongols out of Beijing. The Ming painters exemplified the scholar-amateur painters of the Song and Yuan. The academically trained artists of this time period are best typified by the artist Dong Qichang. Ming porcelain, easily identified by its blue and white ceramics, became highly prized. At the same time, the traditional fine arts and crafts were being embodied as uniquely Ming, as was the building of the Forbidden City in Beijing, and the gardens and

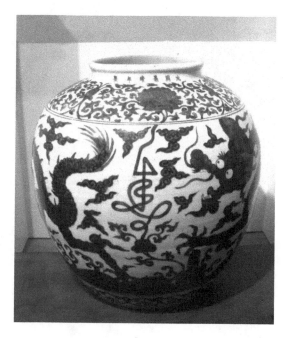

FIGURE 4.8 Ming Vase

palaces within the walls of this most expansive of imperial grounds. The Forbidden City was planned with great attention to geomancy and fung shui.

Once again, this time in 1644 CE, a foreign invader took control of the breadth of China. The Manchu invaded from the north and took control of Beijing. Their long-standing dynasty, which lasted until 1911, is known as the Qing. The Qing respected traditional Chinese art and culture and patronized styles of painting based on Yuan and Ming examples. Larger than life portraits of the ruling Qing show the unique clothing and coiffures of the Manchus.

Throughout this amazing expanse of time and peoples, the iconography of Chinese arts persisted and are recognizable today as hall-marks of a rich and vibrant artistic history.

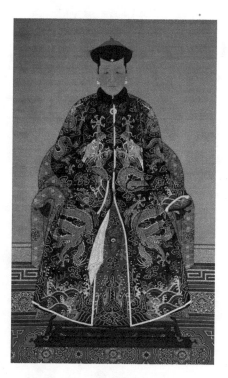

FIGURE 4.9 Lirongbao's Wife

The Medieval Aesthetic Sensibility in Art and Beauty in the Middle Ages

By Umberto Eco

M ost of the aesthetic issues that were discussed in the Middle Ages were inherited from Classical Antiquity. Christianity, however, conferred upon these issues a quite distinctive character. Some medieval ideas derived also from the Bible and from the Fathers; but again, these were absorbed into a new and systematic philosophical world. Medieval thinking on aesthetic matters was therefore original. But all the same, there is a sense in which its thinking might be said to involve no more than the manipulation of an inherited terminology, one sanctified by tradition and by a love of system but devoid of any real significance. It has been said that, where aesthetics and artistic production are concerned, the Classical world turned its gaze on nature but the Medievals turned their gaze on the Classical world; that medieval culture was based, not on a phenomenology of reality, but on a phenomenology of a cultural tradition.

This, however, is not an adequate picture of the medieval critical viewpoint. To be sure, the Medievals respected the concepts which they had inherited and which appeared to them a deposit of truth and wisdom. To be sure, they tended to look upon nature as a reflection of the transcendent world, even as a barrier in front of it. But along with this

they possessed a sensibility capable of fresh and vivid responses to the natural world, including its aesthetic qualities.

Once we acknowledge this spontaneity in the face of both natural and artistic beauty—a response which was also elicited by doctrine and theory, but which expanded far beyond the intellectual and the bookish—we begin to see that beauty for the Medievals did not refer first to something abstract and conceptual. It referred also to every day feelings, to lived experience.

The Medievals did in fact conceive of a beauty that was purely intelligible, the beauty of moral harmony and of metaphysical splendour. This is something which only the most profound and sympathetic understanding of their mentality and sensibility can restore to us nowadays.

> When the Scholastics spoke about beauty they meant by this an attribute of God. The metaphysics of beauty (in Plotinus, for instance) and the theory of art were in no way related. 'Contemporary' man places an exaggerated value on art because he has lost the feeling for intelligible beauty which the neo-Platonists and the Medievals possessed. ... Here we are dealing with a type of beauty of which Aesthetics knows nothing.[1]

Still, we do not have to limit ourselves to this type of beauty in medieval thought. In the first place, intelligible beauty was in medieval experience a moral and psychological *reality*; if it is not treated in this light we fail to do justice to their culture. Secondly, medieval discussions of non-sensible beauty gave rise to theories of sensible beauty as well. They established analogies and. parallels between them or made deductions about one from premises supplied by the other. And finally, the realm of the aesthetic was much larger than it is nowadays, so that beauty in a purely metaphysical sense often stimulated an interest in the beauty of objects. In any case, alongside all the theories there existed also the everyday sensuous tastes of the ordinary man, of artists, and of lovers of art. There is overwhelming evidence of this love of the sensible world. In fact;, the doctrinal systems were concerned to become its justification and guide, fearful lest such a love might lead to a neglect of the spiritual realm.[2]

The view that the Middle Ages were puritanical, in the sense of rejecting the sensuous world, ignores the documentation of the period and shows a basic misunderstanding of the medieval mentality.

This mentality is well illustrated in the attitude which the mystics and ascetics adopted towards beauty. Ascetics, in all ages, are not unaware of the seductiveness of worldly pleasures; if anything, they feel it more keenly than most. The drama of the ascetic discipline lies precisely in a tension between the call of earthbound pleasure and a striving after the supernatural. But when the discipline proves victorious, and brings the peace which accompanies control of the senses, then it becomes possible to gaze serenely upon the things of this earth, and to see their value, something that the hectic struggle of asceticism had hitherto prevented. Medieval asceticism and mysticism provide us with many examples of these two

psychological states, and also with some extremely interesting documentation concerning the aesthetic sensibility of the time.

In the twelfth century there was a noteworthy campaign, conducted by both the Cistercians and the Carthusians, against superfluous and overluxuriant art in church decoration. A Cistercian Statute denounced the misuse of silk, gold, silver, stained glass, sculpture, paintings, and carpets.[3] Similar denunciations were made by St. Bernard, Alexander Neckham, and Hugh of Fouilloi: these 'superfluities', as they put it, merely distracted the faithful from their prayers and devotions. But no one suggested that ornamentation was not beautiful or did not give pleasure. It was attacked just because of its powerful attraction, which was felt to be out of keeping with the sacred nature of its environment. Hugh of Fouilloi described it as a wondrous though perverse delight. The 'perversity' here is pregnant with moral and social implications, a constant concern of the ascetics; for them, the question was whether the churches should be decorated sumptuously if the children of God were living in poverty. On the other hand, to describe the pleasure as wondrous *(mira delectatio)* is to reveal an awareness of aesthetic quality.

In his *Apologia ad Guillelmum*, St. Bernard writes about what it is that monks renounce when they turn their backs upon the world. Here he reveals a similar viewpoint, though broadened to include worldly beauty of all kinds:

> We who have turned aside from society, relinquishing for Christ's sake all the precious and beautiful things in the world, its wondrous light and colour, its sweet sounds and odours, the pleasures of taste and touch, for us all bodily delights are nothing but dung...[4]

The passage is full of anger and invective. Yet it is clear that St. Bernard has a lively appreciation of the very things that he denounces. There is even a note of regret, all the more vigorous because of the energy of his asceticism.

Another passage in the same work gives even more explicit evidence of his aesthetic sensitivity. Bernard is criticising churches that are too big and cluttered up with sculpture, and in so doing he gives an account of the Cluny style of Romanesque which is a model of critical description. He is contemptuous, yet paradoxically so, for his analysis of what he rejects is extraordinarily fine. The passage begins with a polemic against the immoderate size of churches: 'Not to speak of their enormous height, their immoderate length, their vacant immensity, their sumptuous finish, the astonishing paintings that confuse the eye during prayer and are an obstacle to devotion-to me they call to mind some ancient Jewish ritual.' Can it be, he goes on to ask, that these riches are meant to draw riches after them, to stimulate financial donations to the Church? 'Everything else is covered with gold, gorging the eyes and opening the purse-strings. Some saint or other is depicted as a figure of beauty, as if in the belief that the more highly coloured something is, the holier it is...' It is clear enough what he is denouncing here, and on the whole one is disposed to agree with him. It is not aesthetic

qualities that are under question, but the use of the aesthetic for a purpose foreign to the nature of religion, for monetary profit. 'People run to kiss them, and are invited to give donations; it amounts to a greater admiration for beauty than veneration for what is sacred.' This is his point: ornament distracts from prayer. And if it does this, what use are the sculptures, the decorated capitals?

> In the cloisters meanwhile, why do the studious monks have to face such ridiculous monstrosities? What is the point of this deformed beauty, this elegant deformity? Those loutish apes? The savage lions? The monstrous centaurs? The half-men? The spotted tigers? The soldiers fighting? The hunters sounding their horns? You can see a head with many bodies, or a body with many heads. Here we espy an animal with a serpent's tail, there a fish with an animal's head. There we have a beast which is a horse in front and a she-goat behind; and here a horned animal follows with hind-quarters like a horse. In short there is such a wondrous diversity of figures, such ubiquitous variety, that there is more reading matter available in marble than in books, and one could spend the whole day marvelling at one such representation rather than in meditating on the law of God. In the name of God! If we are not ashamed at its foolishness, why at least are we not angry at the expense?

A noteworthy feature of these passages is their style, which is exceptionally well-wrought by the standards of the time. In fact this is typical of the mystics (St. Peter Damien is another who comes to mind): their denunciations of poetry and the plastic arts are models of style. This need not be particularly surprising, for nearly all of the medieval thinkers, whether mystics or not, went through a poetic stage in their youth. Abelard did, and so did St. Bernard, the Victorines, St. Thomas Aquinas, St. Bonaventure. In some cases they produced mere stylistic exercises, but in others they wrote some of the most exalted poetry in medieval Latin. We need only mention Aquinas's Office of the Blessed Sacrament.

The ascetics, however, had views whose extremity makes them all the more suitable for the present argument. For they campaigned against something whose fascination they were well able to understand, and felt to be dangerous as well as praiseworthy. In feeling this they had a precedent in the passionate sincerity of St. Augustine, writing in his *Confessions* about the man of faith, perturbed by the fear that he may be seduced from his prayers by the beauty of the sacred music.[5]

St. Thomas Aquinas, in similar though more amiable tones, advised against the use of instrumental music in the Liturgy. It should be avoided, he said, precisely because it stimulates a pleasure so acute that it diverts the faithful from the path appropriate to sacred music. The end of religious music is best achieved by song. Song provokes the soul to greater devotion, but instrumental music, he wrote, 'moves the soul rather to delight than to a good

interior disposition'.[6] This clearly involves recognition of an aesthetic reality, valid in itself but dangerous in the wrong place.

When the medieval mystic turned away from earthly beauty he took refuge in the Scriptures and in the contemplative enjoyment of the inner rhythms of a soul in the state of grace. Some authorities speak of a 'Socratic' aesthetics of the Cistercians., one founded upon the contemplation of the beauty of the soul. 'Interior beauty', wrote St. Bernard, 'is more comely than external ornament, more even than the pomp of kings'.[7] The bodies of martyrs were repulsive to look upon after their tortures, yet they shone with a brilliant interior beauty.

The contrast between external and internal beauty was a recurrent theme in medieval thought. There was also a sense of melancholy, because of the transience of earthly beauty. Boethius is a moving example, lamenting on the very threshold of death, 'The beauty of things is fleet and swift, more fugitive than the passing of flowers in Spring ... '[8] This is an aesthetic variation on the moralistic theme of *ubi sunt*, a constant theme in medieval culture: where are the great of yesteryear, where are the magnificent cities, the riches of the proud, the works of the mighty? In the background of the *danse macabre*, the triumph of death, we find in various forms a melancholy sense of the beauty that passes. The man of steadfast faith may look on at the dance of death with serenity and hope, but suffer a pang of sorrow none the less. We think of Villon's most poignant refrain: *mais ou sont les neiges d'antan* ?

Confronted with the beauty that perishes, security could be found in that interior beauty which does not perish. The Medievals, in fleeing to this kind of beauty, restored the aesthetic in the face of death. If men possessed the eyes of Lynceus, Boethius wrote, they would see how vile was the soul of Alcibiades the fair, he whose beauty seemed so worthy of love.[9] But this was a somewhat cantankerous kind of sentiment, and Boethius's study of the mathematics of music was quite different in spirit. So too were a number of texts that dealt with the beauty of an upright soul in an upright body, a Christian ideal of the soul externally revealed. Gilbert of Hoyt writes: 'And have regard also for the bodily countenance whose grace can be seen in its abundant beauty; for the exterior face can refresh the spirit of those who look upon it, and nourish us with the grace of the interior to which it witnesses.'[10] And here is St. Bernard:

> When the brightness of beauty has replenished to overflowing the recesses of the heart, it is necessary that it should emerge into the open, just like the light hidden under a bushel: a light shining in the dark is not trying to conceal itself. The body is an image of the mind, which, like an effulgent light scattering forth its rays, is diffused through its members and senses, shining through in action, discourse, appearance, movement—even in laughter, if it is completely sincere and tinged with gravity.[11]

Thus, at the very heart of ascetical polemics we discover a sense of human and natural beauty. And in Victorine mysticism, where discipline and rigour became subsumed in the serenity of knowledge and love, natural beauty was finally recovered in all its positive value.

For Hugh of St. Victor, contemplation requires the use of intelligence; and it is not confined to specifically mystical experience but can arise also when attending to the sensible world. Contemplation, he writes, is 'an easy and clearsighted penetration of the soul into that which is seen';[12] and this then merges into a delighted attachment to the objects of love. An aesthetic pleasure arises when the soul finds its own inner harmony duplicated in its object. But there is also an aesthetic element when the intellect freely contemplates the wonder and beauty of earthbound form. 'Look upon the world and all that is in it: you will find much that is beautiful and desirable ... Gold ... has its brilliance, the flesh its comeliness, clothes and ornaments their colour ... '[13]

We see, therefore, that the aesthetic writings of the period do not consist merely of theoretical discussions of the beautiful, but are full of expressions of spontaneous critical pleasure. It is these which demonstrate how closely the sensibility of the time was interwoven with its theoretical discourses. The fact that they are found in the writings of the mystics gives them, if anything, an added demonstrative value.

One last example involves a subject very common in medieval times: female beauty. It is not perhaps too surprising that Matthew of Vendôme should formulate rules for describing beautiful women in his *Ars Versificatoria*;[14] in fact he was only half serious, indulging in a kind of erudite joke in imitation of the ancients. Also, it seems reasonable that laymen should possess greater sensitivity to the natural world. But we also find Ecclesiastics, writing on the *Canticle of Canticles*, discoursing on the beauty of the Spouse. Even though their aim was to discover allegorical meanings in the text, supernatural analogues of the physical attributes of the dark but shapely maid—still, every so often we find them pontificating on the proper ideal of female beauty, and revealing in the process a quite spontaneous appreciation of women which is earthy enough for all its chastity. Baldwin of Canterbury bestowed his praises upon plaits. He was allegorising, but this fails to conceal his sensitive taste in matters of fashion, for he described the beauty of plaits persuasively and with exactitude, and referred explicitly to their wholly aesthetic appeal.[15] Or there is the singular passage in Gilbert of Hoyt where he defines the correct dimensions of the female breasts, if they are to be truly pleasing. Only nowadays, perhaps, can we see that his gravity is suffused with a certain malice. His ideal reminds us of the ladies of medieval miniaturists, their tight corsets binding and raising the bosom. 'The breasts are most pleasing when they are of moderate size and eminence. ... They should be bound but not flattened, restrained with gentleness but not given too much licence'.[16]

If we turn from the mystics to other spheres of medieval culture, lay or ecclesiastical, we can no longer question the existence of sensitive responses to natural and artistic beauty.

Some authorities claim that the Medievals never discovered how to connect their metaphysical concepts of beauty with their knowledge of artistic techniques, that these were two distinct and unrelated worlds. I hope to cast doubt on this view. To begin with, there was at least one area of language and sensibility where art and beauty were connected, with no apparent difficulty. It is an area well documented in Victor Mortet's *Recueil de textes relatifs*

à l'histoire de l'architecture.[17] In these records of cathedral construction, correspondence on questions of art, and commissions to artists, metaphysical aesthetic concepts mingle constantly with artistic judgments. It is quite clear that this intermingling was an everyday affair. Whether it was recognised also on the philosophical level I shall discuss below.

Another question is this. The Medievals habitually employed their art for didactic purposes. Did they, then, ever advert to the possibility of a disinterested aesthetic experience? The issue here, about the autonomy of beauty in art, is ultimately about the nature and the limits of medieval critical taste. There are many texts which could be used to answer these questions, but a few that are especially representative and significant ought to suffice.

J. Huizinga, in *The Waning of the Middle Ages,* observes that 'the consciousness of aesthetic pleasure and its expression are of tardy growth. A fifteenth-century scholar like Fazio, trying to vent his artistic admiration does not get beyond the language of common-place wonder.'[18] Now this observation is in part correct. But none the less, one must be careful not to equate an imprecision of language with the absence of a state of aesthetic contemplation. What must be noted is how feelings of artistic beauty were converted at the moment of their occurrence into a sense of communion with God and a kind of *joie de vivre.* In fact Huizinga himself takes note of this.[19] Was not this manner of apprehending beauty appropriate to an age marked by an extra ordinary integration of values?

The twelfth century provides a prototype of the medieval man of taste and the art lover, in the person of Suger, Abbot of St. Denis. A statesman and a humanist, Suger was responsible for the principal artistic and architectural enterprises on the lie de France.[20] He was a complete contrast, both psychologically and morally, to an ascetic like St. Bernard. For the Abbot of St. Denis, the House of God should be a repository of everything beautiful. King Solomon was his model, and his guiding rule *dilectio decoris domus Dei.* The Treasury at St. Denis was crammed with jewellery and *objets d'art* which Suger described with loving exactitude. Thus, he writes of

> a big golden chalice of 140 ounces of gold adorned with precious gems, viz., hyacinths and topazes, as a substitute for another one which had been lost as a pawn in the time of our predecessor ... [and] ... a porphyry vase, made admirable by the hand of the sculptor and polisher, after it had lain idly in a chest for many years, converting it from a flagon into the shape of an eagle.[21]

And in the course of enumerating these riches he expresses his pleasure and enthusiasm at ornamenting the church in such a wondrous manner.

> Often we contemplate, out of sheer affection for the church our mother, these different ornaments both old and new; and when we behold how that wonderful cross of St. Eloy-together with the smaller ones—and that incomparable ornament commonly called 'the Crest' are placed upon the golden altar, then

I say, sighing deeply in my heart: 'Every precious stone was thy covering, the sardius, the topaz, and the jasper, the chrysolite, and the onyx, and the beryl, the sapphire, and the carbuncle, and the emerald.'[22]

One is inclined to agree with Huizinga's evaluation of passages like these—that Suger is impressed chiefly by the precious metals, the gems and the gold. The predominant sentiment is one of amazement, a sense of the *kolossal*, rather than of beauty. Suger is thus like the other collectors of the Middle Ages, who filled their storehouses not just with artworks, but also with absurd oddities. The due de Berry's collection included the horn of a unicorn, St. Joseph's engagement ring, coconuts, whales' teeth, and shells from the Seven Seas.[23] It comprised around three thousand items. Seven hundred were paintings, but it also contained an embalmed elephant, a hydra, a basilisk, an egg which an Abbot had found inside another egg, and manna which had fallen during a famine. So we are justified in doubting the purity of medieval taste, their ability to distinguish between art and teratology, the beautiful and the curious.

None the less Suger's somewhat naive inventories, in which he uses almost exclusively a terminology descriptive of precious materials, display a noteworthy union of two elements. There is an ingenuous liking for anything giving an immediate pleasure—and this is an elementary form of aesthetic response; and there is also an uncritical awareness of the materials used in works of art—an awareness that the choice of material is itself a primary and fundamental creative act. This pleasure in the material, rather than in the shaping process, suggests a kind of commonsense stability in the medieval aesthetic response.

Huizinga frequently observes that the Medievals allowed the imagination free rein instead of fastening it to the unique art object before them. This is true, and I shall return to this point. But here we should note that Suger, yet again, has documented for us the medieval transformation of aesthetic pleasure into a mystical *joie de vivre*. There is an ecstatic quality in his experiences of beauty in the church.

> Thus, when—out of my delight in the beauty of the house of God—the loveliness of the many-coloured gems has called me away from external cares, and worthy meditation has induced me to reflect, transferring that which is material to that which is immaterial, on the diversity of the sacred virtues: then it seems to me that J see myself dwelling, as it were, in some strange region of the universe which neither exists entirely in the slime of the earth nor entirely in the purity of Heaven; and that, by the grace of God, I can be transported from this inferior to that higher world in an anagogical manner.[24]

We should note a number of features of this passage. The sensuous presence of the artistic materials clearly provokes a genuinely aesthetic experience. And the experience is neither a simple pleasure in the sensuous, nor an intellectual contemplation of the supernatural. The

passage from aesthetic pleasure to mystical joy is virtually instantaneous, more so than the term 'anagogical' suggests. Medieval taste, we may conclude, was concerned neither with the autonomy of art nor the autonomy of nature. It involved rather an apprehension of all of the relations, imaginative and supernatural, subsisting between the contemplated object and a cosmos which opened on to the transcendent. It meant discerning in the concrete object an ontological reflection of, and participation in, the being and the power of God.

All of these texts have the effect, not of denying to the Medievals an aesthetic sensibility, but of defining the peculiarities of the aesthetic sensibility which they actually possessed. The concept of integration comes to suggest itself in a central explanatory role, where an integrated culture is taken to mean a culture whose value systems are related to one another, within the culture's necessary limitations, by mutual implication.

This integration of values makes it difficult for us to understand nowadays the absence in medieval times of a distinction between beauty *(pulchrum ,Hecorum)* and utility or goodness *(aptum, honestum)*. These terms are sprinkled throughout Scholastic literature and medieval treatises on poetic technique. Often enough the two categories were distinguished on the theoretical level. Isidore of Seville, for instance, said that *pulchrum* refers to what is beautiful in itself, and *aptum* to what is beautiful relative to something else[25]—a formulation inherited from Classical Antiquity, passing from Cicero through St. Augustine to Scholasticism in general. But the medieval view of art in practice, as opposed to theory, tended to mingle rather than to distinguish the two values. The very author who celebrated the beauty of art insisted also upon its didactic function. Suger himself adopted the positions sanctioned at the Synod of Arras in 1025, that whatever the common people could not grasp from the Scriptures should be taught to them through the medium of pictures. Honorius of Autun wrote that the end of painting was threefold: one was 'that the House of God should be thus beautified'; a second was that it should recall to mind the lives of the Saints; and finally, 'Painting ... is the literature of the laity'.[26] The accepted opinion as far as literature was concerned was that it should 'instruct and delight', that it should exhibit both the nobility of intellect and the beauty of eloquence. This was a basic principle in the aesthetics of the Carolingian *literati*.

These views were often abused by being too strenuously pressed. But we should note that they do not represent a myopic and primitive didacticism. The fact was, that the Medievals found it extremely difficult to separate the two realms of value, not because of some defect in their critical sense, but because of the unity of their moral and aesthetic responses to things. Life appeared to them as some thing wholly integrated. Nowadays, perhaps, it may even be possible to recover the positive aspects of their vision, especially as the need for integration in human life is a central preoccupation in contemporary philosophy. The way of the Medievals is no longer open to us, but at least the paradigm they offer us can be a source of valuable insights, and their aesthetic doctrines are here of great importance.

It was not by chance that one of the main problems of Scholastic aesthetics was the problem of integrating, on the metaphysical level, beauty with other forms of value. Their discussions of the transcendental character of beauty constituted one of the main attempts to

establish a ground for their integrated sensibility. They tried to allow—both for the autonomy of aesthetic value and for its place within a unitary scheme of values—or, to put it in medieval terms, within a unitary vision of the transcendental aspects of being.

NOTES

1. E. R. Curtius, *European Literature and the Latin Middle Ages*, translated by Willard R. Trask (London, 1953), p. 224, n. 20.

2. Alcuin admitted that it was easier to love beautiful creatures, sweet scents, and lovely sounds (*speciespulchras, dulces sapores, sonos suaves*) than to love God (C. Halm, *Rhetores Latini Minores* [Leipzig, 1863], p. 550). But he added that if we admire these things in their proper place—that is, using them as an aid to the greater love of God—then such admiration, *amor omamenti*, is quite licit.

3. *Consuetudines Carthusiemes*, chap. 40 (PL, 153, col. 717).

4. This, and the quotations from St. Bernard immediately following, are in his *Apologia ad Guillelmum*, chap. 12 (PL, 182, cols. 914–16).

5. St. Augustine, *Confessions*, X, 33.

6. S.T., II–II, 91, 2.

7. St. Bernard, *Sermones in Cantica*, XXV, 6 (PL, 183, col. 901).

8. Boethius, The Consolation of Philosophy, III, 8.

9. Boethius, The Consolation of Philosophy, III, 8.

10. Gilbert of Hoyt, *Sermones in Candcum Salomonis*, XXV, 1 (PL, 184, col. 129).

11. *Sermones in Cantica*, LXXV, 11 (PL, 183, col. 1193).

12. Hugh of St. Victor (Hugh of Paris), *De Modo Dicendi et Meditandi* 8 (PL, 176, col. 879).

13. Hugh of St. Victor, *Soliloquium de Arrha Animae* (PL, 176, col. 951).

14. Matthew of Vendome, *The Art of Versification*, translated by Aubrey E. Galyon (Ames, Iowa, 1968).

15. Baldwin of Canterbury, *Tractatus de Vulnere Charitatis* (PL, 204, col. 481).

16. *Sermones in Canticum Salomonis*, XXXI, 4 (PL, 184, col. 163).

17. Victor Mortet, *Recueil de textes relatifs à l'histoire de l'architecture*, 2 vols. (Paris, 1911, 1929).

18. J. Huizinga, *The Waning of the Middle Ages*, translated by F. Hopman (Harmondsworth, 1965), pp. 254–5.

19. *J. Huizinga*, p. 256.

20. See Erwin Panofsky, *Abbot Suger on the Abbey Church of St.-Denis and its Art Treasures* (Princeton, 1946). Also Elizabeth G. Holt, *A Documentary History of Art*, 2 vols. (New York, 1957), I, pp. 22–48. Suger's *De Rebus Administratione sua Gestis* is in PL, 186, cols. 1211–39.

21. Erwin Panofsky (1946), pp. 77, 79.

22. Erwin Panofsky (1946), p. 63.

23. See J. Guiffrey, *Inventaire de Jean, due de Berry* (Paris, 1894–6).

24. Erwin Panofsky (1946), pp. 63, 65.

25. St. Isidore of Seville, *Sententiarum Libri*, I, 8, 18 (PL, 83, cols. 551–2).

26. Honorius of Autun, *Gemma Animae*, chap. 132 (PL, 172, col. 586).

What is the Gothic Look

By Robert A. Scott

C athedrals have been part of Christianity from the time of Constantine (306–337). Their design and architectural styles have varied from one historical era to another, but in one important respect they are alike: all cathedrals display a distinctive geometric regularity in their design. This quality reached a high point in the Gothic style, reflecting an effort to achieve a rational, harmonious, and proportional result. Appreciating the role of geometry in their design is fundamental to understanding Gothic cathedrals.

In Salisbury Cathedral, for instance, the total height from ground level to the tip of the spire approximates the overall length from west to east. Inside, the central crossing (the point of intersection of the principal transept with the east-west axis) measures 39 feet by 39 feet (actually, 39 feet 2 inches by 39 feet 6 inches, as slight deviations are inevitable in a building of this magnitude). Virtually every other dimension of the building is directly related to this core dimension (see Figure 6.1). For example, the length of each of the ten bays of the nave is 19 feet 6 inches, or precisely one-half that of the central crossing, and each bay's width is also 19 feet 6 inches (give or take a fraction of an inch). The entire nave is composed of twenty identical spaces, each measuring 19 feet 6 inches square, plus ten identical spaces that each measure 19 feet 6 inches by 39 feet. Taking into account 2 feet of

interior cladding, the nave is almost precisely as wide as it is high, and the two transepts and the presbytery also display an affinity to the core dimensions of the main crossing.

The cathedral church at Sens provides a second illustration. As Otto von Simson describes it, "The ground plan of Sens being designed *ad quadratum,* the square bays of the nave are twice as wide as those of the side aisles; owing to the tripartite elevation, it was possible to give the same proportions to the relative height of nave and aisle." The elevation of the nave is also subdivided so that "the octave ratio of 1:2 permeates the entire edifice."[1]

In his book about Amiens Cathedral, Stephen Murray provides a third illustration of the way geometry enables us to derive the basic overall design of Gothic great churches. Murray says, "The design begins with the square of the crossing. ... Peripheral spaces will be, in a sense, unfolded from the central square." He shows how each dimension of the nave, choir, and double aisles of Amiens can be drawn by rotating diagonal lines from the central crossing (see Figure 6.2). He notes further that "the designer is obviously also concerned with allowing numbers to express proportions—hence, the repetition of 3's and 5's; of 5's and 7's."[2] A similar proportionality has been found repeatedly in other Gothic cathedrals and great monastic churches, including ones built well before the Gothic style appeared. Clearly, regular proportions and modular arrangements of repeated volumes were important to medieval architects.

Not all cathedrals, Gothic or otherwise, of course, are constructed according to the same measurements in feet and inches that one finds at Salisbury or Amiens. Renovations had to accommodate the dimensions of the existing buildings. In any case, no uniform standard measure of length yet existed. Yet what these spaces do have in common is a quest for geometric precision regardless of any specific measure of length. It is as if geometry were functioning as the "genetic code" for each building, in the sense that each has its own characteristic

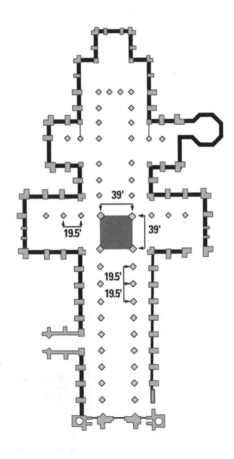

FIGURE 6-1 The design of salisbury cathedral is geometrically derived from a square 39 by 39 feet.

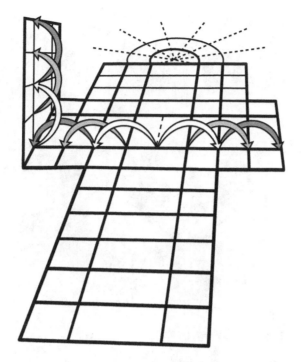

FIGURE 6-2 How the plan of Amiens Cathedral "unfolds" from the center.

proportionality based on variations of a single length from which all, or nearly all, other features of the building's design derive. As Victor Hugo said of the design of Notre Dame Cathedral in Paris, "To measure the toe is to measure the giant."[3]

The quest for geometric uniformity, when followed consistently, gives Gothic cathedrals their characteristic organic unity. Every part of the building is linked logically, harmoniously, and proportionally to the whole. Looking again at the floor plan of Salisbury Cathedral shown in Figure 6.1, we see that the easternmost bay of the nave is essentially duplicated nine times. This duplicative quality applies not only to the broad dimensions of a bay space, but down to the finest detail. The art historian Erwin Panofsky calls this facet of design the principle of "progressive divisibility." According to this principle, he explains, "supports were divided and subdivided into main piers, major shafts, minor shafts, and still more minor shafts; the tracery of windows, triforia, and blind arcades into primary, secondary, and tertiary mullions and profiles; ribs and arches into a series of moldings."[4] The phrase "progressive divisibility" conveys the idea of a "visual logic" in which the subordinate members of a structure are related to one another to form a coherent whole. One hallmark of the Gothic style is the manner in which this principle is expressed visually, often even in the smallest details of individual shafts and moldings. The piers, shafts, and vaulting of Amiens Cathedral (Figures 6.3 and 6.4) exemplify this quality.

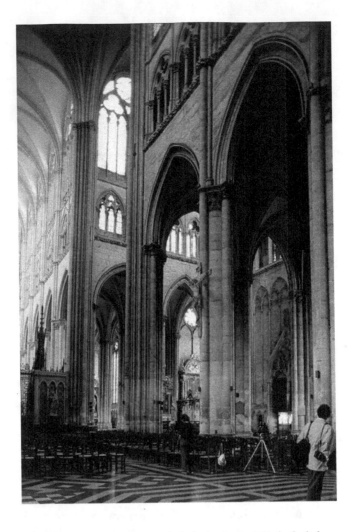

FIGURE 6-3 The piers and shafts in Amiens Cathedral show what Erwin Panofsky terms "progressive divisibility," a characteristic of Gothic design.

The design of a great church, then, reflects a desire to achieve a series of precise, geometrically related components, each part deriving its definition from the building as a whole, each subpart deriving its measurements from the element to which it belongs. One practical result is that the components of the building are more or less identical repetitions of each other. Once segment A has been built, let's say the first bay of a nave, that bay serves as a template for the second bay, the second a template for the third, and so on. Having built one primary module, such as a bay span or width, the master mason could generate all other elements in the scheme by applying numerical rules, learned by rote through steps of constructive geometry. In other words, all the principal elements of a design could be automatically indicated and interrelated without recourse to calculation.

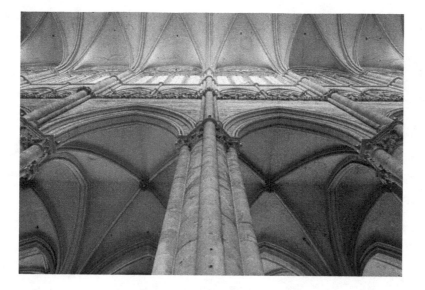

FIGURE 6-4 "Progressive divisibility" is also a feature of Gothic ceiling vaults.

If geometric regularity is a feature of all great churches, what, then, distinguishes Gothic cathedrals from others? The key to answering this question is understanding the central defining element of the Gothic style—light. All of the features we associate with Gothic architecture—pointed arches, flying buttresses, ribbed vaults, soaring ceilings, stained glass windows, pinnacles and turrets—were developed in the service of the desire to flood the interior space with as much light as possible.

The interiors of Romanesque great churches are characteristically somber. As originally built, they were dimly lit, and it is not unusual to discover areas of the interior that are barely touched by light. Moreover, the walls are ponderous, solid, and somber. In dramatic contrast to this style, the walls of Gothic cathedrals appear almost porous. Light permeates the interior and merges with every aspect of it, as though no segment of inner space should be allowed to remain in darkness, undefined by light (see Figure 6.5).

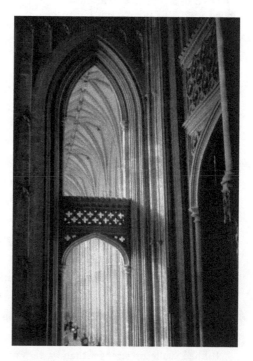

FIGURE 6-5 Light reaches the highest points in a Gothic building, as shown here in the side aisle of Canterbury Cathedral. Copyright © by John Wilkes.

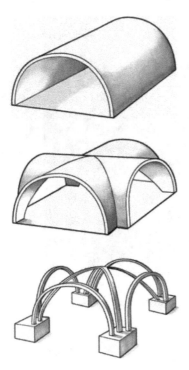

FIGURE 6-6 A barrel vault and a ribbed vault. The barrel vault must be supported along its entire length by thick walls, whereas the ribbed vault can rest on just a few "springing points."

Today visitors to Gothic cathedrals, especially in England, often find clear glass in the windows, but this was the result of later renovations. The medieval builders' ideal is exemplified by the interior of Chartres or Canterbury Cathedral, where the glass is colored in deep primary tones. As a result, even though the interiors are filled with light, the spaces acquire deep and rich color tones. The attempt to combine these two things—increased light and deep color—impelled the builders to reach for greater and greater heights. The aim was to transform the interior spaces into a semblance of the Heavenly Jerusalem.

Flying buttresses, ribbed vaults, and pointed arches—the characteristic elements of the Gothic style—all worked together to permit larger windows and to open up the interior spaces, allowing the increased light to penetrate the building more completely. But how exactly did they do this? What, for example, was the advantage of the Gothic ribbed vaults over the earlier barrel, or tunnel, vaults? A barrel vault—the simplest kind of vault—is just a longitudinally extended arch. It must be supported along its entire length by thick walls. If the objective is to achieve interior illumination, the barrel vault cannot help, because it encloses space rather than opening it, and it cannot be penetrated to permit light to enter from above without risking collapse. The ribbed vault was developed to overcome these limitations (see Figure 6.6).

The ribbed vault replaced the "groin" that occurs at the point where two tunnel vaults intersect with newly invented "ribs," as shown in Figure 6.6. By articulating the lines of the groin, the ribs can rest on a few specific "springing points," which themselves rest on round pillars, or "piers." The spaces between the ribs can then become "webbing," or sculpted surfaces that open up, heighten, and give delicacy to the vaulted unit. The spaces between the piers can be left entirely open or become a thin wall pierced with windows. This technique of ribbed vaulting is used not only at the intersection of two narrow aisles or walkways, where the tunnel vault would use groins, but also along the full length of each aisle, and ribbed vaults can even form the ceiling of huge spaces in the cathedral, including the choir and the nave (see Figure 6.7).

Ribbed vaults are stronger than barrel vaults, and they require less material to build. In addition, ribbed vaults are actually easier to build, because the ribs and webs can be built separately, while a barrel vault must be built and supported as a single unit. Ribbed vaults

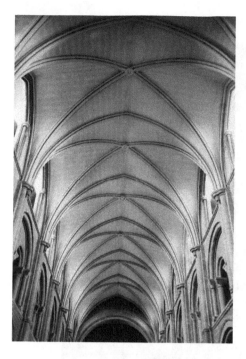

FIGURE 6-7 Another of my personal favorites is Christchurch Priory. This picture of the nave reveals how ribbed vaults can span wide spaces as well as narrow ones, leaving every part of the church open to light.

are more flexible and adaptable to different architectural styles than groin vaults are, and they permit more variations, including spanning greater distances without the danger of collapse.

The pointed arch also has many architectural advantages. One problem with the rounded arch is that its height is dictated by its width. This is not true of the pointed arch, which can span varying distances while the crowns of all the arches in a building remain more or less even. Pointed arches are sturdier, by a factor of 20 to 25 percent, than rounded arches. And the thrust generated by a pointed arch is directed more effectively toward the supporting piers and walls than is the case for a rounded arch.[5]

Figure 6.8 is a drawing of three sections of the nave of Winchester Cathedral. The bay on the left shows us what the original Romanesque bay looked like; the middle bay shows how it was carved back; and

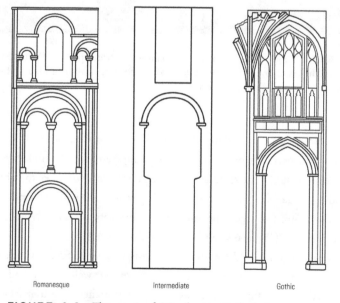

Romanesque Intermediate Gothic

FIGURE 6-8 The nave of Winchester Cathedral was transformed from the Romanesque to the Gothic style by cutting back the original Romanesque bays.

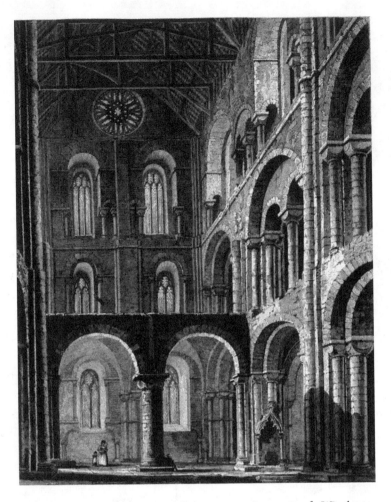

FIGURE 6-9 The soaring Romanesque transept of Winchester Cathedral is characterized by solid-looking construction, rounded arches, plain, thick walls, and dark recesses.

the right bay shows what it looked like after the masons had transformed it into the Gothic style by refacing the existing stone and installing pointed arches. Like ribbed vaults, pointed arches require less material, are stronger, and open up the interior space to light, promoting skeletal building. Builders can go higher while using more wall space for windows. Nowhere have I seen the contrast of styles demonstrated as dramatically as at Winchester, with its Romanesque transepts (Figure 6.9) and Gothic nave (Figure 6.10).

Light generally requires height, and to get it, designers had to find ways to siphon off the weight of the roof and high vaults, other than onto interior walls, which had been opened up and "thinned out" by the extensive use of pointed arches. The transfer of stress was achieved by the third component we associate with the Gothic design, the flying buttress. Romanesque churches used "quadrant arches" (quarter-circles) to buttress the pressure, or

thrust, generated by their high barrel vaults. To achieve the Gothic aim of a light-filled interior, buildings had to become taller—too tall to be supported by traditional quadrant arches. The supporting arches had to be raised above the aisle roofs to abut the high vaults, as if they were flying over them; hence the expression "flying buttresses." Flying buttresses shifted the weight of the roof and vaults away from the supporting walls to side structures that in turn carried it down to the ground (see Figure 6.11).

Examples of ribbed vaults and pointed arches can be found in pre-Gothic churches. A leading student of French Gothic architecture of the twelfth and thirteenth centuries, Jean Bony, suggests that pointed arches were introduced into western Europe from Islamic architecture by crusaders or, in some still unknown manner, via northern Italy.[6] Another expert on Gothic architecture, Paul Frankl, asserts

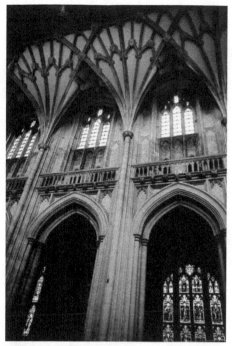

FIGURE 6-10 Winchester Cathedral's Gothic nave features ornate carving and high windows, a dramatic contrast to the Romanesque transept shown in Figure 6.9.

that the introduction of diagonal ribs to a groin vault is traceable to the vaults of the choir aisle of Durham Cathedral in England, which were constructed between 1093 and 1096.[7] Although the flying buttress is a unique creation of Gothic architecture, its antecedents are traceable to the Romanesque quadrant arch. In other words, all three principal elements associated with Gothic architecture arose out of church-building activity during the Romanesque period.

Beyond these three elements, Gothic architecture introduced wall arches, built over the tops of walls to create a system of ribs anchored on the lateral surfaces of the walls. These wall arches, together with transverse arches and diagonal ribs, were met by the flying buttresses about one-third of the way up from their springing to counter pressure and thrust. Wall arches were necessary because ribs alone could not reduce the amount of weight exerted on the walls. They enabled the builders to concentrate the forces of thrust down toward the area from the springing point to a point about one-third up the vaults (the "haunch"), which was then counterbalanced by the flying buttresses. The end result is a skeletal system that is anchored at the points of upright buttresses, thereby allowing the wall surface between the buttresses to be replaced by large expanses of colorful stained glass.

What makes Gothic architecture revolutionary is not that it used new or different materials. Gothic churches were made of the same stone, wood, and glass that had been used to build Romanesque and other pre-Gothic churches; indeed, the Gothic parts of some

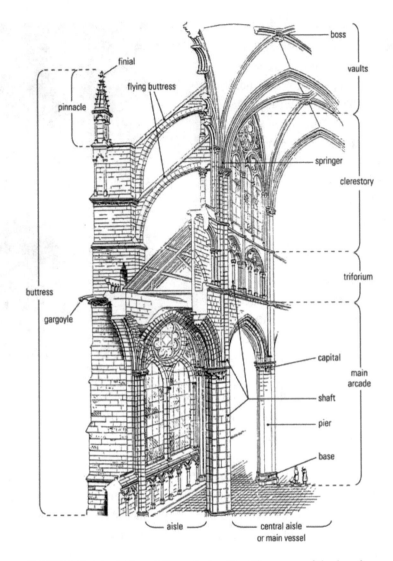

FIGURE 6-11 This artist's rendering identifies some of the key features of Gothic design.

cathedrals were built by recycling materials that had been used in Romanesque churches. What was different was the way the Gothic style combined the elements of design to create an entirely new, organically unified whole. Gothic design amounted to a new vision of the way to combine the distinctive advantages of ribbed vaulting and pointed arches with a new system for buttressing high vaults and roofs to create an interior space that was expansive, soaring, and bright (see Figure 6.12).

The Gothic style, of course, did not materialize all at once in its mature form. According to Frankl, the Gothic style evolved slowly out of the Romanesque, starting from the time when diagonal ribs first were added to groin vaults. The principles inherent in the first ribbed vaults, says Frankl, had profound implications for the design of other features, such as windows,

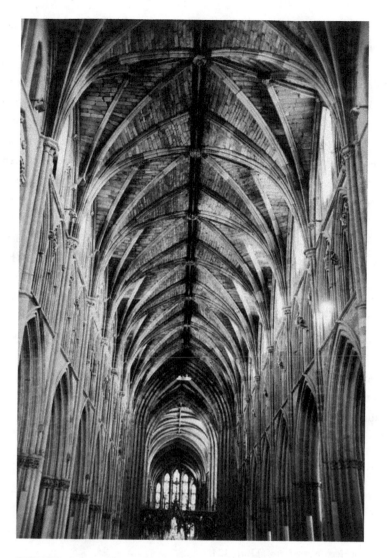

FIGURE 6-12 The nave of Worcester Cathedral shows how ribbed vaulting, pointed arches, and new systems of buttressing were combined to create a space that is high and bright. Copyright © by Lois Gerber.

shafts, wall arches, plinths, and moldings, eventuating in Gothic style's mature form. The pointed arch eventually came to be combined with the ribbed vault at a later date, and the flying buttress emerged after the pointed arch appeared. But only during the so-called High Gothic period, which Frankl dates from 1194 through 1300, did all the innovations begin to coalesce into a coherent style in cathedrals like Chartres.[8]

Supporting Frankl's thesis is the fact that no name for the style is known to have existed at the time it first appeared. Indeed, it is unlikely that any special name, beyond simply "new work," or *novum opus,* existed for it at the time. The label "Gothic" never appeared until the

fifteenth century, when it was used pejoratively to describe things regarded as crude, rustic, coarse, and uncivilized. Frankl tells us that one school of thought, in some unexplained way, associates the style with the Goths who, in A.D. 410, under the leadership of Alaric, destroyed parts of Rome. Another school also associated it with the Germans, but in this case the myth is that it originated in forests. The claim is that the Germans would not cut down trees, so instead they bound the top branches of living trees together, thereby creating the pointed arch. This theory that the Gothic style was born in the forests of Germany persisted with incredible tenacity, and one hears it occasionally even today.[9] Not until the eighteenth century did a more positive view of the Gothic style emerge among art historians. The quest to understand the concepts inherent in this style then began in earnest.

By now it should be clear that the most important part of a Gothic cathedral is its interior space. Here the emphases on geometry and light fuse to create an image of God's house. Of course, the outside appearance of the building mattered, but the primary goal in building these cathedrals was the illumination of interior spaces. Otto von Simson has likened the exterior of the Gothic cathedral to the backstage area in a theater, where props are hung to produce the interior scenery. Others compare it to the "wrong side" of an elaborately designed sweater.[10] From the outside, one sees only the structure that was needed to support the glass and perfect geometric forms inside. At this point one may wonder why geometry and light were so important in designing great churches. Is there a connection to ecclesiastical, theological, and philosophical precepts of the time?

NOTES

1. Otto von Simson, *The Gothic Cathedral: Origins of Gothic Architecture and the Medieval Concept of Order*, 144.
2. Stephen Murray, *Notre-Dame, Cathedral of Amiens: The Power of Change in Gothic*, 40–41.
3. Victor Hugo, *Notre-Dame of Paris*, 124.
4. Erwin Panofsky, *Gothic Architecture and Scholasticism*, 48.
5. For information on different kinds of arches, see Jean Bony, *French Gothic Architecture of the Twelfth and Thirteenth Centuries*, 17–21; John Fitchen, *The Construction of Gothic Cathedrals*, 78–80; J. E. Gordon, *Structures*, 171–97; Mario Salvadori, *Why Buildings Stand Up*, 213.
6. Bony, *French Gothic Architecture*, 17.
7. Paul Frankl, *Gothic Architecture*, 3.
8. See Paul Frankl, *Sources from the Gothic Period*.
9. See Frankl, *Sources from the Gothic Period*, and *Gothic Architecture*, 218.
10. Von Simson, *Gothic Cathedral*, 5.

Describing Art

By Marco Ruffini

We do not explain pictures: we explain remarks about pictures—
or rather we explain pictures in so far as we have considered
them under some verbal description or specification.

MICHAEL BAXANDALL[1]

While *ekphrasis*, or the verbal description of works of art, is generally construed as an act of preservation that invokes the work of art as a completed, past act, there are also, as the epigraph borrowed from Baxandall implies, significant ways in which description mediates and conditions how works of art come to be understood or explained. Having analyzed the marginalization of the figure of the artist in the conception and composition of the *Lives*, in this chapter I trace the effect of that turn on the manner in which art comes to be described. I isolate and analyze two modes of description, each of them with reference to the conception of art and of authorship they entail and project.

The *Lives* deploys two different descriptive modes, which in turn relate to discrete conceptions of art and authorship. One of these modes is the description of the work of

art as a mimetic feat, which emphasizes the illusionistic qualities of the work and its effect on the viewer. By referring to the work of art as pertaining to the sensible world and as man-made, this mode of description links the figure of the artist to the work of art—and even, as in Michelangelo's case, links it to pictorial or sculptural gestures on the part of the artist. A second or diegetic mode of description construes the work of art as the representation of forms and subjects of universal value, which transcend the limited and finite scope of mimetic art. This second mode depends on the notion of the work of art as independent of and even compromised by the recognition of authorship. Moreover it instigates a degree of disjuncture with the biographical narrative. These two primary descriptive modes coexist and, as we will see, are often inextricably connected, yet the latter becomes increasingly dominant in the second edition. Diegetic descriptions do not develop systematically and linearly in the *Lives*, nor does their inclusion respond to a premeditated editorial intention. Yet their appearance in the Giuntina is integral to the increasing subordination of the biography to the description of the work of art in the book. Broadly speaking, by reading works of art as independent from the psychobiological identity of their maker, informed by rational principles (order and measure) and universal values (*historia* and allegorical meanings), diegetic descriptions signal an extemporaneous but progressive refocusing of the *Lives* under the point of view of the academic art.[2]

The description of Michelangelo's *Last Judgment* serves in this chapter as a representative case of the description of art as mimetic. These formidable passages emphasize the expressive details of the fresco while at the same time asserting its absolute identity with Michelangelo. The description of Vasari's decoration of the *Sala Grande* (or *Salone dei Cinquecento*) in Palazzo Vecchio is exemplary of the second, diegetic descriptive mode. It offers a comprehensive account of the program's subject matter and overall composition while disregarding expressive and stylistic qualities. If the description of the *Last Judgment* clearly defines authorship as bound to the biological identity of the artist, the notion of authorship that informs the description of the *Sala Grande* is elusive. In an attempt to clarify the latter notion of authorship, I analyze a third case, the Giuntina narrative of Michelangelo's efforts at St. Peter's, the major architectural work he left unfinished. Inserted in the myth of the divine artist, this narrative posits an exclusive association between the work and Michelangelo. At the same time, fixated on the model's formal features, it was intended to defend the project from changes by the architects who would have realized it after Michelangelo's death. As a result the narrative of St Peter's defines individual authorship as an abstract notion freed from the material and temporal constraints of mimetic art and able to survive the artist's life.

Before we look at these examples, let me also make explicit an important point that this chapter raises about the relationship between descriptive modes and artistic genres. It may seem natural or inevitable that the description of a sculpted or painted human figure would be affective and that the description of architecture, an intrinsically mechanical work, would not. This intrinsic affinity between descriptions and works of art is not, however, a given in art writing. Art historians after Vasari described Michelangelo's architectural work in St. Peter's in

sculptural terms, as if his constructions were human bodies and their structural articulations bones and muscles. Moreover the idea of a "natural" affiliation between description and work of art is especially misleading in light of the fact that the distinction among genres does not hold for academic art. According to Vasari and Borghini, all academic art is "architectural" as it is governed by rational, technical, and replicable principles. The dominance of the diegetic mode in the second edition is in fact inseparable from the increasing importance given to architectural principles in the redefinition of academic art.

1.

"Michelangelo's bodies," Georg Simmel wrote, "are so completely interpenetrated with Michelangelo's spirituality and his interiority that even the expression 'interpenetration' implies an excessive measure of dualism."[3] The absolute identification of Michelangelo with his art, as Simmel put it in 1910–11, has evolved into a commonplace of art historical and critical accounts of the artist and his work, whose origins lie in the *Lives*. And that identification was born of a peculiar mode of description, which emphasizes the exceptional naturalism of the figures Michelangelo creates. This is the mode I refer to as *mimetic*.[4]

Consider, for example, the description of the *Last Judgment*, which emphasizes Michelangelo's supreme ability to represent the human figure and to imbue it with a lifelike presence.[5] The description characterizes the multitude of human figures represented in the fresco as a complete catalogue of human emotions ("filled with all the passions known to human creatures") and psychological characterizations ("the proud, the envious, the avaricious, the wanton"; Figs. 7.1–7.4).[6] The description presents the work as a fragment of the world, to be experienced as if the actual event were taking place in front of one's eyes. Nothing is idealized or abstracted: the figures of the sinners do not symbolize but embody perdition; they are so vividly represented that viewers experience their very torments (Fig. 7.2). Even the music the angels play—the sound of the seven trumpets calling the end of human time— is palpably terrifying (Fig. 7.3).[7] Indeed the mimetic force of the work, the author of this passages writes, renders description impossible.[8]

A primary feature of this mimetic mode of description is the association it maintains between the work of art and its maker, up to and including specific aspects of the artist's persona. This characteristic is echoed in the biographies of numerous protagonists of the *Lives*. The bizarre effects of light in Piero di Cosimo's *Visitation with the Saints Nicholas and Anthony Abbot* (National Gallery of Art, Washington), for example, reflect the artist's strangeness. The pallor of Parri Spinelli's figures are linked to the fact that the artist had been the victim of violent aggression, the trauma of which, we are told, informed his artistic imagination. In much the same way the dark and mischievous characters of Andrea del Castagno's figures echo the violent personality of the artist. These and other instances have led art historians

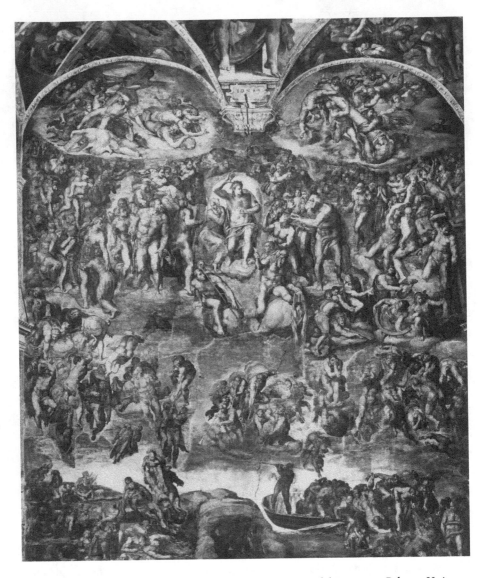

FIGURE 7-1 Michelangelo, *Last Judgment* (1541). Città del Vaticano, Palazzo Vaticano, Sistine Chapel. Alinari / Art Resource, NY.

to register the identification between art and the artist's psychology as one of the dominant features of the *Lives*.[9]

A similar association of works with their maker is at play throughout the descriptions of Michelangelo's work. However, whereas the characters and experiences of Piero di Cosimo, Spinelli, and Castagno are related to representations, in Michelangelo's case the pictorial mark, which creates the mimetic illusion, is the index of personality. Michelangelo's identity finds expression not in the emotive states of the figures in the *Last Judgment* or their psychological characterization, but in the very lines and forms he traces on the wall. In fact after having translated the illusionistic qualities of the *Last Judgment* into words, the description

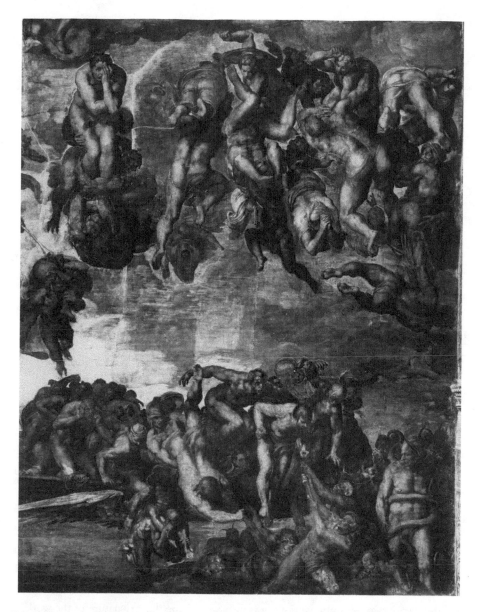

FIGURE 7-2 Michelangelo, *Last Judgment* (1541). Città del Vaticano, Palazzo Vaticano, Sistine Chapel. Detail. Scala / Art Resource, NY.

proceeds by looking at the work from a different angle. It examines the figures' outlines on the surface, concentrating on the junctures that separate and unite their forms (citing "a harmony of painting that gives great softness, and fineness in the parts").[10] This section of the description, which contrasts with the emphatic exaltation of the emotional effects produced by the figures, redirects the reader's eye from the illusionistic effect of the image to the bidimensional world of painting, where the very mystery of mimesis takes place. The figures are read as a formal syntax that is unequivocally associated with Michelangelo: "The outlines of

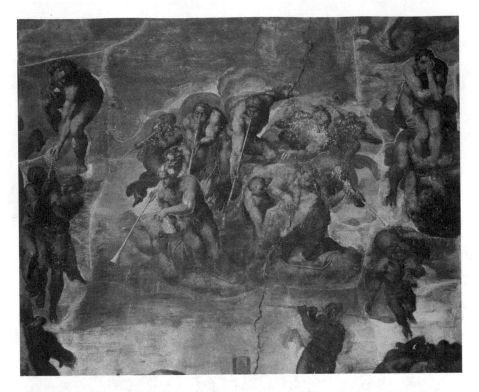

FIGURE 7-3 Michelangelo, *Last Judgment* (1541). Città del Vaticano, Palazzo Vaticano, Sistine Chapel. Detail. Alinari / Art Resource, NY.

the forms [were] turned by him in such a way as could have not have been achieved by any other but Michelangelo."[11] Every detail of the fresco constitutes an unerring sign of a unity of intention, which reinforces the absolute relationship between the artist and the work: "It is extraordinary to see such harmony of painting, that it appears as if done in one day, and with such finish as was never achieved in any miniature."[12]

Arguably this portion of the description does not refer to the work as mimetic, as it makes no reference to its illusionistic qualities. But the dissolution of the mimetic image into the pictorial mark is a component of the same visual hermeneutic. Indeed mimetic art relies on the interplay of two perceptions: the eye is deceived by the illusory nature of the work of art, and the mind detects the deception and the work of art becomes visible as an object. The description of the *Last Judgment* is divided according to this split: it accounts for the emotional effect of the figures on the viewer and subsequently investigates the making of the fiction by calling attention to the pictorial marks on the surface of the wall.

Whereas the art of Piero di Cosimo, Spinelli, and Castagno is associated with or rooted in one or more specific personal characteristics, Michelangelo is one with his art. Every formal element of his works, be it a human figure or a simple line, issues from and indexes a gesture that he, and only he, can make. This unequivocal referentiality is further strengthened by an evaluation of mimesis that is unequaled in any other artist included in the *Lives*. Michelangelo

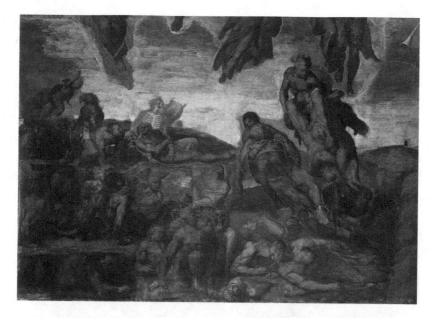

FIGURE 7-4 Michelangelo, *Last Judgment* (1541). Città del Vaticano, Palazzo Vaticano, Sistine Chapel. Detail. Scala / Art Resource, NY.

does not merely imitate but creates nature inspired by "divine grace and knowledge." Such description of his work redefines the moment of awareness in mimetic art, when the viewer's mind detects the work as a deception (and the work of art becomes visible as an object), as the acknowledgment of an act of creation. This difference, and the attribution to the artist and his work of a divine creative force, signals a major cultural shift that has been widely explored in the scholarship on Renaissance art, on Michelangelo, and on the *Lives*. In the late Middle Ages the ennobling attribution of divine creativity derived from the metaphor of God as Divine Author was limited to poets. The idea of God as artist (*artifex*) was also available, but, as Panofsky noted, the inverse relation, the artist as God, became conceivable only in the culture of the Renaissance. Beginning in the middle of the sixteenth century the artist, more than the poet, increasingly embodied divine creativity.[13] At the time Michelangelo's biography was written the divine status of the artist was a commonplace. Like Vasari, Ariosto, Rosso Fiorentino, Pietro Aretino, Anton Francesco Doni, Condivi, Varchi, and Francisco de Hollanda all attributed to the artist godlike abilities even while he was alive—and in this regard they ennobled the already prestigious status of the artist among his contemporaries.

This paradigmatic shift explains the extraordinary narrative of the *Moses* (Fig. 7.5), the masterpiece Michelangelo sculpted for the tomb of Julius II, emphatically described as a "divine thing":

> The arms with their muscles, and the hands with their bones and nerves, are
> carried to such a pitch of beauty and perfection, and the legs, knees, and feet
> are covered with buskins so beautifully fashioned, and every part of the work

is so finished, that Moses may be called now more than ever the friend of God, seeing that He has designed to assemble together and prepare his body for the resurrection before that of any other, by the hands of Michelangelo.[14]

Moses is so complete and so perfectly expresses the figure's own divinity and proximity to God that, in a stunning rhetorical twist, Michelangelo resurrects his body, which has been prepared by God himself for the artist. The reference to the Israelites who worshipped the sculpture ("Well may the Hebrews continue to go there, as they do every Sabbath, both men and women, like flocks of starlings, to visit and adore that statue; for they will be adoring a thing not human but divine")[15] makes reference to the biblical account of angels who hid

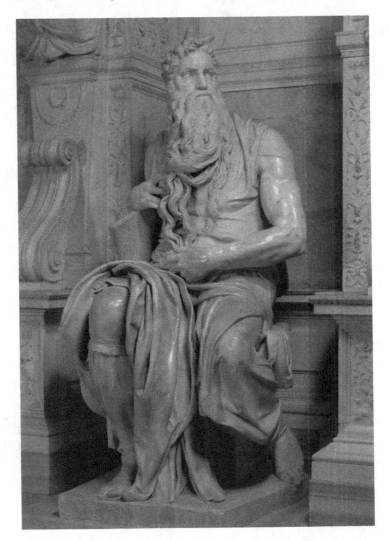

FIGURE 7-5 Michelangelo, *Moses* (1513–15). Rome, Church of San Pietro in Vincoli. Scala / Ministero per i Beni e le Attività culturali / Art Resource, NY.

Moses' body to prevent the Israelites from practicing idolatry after his death.[16] The hyperbole of this description underlines the difference between Michelangelo's creativity, which makes divinity visible, and the mere imitation of nature, which is inherently false (and potentially an incitement to idolatry) that artists practiced before him. The representation of *Moses* that the angels have been impeding since the age of the old law to prevent the adoration of false idols is now made possible by Michelangelo through his art. The explicit interpretation in this description of artistic style as the "stylus" of God is unique in art literature.[17]

Positing divinity as a property shared by both the work and the artist, the description of Michelangelo's work is rhetorically bound to the famous *incipit* of Michelangelo's biography, which fashions the artist's birth as messianic for the arts.[18] This semantic interrelation between the artist's life and work is especially marked in the reference to the *Last Judgment* as "the exemplar and the grand manner of painting sent down to men on earth by God."[19] Michelangelo is the spirit that God sent down, like his frescoes, a comparison further emphasized in the Giuntina, which added the significant, albeit erroneous, detail that the fresco was unveiled on December 25, the day of the Nativity.[20]

In sum the description of art as mimetic—and even more so not as mere imitation but as a sign of divine creativity—makes possible an art historical narrative centered on the figure of the artist. Likewise the identity of the artist, a psychobiological unit that involves singularity and sameness as well as repetition, generation after generation, provides a model for the narrativization of mimetic art and its organization as a historical narrative. Art can be written as the story of what individual artists did and their effect on viewers through time, following the classical historiographic models of the lives of "illustrious men" and accounts of *gestae* (actions). Proceeding from one mimetic invention to another, upholding an ideal fusion of art and the physical world, the history of mimetic art unfolds as a succession of exceptional individuals (great masters) and actions (masterpieces).[21]

In the *Lives* the course of mimetic art reaches its apex in the descriptions of Michelangelo's work, where the identification between the artist and the work of art implies, in Simmel's terms, an absolute spiritual unity. This total correspondence, which binds mimetic art to the limited temporality of the artist's biological life, was incompatible with institutional art, with an idea of art as discipline and as a collective product. Mimetic art is inherently subjective, related to what an individual artist did or did not do and to the specific space and time in which he or she lived. Other phenomena and principles that extend beyond the life of an individual artist are also taken into consideration, but they are still ultimately informed by the psychobiological identity of the artist. This is the case of style as a form of individual expression or of the so-called *qualità dei tempi* (quality of the times), defined in the *Lives* as the cultural and technical means available to an individual artist at a specific time. Ultimately and inevitably the description in the *Lives* of art as mimetic clashed with the program of institutionalization of the figurative arts Borghini and Vasari promoted, which favored and necessitated art's very capacity to transcend time. Mimetic descriptions in the *Lives* are key to interpretations of Vasari and Renaissance art. Their multilevel reference to human temporality, the vividness

they attribute to the work of art, and the absolute identification they pose between the work of art and its maker shape and are shaped by the dominant understanding of Italian Renaissance art and its place in the history of culture. Another descriptive mode, however, capable of challenging these founding principles of Renaissance art, emerges in the *Lives*, and forcefully in the Giuntina.

2.

Borghini and Vasari's program for academic art envisioned works of art as the product of rationality rather than of emotions and feelings. Art originates "from knowledge" and not from "the depth of our hearts." The academician does not create under the influence of divine inspiration, as did Michelangelo, but operates on the basis of a progressively acquired knowledge following rational rules. This mode of artistic production is not well-suited to or served by the descriptive mode at play in the accounts of Michelangelo's *Last Judgment*, with its focus on the work's naturalism and emotional qualities. But if the description of art as mimetic is unsuited to it, how is institutional art described in the *Lives*? The description of Vasari's decorative program in the *Sala Grande* in Palazzo Vecchio in Florence, a work that Vasari immodestly considered "great and most important," and superior to the contemporary decorations in the Venetian Ducal Palace and in the *Sala dei Re* in the Vatican Palaces (Figs. 7.6–7.10), may provide an answer. Vasari included the description of the ceiling decoration, which he began to design in 1563 and rushed to completion in fall 1565, in time for the festivities of the wedding of Francesco I (on December 16), in his own biography in the Giuntina.[22]

The *Sala Grande*, representing "the history of Florence from its foundation to the present time," is a monumental "history painting," a genre long celebrated, from the treatise *De pictura* by Leon Battista Alberti to the *curriculum* of European academies in the nineteenth century, as the noblest.[23] The ambitious commission involved raising the ceiling twelve *braccia* (about seven meters) and building a monumental wooden tripartite gilded frame, decorated with thirty-eight panels of different shapes and dimensions. The program features two major themes: the conquest of Pisa and Siena (in the two long lateral bands) and the history of Florence, from its Roman foundation to the present (in the middle band). The two extremities of the ceiling, adjacent to the short walls, are decorated with representations of the Florentine state: two large ovals representing the *quartieri* of Florence, surrounded by smaller, square panels representing Tuscan cities and territories. For the three small portions of frame that cover the trapezoidal area generated by the oblique wall, Vasari designated playful putti; portraits of his main assistants, Bernardo di Madonna Mattea, Battista Botticello, Matteo da Faenza, and Stefano Veltroni; and an inscription that records the work's completion in 1565. The decorative program, conceived by Borghini and designed by Vasari, was modified multiple times at

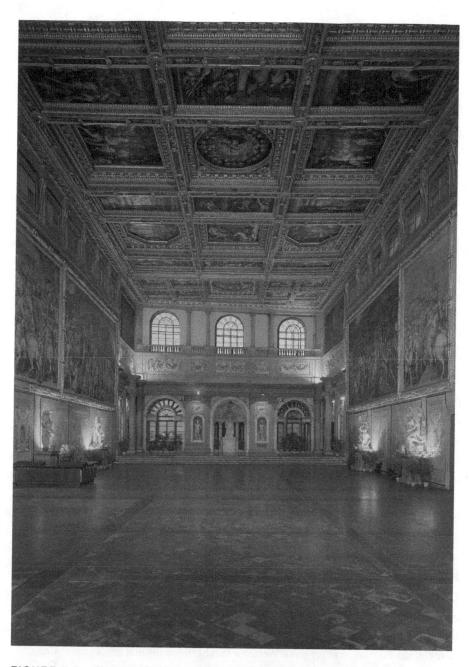

FIGURE 7-6 Giorgio Vasari, *Sala Grande* (1562–72). Florence, Palazzo Vecchio. Scala / Art Resource, NY.

Cosimo I's request. These changes shifted the focus of the decoration from the exaltation of Florence's republican past to the present rule of Cosimo I. The major change concerned the central oval originally containing the *Personification of Florence in Glory,* which was replaced by

FIGURE 7-7 Giorgio Vasari, *Sala Grande*. Ceiling (1562–65). Florence, Palazzo Vecchio. Scala / Art Resource, NY.

the *Apotheosis of Cosimo I*, a portrait of Cosimo I surrounded by the symbols of the Florentine arts and métiers.[24]

Although the description emphasizes Vasari's contribution to the decoration, in part in emulation of Michelangelo's heroic labors in the *Sistine Chapel* and in part in response to the widespread criticism of Vasari's indiscriminate use of assistants since the decoration of the *Sala dei Cento Giorni* at the Cancelleria, the decoration of the *Sala Grande* was a collaborative work.[25] It involved, to various degrees and at different times, his most faithful assistants and prominent young academicians, some of them also active in the decoration of Michelangelo's exequies: Jan van der Straet, Jacopo Zucchi, Battista Naldini, Tommaso di Battista del Verrocchio, Prospero Fontana, Orazio Porta, Santi di Tito, Michele di Ridolfo del Ghirlandaio, Alessandro Fei del Barbiere, and the previously mentioned Marco da Faenza and Stefano Veltroni.[26] Two years after the completion of the ceiling Vasari began the decoration of the large walls with battle scenes thematically connected with the ceiling. In the *Lives* he mentions the work as in progress. We know that he began the first battle scene, *Maximilian of Austria Attempts the Conquest of Leghorn*, in August 1567, the same month as the *Lives'* imprimatur.[27]

As I mentioned in the previous chapter, Vasari wrote an incomplete précis of his own biography, one of the last to be included in the book, and asked Borghini to add information on the most recent works they realized together. It is thus possible that the following description, although it refers to Vasari in the first-person singular, primarily is the fruit of Borghini's pen.

FIGURE 7-8 Giorgio Vasari, *Sala Grande*. Ceiling (1562–65). Florence, Palazzo Vecchio. S.S.P.S.A.E. / Polo Museale della Città di Firenze, Gabinetto Fotografico.

And here I will leave it to the judgment of everyone not only in our arts but also outside them, if only he has seen the greatness and variety of that work, to decide whether the extraordinary importance of the occasion should not be my excuse if in such haste I have not given complete satisfaction in so great a variety of wars on land and sea, stormings of cities, batteries, assaults, skirmishes, buildings of

cities, public councils, ceremonies ancient and modern, triumphs, and so many other things, for which, not to mention anything else, the sketches, designs, and cartoons of so great a work required a very long time. I will not speak of the nude bodies, in which the perfection of our arts consists, or of the landscapes wherein all those things were painted, all of which I had to copy from nature on the actual site and spot, even as I did with the many captains, generals, and other chiefs, and soldiers, that were in the emprises that I painted.[28]

The description praises the ceiling decoration for the unprecedented variety of subjects represented. "In short," the description concludes, "I will venture to say that I had occasion to depict in that ceiling almost everything that human thought and imagination can conceive; all the varieties of bodies, faces, vestments, habiliments, armor, helmets, cuirasses, various headdresses, horses, harnesses, caparisons, artillery of every kind, navigations, tempests,

FIGURE 7-9 Giorgio Vasari, *The Foundation of Florence* (1563–65). Florence, Palazzo Vecchio, Sala Grande. S.S.P.S.A.E. / Polo Museale della Città di Firenze, Gabinetto Fotografico.

FIGURE 7-10 Giorgio Vasari, *Siege of Pisa* (1563–65). Florence, Palazzo Vecchio, Sala Grande. S.S.P.S.A.E. / Polo Museale della Città di Firenze, Gabinetto Fotografico.

storms of rain and snow, and so many other things that I am not able to remember them."[29] The impressive effect of the work is magnified by its monumental size: "about forty large scenes, and some of them pictures ten braccia in every direction, with figures very large and in every manner."[30]

The archetype of the account of the *Sala Grande* is the Homeric description of Achilles' shield at the end of chapter 18 (lines 478–608) in the *Iliad*, where Haephestus shows the shield to the hero's mother, Thetis. Beginning with a detailed account of its structural and material composition, Haephestus emphasizes the work's greatness and variety by offering an exhaustive and systematic inventory of its subject matter. The *ekphrasis* encompasses the whole world, physical and human, symbolically contained in the work's medium (the four metals) and circular form. As striking as the naturalism of the genre scenes may be, nothing on the shield occurs in a specific space or time. The women "making a porridge of much white barley for the labourers' dinner," for example, is a fragment of an ideal view of the world—the representation of everyday life in every countryside at any time. In the same way the "history of Florence" in the *Sala Grande* is not structured as a narrative commemoration of a specific event or series of events, as in the Quattrocento and Cinquecento Florentine tradition of history painting, but as a universal history of epic magnitude.

The only work of art to which the *Sala Grande* is compared in the biography of Vasari is the *Last Judgment,* and the differences between the descriptions are striking. Although it enthusiastically records a variety of figurative elements, the description of the *Sala Grande* does not attempt to re-create what the work "expresses," but rather refers directly to what it represents and to what any viewer, even today, would be able to observe and identify. As Adolfo Venturi put it, "We do not look for any human or dramatic value here."[31] Nude bodies, so central to Michelangelo's art, are also present, but as yet another of the numerous components engaged in the decorative scheme of representing everything.[32] From a linguistic point of view the two descriptions differ widely as well. The emphasis on literality in the description of the *Sala Grande* differs markedly from the metaphorical language used to describe the illusory and emotional qualities of Michelangelo's figures.

The examples adduced here from the *Lives* are somewhat unusual in their strict adherence to one or the other of the two descriptive modes under discussion.[33] But even when intertwined, as it is often the case in the book, and more so in the Giuntina, they refer to discrete ways of seeing and artistic judgments: one emphasizes individual and particular aspects of a work according to the principle that a part can stand for the whole, and the other understands the work of art as an integrated larger whole, according to the opposite principle that "una parte non è il tutto" (a part is not the whole).[34] Whereas the former finds its ideal manifestation in the sculpted human body, a synthetic totality available to the senses, the latter privileges architectural, historical, allegorical subjects (or, ideally, the combination of the three)—analytic totalities perceivable by the intellect.[35] Thus where the description of the ceiling of the Sistine Chapel praises the *terribilità* of the figures, the mode, centered on the emotional effects produced by the work's details, is consistent

with that used to describe the *Last Judgment*. But where the description of the same ceiling highlights Michelangelo's subordination of the fictive architectural framework to the representation of human figures (Michelangelo "è ito accomodando più il partimento alle figure che le figure al partimento"; he adapted the architectural framework to suit the figures rather than the figures to the architectural framework) the mode is the one used to describe the *Sala Grande*.[36] Whereas the former instance coincides with Michelangelo's biographical narrative, the latter is independent of it and corresponds to the point of view of academic art. That this commentary on the architectural frame of the Sistine Chapel appears only in the second edition of the *Lives* is consistent with the fact that the descriptive mode deployed in the case of the *Sala Grande* takes the upper hand in the Giuntina.

Diegetic descriptions are more frequent and more extended in the second edition. We have already encountered a few of them, such as the descriptions of Michelangelo's exequies (including the account of Buontalenti's painting) and of the Sforza Almeni façade. Other examples include the descriptions of the decoration for the wedding of Francesco I, the Medici villas at Castello and at San Casciano, Villa Farnese at Caprarola, and Palazzo Doria in Genua. Diegetic descriptions were often written independently as iconographic programs and disseminated as independent publications. The text of the exequies of Michelangelo, based on Borghini's iconographic program for the funeral, was published in 1564, soon after the funeral, and included only later in the *Lives*. The detailed description of the decorative program displayed for the baptism of Eleonora de' Medici, daughter of Francesco I, which Vasari and Borghini designed and realized in 1568, was published as a booklet in the same year as the Giuntina.[37] The *Ragionamenti*, a description of the decoration of Palazzo Vecchio in the form of a dialogue between Vasari and Francesco I, to which the *Lives* refers at the end of the description of the *Sala Grande*, was begun by Vasari in 1558, probably completed in 1567, and published by Giorgio Vasari the Younger after Vasari's death in 1588.[38] The *Ragionamenti* consists of a collation of iconographic programs by different authors and historical sources used for the decoration of Palazzo Vecchio celebratory of the Medici. The intention and effect of the description are purely diegetic, leading the reader into an abstract time and space informed by an ideal integration of the architectural order and structure of the building with the historical and allegorical meanings the decoration displays.

3.

In the *Lives* the main functions expressed by the two modes explicated here—the definition of authorship as bound to the biological identity of the artist and its counterdefinition as an impersonal value—are dialectically engaged in the narrative of St. Peter's, Michelangelo's unfinished last work. The completion of St. Peter's, the major enterprise undertaken by Michelangelo during his final years in Rome, was left unfinished after many years of tribulation. The construction of the church was a gigantic enterprise, obstructed by material and

FIGURE 7-11 Michelangelo, Giacomo della Porta, and Domenico Fontana, *St. Peter's Dome*. (1587–90) Città del Vaticano. Alinari / Art Resource, NY.

financial difficulties. Incapable of being carried out by a single architect, it was a collective multigenerational enterprise not unlike the construction of a medieval cathedral. The Fabbrica di San Pietro, the office instituted to supervise the execution of work on the church, oversaw a succession of chief architects and collaborators. Donato Bramante began the construction of the new church under Pope Julius II around 1505; Michelangelo served as architect in chief from 1546 until his death. The church was eventually completed, with the erection of the dome by Giacomo della Porta and Domenico Fontana, under the pontificate of Sixtus V in 1590, twenty-six years after Michelangelo's death (Fig. 7.11). In 1558, predicting the impossibility of completing the construction, Michelangelo's advisors and Vasari himself solicited him to produce a large-scale wooden model to fix and to represent his conception of the whole project. This model, about sixteen and a half feet high, representing half of the drum of the dome, in a scale of 1:15, was completed in 1561. It is now in the Fabbrica di San Pietro at the Vatican (Fig. 7.12).[39]

After Michelangelo's death Vasari showed a keen interest in the artist's plans for St. Peter's. The seven pages of the *Lives* dedicated to the description of Michelangelo's later model of the dome comprise the most significant addition to the life of the master in the second edition (excluding the sixty-page account of the exequies). Vasari had the opportunity to see the model in construction in spring 1560 and to compare the completed model with the master's drawings and the information on the project he already possessed during his sojourn in Rome in the winter of 1567.[40] Specifics about the project were also included in the Giunti booklet on Michelangelo's exequies. But the description in the *Lives*, as the passage "and it only remains for us to begin the vaulting of the tribune" suggests, was likely written by someone directly involved in the church's construction.[41] This possibility squares with Vasari's request from Florence for detailed information regarding Michelangelo's activity in St. Peter's.[42]

The description proceeds from the existing base of the tribune, built under Michelangelo's direction, to the project for the lantern of the dome, which came to be installed only two hundred years later and in a different shape. I cite here two passages. The first concerns the

FIGURE 7-12 Michelangelo, *St. Peter's Dome*. Wooden model (1558–61). Città del Vaticano, Fabbrica di San Pietro. Scala / Art Resource, NY.

lower part of the tribune, built under Michelangelo's direction. The second refers to vaulting designed by the artist and rendered in the wooden model and in a few preliminary sketches.

> I must begin by saying that according to this model, made under the direction of Michelagnolo, I find that in the great work the whole space between the tribune will be one hundred and eighty six palms, speaking of its width from wall to wall above the great cornice of travertine that curves in a round in the interior, resting on the four great double piers that rise from the ground with

their capitals carved in the Corinthian order, accompanied by their architrave, frieze, and cornice, likewise of travertine; which great cornice, curving right round over the great niches, rests supported upon the four great arches of the three niches and of the entrance, which form the cross of the building. Then there begins to spring the first part of the tribune, the rise of which commences in a basement of travertine with a platform six palms broad, where one can walk; and this basement curves in a round in the manner of a well, and its thickness is thirty-three palms and eleven inches, the height to the cornice eleven palms and ten inches, the cornice above it about eight palms, and its projection six and a half palms. Into this basement you enter in order to ascend the tribune, by four entrances that are over the arches of the niches, and the thickness of the basement is divided into three parts; that on the inner side is fifteen palms, that on the outer side is eleven palms, and that in the center is eleven palms and eleven inches, which make up the thickness of thirty-three palms and eleven inches. The space in the center is hollow and serves as a passage, which is two squares in height and curves in a continuous round, with a barrel-shaped vault; and in line with the four entrances are eight doors, each of which rises in four steps, one of them leading to the level platform of the cornice of the first basement, six palms and a half in breadth, and another leading to the inner cornice that curves round the tribune, eight palms and three quarters broad, on which platforms, by each door, you can walk conveniently both within and without the edifice, and from one entrance to another in a curve of two hundred and one palms, so that, the sections being four, the whole circuit comes to be eight hundred and six palms.[43]

Up to this point Michelangelo has finished the masonry of the building; it now remains that we commence the vaulting of the Cupola, of which, since we have the model, we will continue to describe the arrangement as he has left it to us. The centers of the arches are directed on the three points which form a triangle as below:

A. B.

C.

The lowermost, or point C, determines the form, height, and width of the first half circle of the tribune, which Michelangelo has ordered to be constructed of well-baked bricks.[44]

Only a transcription can convey the description's obsessive engagement with the anatomy of the architectural model, sufficient to exasperate even an expert reader. Editorially speaking, this description is an infelicitous insertion that contrasts with the celebrated narrative

structure of the *Lives*, especially with the anecdotal disposition of Michelangelo's biography. Abruptly interrupting the biographical pace and structure of the "Life of Michelangelo," this *semplice narrazione* (simple narration) takes an entirely different approach to Michelangelo's work.

The description of the model of St. Peter's features the same characteristics, mutatis mutandis, as the description of the *Sala Grande*. It describes the work in straightforward and literal terms, listing materials and measurements and praising its "greatness," "richness," "variety," "strength and durability in every single part." The model's architectural elements are defined as varied, appropriate, strong, durable, and rich. The only mimetic effect the description creates is when it projects the reader inside the church as a fictive visitor. However, this virtual tour ultimately leads the reader to a timeless geometrical space in which he is given precise instructions on "how to build" the dome following Michelangelo's original plan.

It is this purposiveness—"how to build" Michelangelo's dome—that motivates and explains the inclusion of this description in the biography of the artist. The description's literalism and technicality are instrumental to preserve Michelangelo's original plan after his death, thus to guarantee its execution according to his intention by whoever inherited the artist's position at the Fabbrica. The text protects the project from future deviation and alteration. As Vasari states, "These my writings, such as they may be, may be able to assist the faithful who are to be the executors of the mind of that rare man, and also to restrain the malignant desires of those who may seek to alter it."[45] Diegetic description served to ensure the legacy of the artist and to enable the completion of his work.

The exhaustive description of Michelangelo's model jarringly punctuates an otherwise sustained narrative account—and one structured by mimetic modalities and, crucially, the integral association of works with their author. As per the dialectic mentioned earlier between the two descriptive orientations, Vasari's documentation required the authority of Michelangelo. Echoing widespread opinion sustained by Michelangelo's own statements, the biography reports that Paul III had been inspired by God to summon the artist for the construction of the dome.[46] Quotations from Michelangelo's letters, excerpted from autograph letters sent to Vasari directly by the artist, were also inserted in the biography:

> Messer Giorgio. To the end that it may be easier to understand the difficulty of the vault by observing its rise from the level of the ground, let me explain that I have been forced to divide it into three vaults, corresponding to the windows below divided by pilasters; and you see that they rise pyramidally into the center of the summit of the vault, as also do the base and sides of the same. ... The vault, with its sections and hewn stone-work, is all of travertine, like all the rest below; a thing not customary in Rome.[47]

> Whereupon Michelangelo wrote to Vasari on the same sheet ... "God give me grace that I may be able to serve him [Cosimo I] with this my poor person," for

his memory and brain were gone to await him elsewhere. The date of this letter was August in the year 1557. ... All these things, and many more that it is not necessary to mention, we have in our possession, written in his hand.[48]

Evidently Vasari felt obliged to demonstrate the authenticity of the technical information he provided. As we may infer from the first quotation, Michelangelo himself considered Vasari his intellectual executor and specified the technical details of the construction (note, for example, how the passage anticipates the predictable objection to the use of travertine in lieu of the traditional Roman bricks).[49] The second quotation reinforces the description's authenticity by offering verification reminiscent of a testamentary document: the invocation of God and the last will, the declaration of the date, and the possession of the autograph.

Up to this point we have been concerned with the coexistence in the *Lives* of two antithetical conceptions of art, one mimetic and the other diegetic and academic. These conceptions relate in turn to alternative points of view and temporalities: one envisions art as a historical trajectory traced by exceptional individuals; the other conceives of art as the representation of supra-individual principles and values. These alternative points of view are complexly intertwined in the text under discussion. When Vasari's academic eye considers St. Peter's dome, a work that existed only in Michelangelo's mind, it also retains the image of its mythical author. In this instance Michelangelo's authorship does not reside in the pictorial mark, but in the intellectual formulation of the work, which is independent of and distinct from its execution. Thus the narrative of St. Peter's, which relies on a conception of the divine artist, albeit not one that hinges on the artist's capacity to create perfect bodies, invites us to reconsider the two modes available to Vasari to compare God to the artist: as the sculptor who modeled man out of clay, and as the architect who designed the world. The first is grounded in the awe evinced by the inexplicable creation of life; the second is based on an appreciation of the rational structure of the world, or the articulation of a fabricated construction. Both imply original creations, but only the latter comparison can accommodate an idea of art based on rational principles and values, superseding human time and space.

The celebration of the "divine artist" in the narrative of the dome of St. Peter's depends on and highlights two considerations central to Vasari's conception of academic art. We have encountered them both already, from other perspectives and in other contexts. First, a work of art designed by one artist can be executed by another. Second, the faithful execution of a work depends on its having been designed rationally, with order, proportion, and measure—features, not coincidentally, of architectural works. If painting and sculpted works required the direct intervention of the master and special artistic skills on the part of assistants, as we have seen in the case of Cristofano Gherardi, architecture exemplifies (then as now) the absolute separation between invention and execution. This distinction was clear to Borghini, who considered architecture an exemplary discipline on account of the separation between design and execution and the definition of mastery by virtue of design. Borghini mused over these issues in his *Selva di notizie* and almost certainly discussed them with Vasari in the

summer of 1564, at the same time he received accounts of Michelangelo's activity from his informants in Rome.[50]

In sum whereas the description of the *Last Judgment* posits an absolute association between the work and the artist's persona, the narrative of St. Peter's redefines authorship in abstract terms and *in absentia personae*, as a timeless artistic form. Here too Vasari locates authorship in the psychobiological integrity of the author, expressed as Michelangelo's will, but he redefines it as an abstract value (*modo di disegno*) freed from biological or temporal coordinates. As Howard Burns has shown, Michelangelo struggled mightily to impose his singular authorship on St. Peter's.[51] According to Burns, Michelangelo's obsessive commitment to the completion of the monument mirrored the anxiety of the Renaissance artist and his defense of his personal identity against the impersonal forces of time. The solution to this vexing problem seemed for many contemporary artists to lie in academic art, which honored the division between conception and production. Notably, then, the timelessness of conception that Vasari identified and identified with in the case of St. Peter's dome contrasts with the pressures of time and biographical advances that Michelangelo struggled with in his final years and in this project above all. The description of Michelangelo's plan for St. Peter's certainly contributed to the diffusion of representations of the whole building according to a presumed final project Michelangelo never produced. The most relevant are the engravings by Etienne Dupérac in the *Speculum Romanae magnificentiae* (1569), which shows the dome as hemispheric, and two drawings in the Uffizi (Collection Santarelli 174–75), which represent the church's floor plan and section.[52]

Defining Michelangelo's authorship as an abstract value entailed, as did its inverse, (mythical) construction, keeping the realities of historical circumstances at bay. In his account of Michelangelo's design Vasari portrayed the other architects involved at St. Peter's, who both preceded and succeeded Michelangelo (Bramante, Raphael, Antonio da Sangallo the Younger; Pirro Ligorio, Jacopo Vignola, Giacomo della Porta, and Domenico Fontana) as merely instrumental to the execution of the master's project. Vasari also glossed over the ongoing threats to the project's integrity posed by political and financial factors (e.g., the pause in construction between 1552 and 1555) and the death of the patron popes Paul III (1549), Julius III (1555), Marcellus II (1555), and Paul IV (1559).[53] Vasari was even undeterred by the major historical contradiction to his version of the story, namely that Bramante, and not Michelangelo, was the *primo autore* of the Renaissance St. Peter's. Indeed the four pillars designed by Bramante were central to all future designs and remain the only structural element to survive multiple constructive and destructive transformations. Evoking the myth of the "divine artist" and the widespread opinion that Michelangelo was summoned for the project due to God's intervention, Vasari effectively defrauded Bramante of the title of *primo autore*, which time and material evidence would ultimately assign to him.[54]

However, and surprisingly, Michelangelo himself undermined Vasari's efforts by failing to support the assumption that the dome's design sprang fully formed from his mind. After having constructed the model he reworked the design of the church, following his customary

practice of modifying projects in response to the process of construction.[55] His organic conception of architecture, which obeyed biological rather than structural imperatives, ran counter to Vasari's attempt to distinguish the planning phase from the execution. As Michael Hirst has pointed out, the later alterations to the attic story, previously interpreted as a posthumous phase of the project, were likely conceived by Michelangelo himself.[56] The artist changed the circular openings in the drum, a component visible in the famous drawing of Lille designed by Michelangelo and his assistants between 1547 and 1554 (Fig. 7.13), into large square windows around 1557, during its elevation.[57] Later he also redesigned the frames of the windows of the dome, thus altering the solution represented in the model.[58] Finally documents and surviving drawings suggest (but the point is debated) that Michelangelo was never completely resolved about the external shape of the dome later realized by Giacomo della Porta and Domenico Fontana between 1587 and 1590 (Fig. 7.11). The drawing of Lille shows, for example, that Michelangelo had initially opted for a slightly more pointed curvature.[59] The wooden model plays an ambiguous role in this story. Not only does it not faithfully

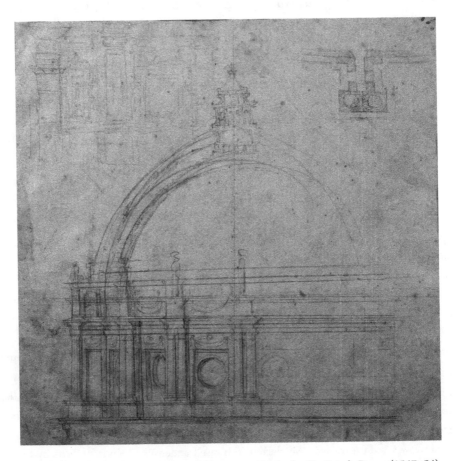

FIGURE 7-13 Michelangelo and assistants, *Study for St. Peter's Dome* (1547–54). Lille, Palais des Beaux-Arts, Cabinet des Dessins, Collection Wicar, No. 93. Réunion des Musées Nationaux / Art Resource, NY.

represent Michelangelo's final idea but, having been used by his successors Giacomo della Porta and Luigi Vanvitelli, it ended up legitimizing posthumous changes. Michelangelo's working procedure, as embodied by the wooden model, defied and undermined Vasari's attempt to describe the work as frozen in time and to establish an exclusive association between the monument and the artist as its *primo autore*.[60]

The diffusion of the mimetic mode of describing Michelangelo's work has been vast beyond measure, in large part because it suits his organic conception of architecture, but also because of the impact of the descriptions of his paintings and sculptures in the *Lives*. In contrast with the narrative of St. Peter's in the *Lives*, for example, Sandro Benedetti describes the church's dome as if it were a sculpture, a "human body" composed of "bones and muscles."[61] Benedetti's description throws into relief the stretch involved in approaching, as the *Lives* did in this instance, Michelangelo's architectural work as a spatial exercise conditioned by geometrical and mathematical principles. This duplicity is key in Vasari's understanding of Michelangelo. Much like the nomination of the aging artist as "first academician" in 1563 and the funeral honors paid to him the following year, the description of St. Peter's dome further exemplifies how the recursive return to the myth of the divine artist that the *Lives* itself created comes to define and legitimize the fundamental principles of academic art. On the one hand, the description is meant to serve Michelangelo's art. On the other, it prompts an idea of art and authorship that Michelangelo himself would never have recognized in his own work.

NOTES

1. Baxandall 1985, 1.
2. My reading contrasts with the following statements in Alpers 1960, 191, 201: "Whether at the beginning of art with Giotto or toward the end with Raphael, the descriptions are alike"; and "*Ekphrasis* is not used by Vasari as a critical tool." Alpers interpreted what I refer to as the diegetic mode as a degeneration of the description, in her words a "grotesque exaggeration of *ekphrasis*" (203). On the coexistence in the *Lives* of contrasting artistic views, see Waźbiński 1976; Ferrari 2001.
3. Simmel 1985, 114, my translation. "Michelangelo's plastic language," Matteo Marangoni wrote, "is not a symbol of Michelangelo's soul, but his whole soul and very art" (1943, 57, my translation).
4. My definition of mimetic description as developed in this chapter is indebted to Alpers 1960.
5. "It is enough for us to perceive that the intention of this extraordinary man has been to refuse to paint anything but the human body in its best proportioned and most perfect form and in the greatest variety of attitudes, and not only this, but likewise the play of the passions and contentments of the soul" (Vasari 1966–87, 6:69, 1996, 2:691). "Any art expert," the description

continues, "sees in those figures such thoughts and passions as were never painted by any other but Michelangelo" (Vasari 1966–87, 6:74 [T and G], 1996, 2:694).

6. For both quotations, see Vasari 1966–87, 6:73 (T and G), 1996, 2:694.

7. The trumpets played by the seven angels "as they sound the call to judgment, cause the hair of all who behold them to stand on end at the terrible wrath their countenances reveal" (Vasari 1966–87, 6:72 [T and G], 1996, 2:693).

8. Invoking qualities for which Michelangelo is still championed, the description emphatically claims that no words can account for the overwhelming overall effect: "And, of a truth, the terrible force and grandeur of the work, with the multitude of figures, are such that it is not possible to describe it" (Vasari 1966–87, 6:73 [T and G], 1996, 2:694).

9. Schlosser 1977, 327, considered the spiritual unity between the artist and his/her work in the *Lives* as the expression, in a mythological form, of a principle that he considered still valid in art theory and criticism. On the rhetorical function of these correspondences and their fortune in art history, see Barolsky 1998.

10. Vasari 1966–87, 6:74 (T and G), 1996, 2:694.

11. Vasari 1966–87, 6:74 (T and G), 1996, 2:694–95.

12. Vasari 1966–87, 6:73 (T and G), 1996, 2:694.

13. See the main studies: Panofsky 1968; Kris and Kurz 1979; Kemp 1977. Giovanni Villani, in his *Nuova Cronica* (1300–48), may have been the first to apply to the arts a metaphorical language based on the idea of divine creativity. On this early example, see Schlosser 1977, 107. On the divinity of Michelangelo's art as a reading key of Cinquecento naturalism, see S. J. Campbell 2002.

14. Vasari 1966–87, 6:28–29 (T and G), 1996, 2:661.

15. Vasari 1966–87, 6:29 (T and G), 1996, 2:661.

16. *Deuter.* 34:5. See Barocchi 1962, 367. In his famous analysis of the statue, Sigmund Freud 1900–1953, 11:213, does not mention Vasari, although Freud's self-identification with the repented Hebrews who flocked to the church to adore the statue is clearly triggered by the description of the statue in the *Lives*: "I have crept cautiously out of the half-gloom of the interior as though I myself belonged to the mob upon whom his eye is turned—the mob which can hold fast no conviction, which has neither faith nor patience, and which rejoices when it has regained its illusory idols." On the *Moses* in Freud and Vasari, see Bergstein 2006, 158–61. More generally, on Freud's analysis of the statue, see Trincia 2000.

17. On the semantic relation between "style" and "stylus," see Sauerländer 1983; Ginzburg 1998. This power of the artist to effect a quasi-divine mimesis is a topos of Michelangelo's biography. The description of the figures in the lower register of the *Last Judgment* invokes Dante's famous verse, "Morti parean li morti et vivi i vivi" (The dead look dead, the living alive; Vasari 1966–87, 6:70–71 [T and G]), and thus emphasizes the naturalism of the figures, even as it recalls the divine power of the artist to define and defy the boundary between death and life. Figures that in Dante's poem were made by God now issue from Michelangelo's hands. In the same way the sculpting of *David* from the block of marble previously damaged by the work of Agostino di

Duccio (Simone da Fiesole, according to the *Lives*) is described as a miraculous resurrection: "Truly it was a miracle on the part of Michelangelo to restore to life a thing that was dead" (Vasari 1966–87, 6:20 [T and G], 1996, 2:654). The sculpting of Christ in the Roman *Pietà* inspires the author of the biography to write, "It is certainly a miracle that a stone without any shape at the beginning should ever have been reduced to such perfection as Nature is scarcely able to create in the flesh" (Vasari 1966–87, 6:17 [T and G], 1996, 2:652). In the same description the reference to the body of Christ as a "divine body" is replaced in the second edition by the description of its anatomical qualities ("details in the muscles, veins, and nerves over the framework of the bones"; Vasari 1966–87, 6:16, 1996, 2:652), a change that further highlights the connection between naturalistic and transcendental values in the description of Michelangelo's art.

18. "Having perceived the infinite vanity of all those labours, the ardent studies without any fruit, and the presumptuous self-sufficiency of men, which is even further removed from truth than is darkness from light, and desiring to deliver us from such great errors, [God] became minded to send down to earth a spirit with universal ability in every art and every profession, who might be able, working by himself alone, to show what manner of thing is the perfection of the art" (Va-sari 1966–87, 6:3, 1996, 2:642).

19. Vasari 1966–87, 6:74 (T and G), 1996, 2:695.

20. Vasari 1966–87, 6:75. The fresco was instead revealed on October 31, 1541. See Barocchi 1962, 1406; Cohen 1998.

21. On this art historical tradition, see the still fundamental Gombrich 1960a.

22. Vasari 1966–87, 6:401–2. Vasari amplified the importance of the decoration and compared it to similar enterprises in a letter to the duke, Vasari 1923–40, 1:722–23: "A work that will surpass any other ever made by mortals because of its grandeur and magnificence, whether it be the decoration in stone, the bronze statues, the marbles, the fountains, or the inventions and stories of the paintings … since all these inventions were born—all, I say—from your [Cosimo I's] exalted conceits, [the hall,] together with the richness of its material, will surpass all the halls made by the Venetian Senate and all the kings and emperors and popes that ever were because, even if they had had the money, none of them had in their palaces either a masonry fabric so grand and so magnificent or the indomitable spirit to know how to begin an enterprise so awesome and of such importance" (Partridge and Starn 1992, 188). On the *Sala Grande*, see Barocchi 1964, 53–62; Partridge and Starn 1992, 151–256, 267–304; van Veen 2006, 54–80. On the iconographic program and preparatory drawings, see Allegri and Cecchi 1980, 231–73; Barocchi 1963, 38, 61–63; Pillsbury 1976; Corti and Davis 1981, 168–71 (essays by A. Cecchi, A. Petrioli Tofani, M. Daly Davis).

23. Alberti 1991, 71, 93. On the relevance of *historia* in art and art literature, see Alpers 1976.

24. On this change, see van Veen 1992, 2006, 66–67.

25. "And although some of my young disciples worked with me there, they sometimes gave me assistance and sometimes not, for the reason that at times I was obliged, as they know, to repaint everything with my own hand and go over the whole picture again, to the end that all might be in one and the same manner" (Vasari 1966–87, 6:402, 1996, 2:1058).

26. See Barocchi 1964, 57–62; Allegri and Cecchi 1980, 236–37, 248, 261–63.

27. Vasari 1938a, 95.

28. Vasari 1966–87, 6:401, 1996, 2:1057.

29. Vasari 1966–87, 6:401–2; Partridge and Starn 1992, 210–11.

30. Vasari 1966–87, 6:402, 1996, 2:1058.

31. Venturi 1931, 12, my translation.

32. Alberti 1991, 93, first clarified the relative value of the nude in painting: "We should take care to learn to paint well, as far as our talent allows, not only the human figure but also the horse, the dog and other living creatures, and every other object worthy to be seen. In this way, variety and abundance, without which no historia merits praise, will not be lacking in our works." Alberti 1991, 75, also claimed variety as a fundamental quality in history painting: "The first thing that gives pleasure in a 'historia' is a plentiful variety … So in painting, varieties of bodies and colours is pleasing. I would say a picture was richly varied if it contained a properly arranged mixture of old men, youths, boys, matrons, maidens, children, domestic animals, dogs, birds, horses, sheep, buildings, and provinces."

33. These two descriptive modes referred to as the mimetic and the diegetic are not unique to the *Lives*, nor are they as distinct from one another as the examples cited may suggest. Dante's *visibile parlare* is one of the earliest early modern instances of the description of works of art as mimetic. Yet Dante's notion of a speaking picture is primarily didactic and moralizing. In other instances diegetic descriptions occur in a cultural context dominated by a mimetic conception of art and by the cult of the figure of the artist. Indeed this is the Renaissance legacy of classical *ekphrasis* and as such applies also to the making of art. On the basis of Homer's description—the archetype of the description of the *Sala Grande*—Raphael painted Achilles' shield on the vault of the *Sala di Costantino* in the Vatican Palace, with the intention of competing with the best artists of the past. The translation into painting of Lucian's *ekphrasis* of Apelles' *Calumny*, made even more famous by Alberti's account in his *De pictura* (1972, 3:52), by Renaissance painters such as Mantegna, Botticelli, Dürer, and Peruzzi occurred within the same cultural context and motivated by a similar competitive orientation. On ekphrasis in Alberti's *De pictura*, see Cieri Via 2007.

34. We find this latter principle in the Giuntina (Vasari 1966–87, 5:464), in a passage critical of Battista Franco's narrow interpretation of Michelangelo's style.

35. This does not mean, however, that diegetic descriptions do not produce an emotional response in the viewer. For example, when Aeneas looks at the decoration of the temple of Juno (*Aeneid*, I, 441–97), a work described by Virgil following the Homeric model, he is moved to tears after recognizing the story as a possible representation of his own life and tribulations. In the same way when Vasari underlines the figurative unity of the *Sala Grande* in the Giuntina, or the "miraculous integrity" of the whole decoration of Palazzo Vecchio in the *Ragionamenti*, he implies the fact that the same decoration can be perceived as such after having understood its historical and allegorical significance.

36. Vasari 1966–87, 6:38, 1996, 2:669. On the relation between figure and frame in the Sistine Chapel, and its connection to Michelangelo's architectural ideas, see Brothers 2009; and later in this chapter.

37. Vasari 1568a. The description was also the subject of a letter from Vasari in Florence to Sangalletti in Rome, February 28, 1568, Vasari 1923–40, 2:368–77. See also Sangalletti's reply from Rome to Vasari in Florence, March 13, 1568, Vasari 1923–40, 2:379. For the dating of the booklet, see C. Davis in Corti and Davis 1981, 203–4; Vasari 2008, 37, n. 57.

38. Vasari 1588. For references to the dialogue in the *Lives*, see Vasari 1966–87, 6:400, 402. Domenico Mellini 1566, 125, cited in Corti and Davis 1981, 211 (essay by P. Tinagli Baxter), also mentions the *Ragionamenti* as forthcoming in his *Description of the Entry of Joanna of Austria*. On the *Ragionamenti*, see chapter 1, n. 68; Passignat 2007.

39. Michelangelo had already realized two clay models, now lost, one two weeks after his nomination as chief architect of the Fabbrica in late 1546 and a second in 1557. He also realized two earlier wooden models. One, realized in 1546–47, was probably used for the engraving published by Vincenzo Luchinon (1564) included in the *Speculum Romanae magnificentiae* and, along with other sources, for the painting by Domenico Passignano in the Casa Buonarroti (see chapter 1). On this model, see Saalman 1975, 382–86, 396–97, 405. The second, now at the Fabbrica di San Pietro, representing the apse, was executed in 1556–67 and inserted in the preexisting model by Antonio da San-gallo the Younger. On these models, see Millon and Smyth 1988, 19– 74, 93–187; Millon and Lampugnani 1994, 665–66; Brodini 2009, 173, 175. Of the vast bibliography on Michelangelo and St. Peter's, see Wittkower 1964; Thoenes 1997, 2006; Bruschi 1997; Benedetti 2000; Bredekamp 2005.

40. See Vasari's letter from Rome to Cosimo I in Pisa, April 9, 1560, Vasari 1923–40, 1:559, cited in Bellini 2008, 178. On the correspondence between Vasari and Michelangelo regarding St. Peter's, see Beltrami 1929. On Vasari's 1567 sojourn in Rome, see chapter 3, n. 110.

41. Vasari 1966–87, 6:98, my translation. I thank Charles Hope, who pointed out this passage to me. This description finds an important precedent in Antonio Manetti's 1970, 70–77, account of Brunelleschi's dome, based on the lengthy quotation of a technical document (supposedly a copy of an original document by Brunelleschi owned by the Opera del Duomo) and paraphrased in the biography of the architect in the *Lives* (Vasari 1966–87, 3:160–62 [T and G]).

42. Vasari 1923–40, 2:66,77. See also chapter 3, n. 83.

43. Vasari 1966–87, 6:96–97, 1996, 2:721–22 (with minor revisions).

44. Vasari 1966–87, 6:98–99, 1996, 2:724.

45. Vasari 1966–87, 6:96, 1996, 2:721.

46. "For that work [St. Peter's] Michelangelo for seventeen years attended constantly to noting but establishing it securely with directions, doubting on account of those envious persecutions lest it might come to be changed after his death; so that at the present day it is strong enough to allow the vaulting to be raised with perfect security. Thus it has been seen that God, who is the protector of the good, defended him as long as he lived, and worked for the benefit of the fabric and for the defense of the master until his death" (Vasari 1966–87, 6:106, Vasari 1996, 2:733).

47. Vasari 1966–87, 6:95, 1996, 2:719 (with minor variations).

48. Vasari 1966–87, 6:95, 1996, 2:720, (with minor variations).

49. On the controversial use of travertine at St. Peter's, see, for example, the anonymous letter (as Frey suggests, by Michele degli Alberti or Antonio del Francese) from Rome to Vasari in Florence dated March 1564, Vasari 1923–40, 2:64–65.

50. Barocchi 1971–77, 1:662–68. On Borghini and Vasari's conversations on the *Selva di notizie*, see Vasari 1923–40, 2:101. On Va-sari's informants, see chapter 3, n. 83. The influence of Alberti's architectural theory is crucial to this point. See especially Trachtenberg 2005, 125–26.

51. Burns 1995.

52. On this visual documentation (Mussolin 2009, 298–99, 302–3), see Zanchettin 2009, 180. On the status of the work at the time of Michelangelo's death, see Ackerman 1986, 264.

53. Regarding the phases of the troubled construction of the church, for sure, works were also interrupted for a few months between the papacies of Paul III and Julius III (1549–50). More problematic, as Zanchettin 2009, 185–86, argued, is the supposed temporary suspension under the papacy of Paul IV.

54. Note, however, that the legitimization of Michelangelo as the *primo autore* is not consistent in the *Lives*. In the biography of Bramante, Michelangelo is said to have considered himself the mere executor of Bramante's project (Vasari 1966–87, 4:83): "Finally Michelangelo Buonarroti, sweeping away the countless opinions and superfluous expenses, has brought it to such beauty and perfection as no one of those others ever thought of, which all comes from his judgment and power of design; although he said to me several times that he was only the executor of the designs and arrangements of Bramante, seeing that he who originally lays the foundations of a great edifice is its true author" (Vasari 1996, 1:667, with minor variations). This passage resonates with Michelangelo's letter of spring 1547, cited in Saalman 1975, 389. On Michelangelo's consideration of his own work as an execution of Bramante's original plan, see also Thoenes 2006, 64. On Michelangelo and Bramante, see Robertson 1986. Note also the contrast between the interpretation of Michelangelo's architecture, as given by the narrative of St. Peter's in the *Lives*, and the idea, also expressed in the *Lives*, already in the Torrentiniana (Vasari 1966–87, 6:54–55), that Michelangelo's architecture breaks "reason and rules."

55. On Michelangelo's architectural practice, see Ackerman 1986; Saalman 1975, esp. 401; Nova 1984; Maurer 2004; Brothers 2008.

56. Hirst 1974. Discussed in Millon and Smyth 1988, 142–47; Burns 1995, 120–23.

57. See Saalman 1975, esp. 404; Maurer 2004, 126–30; Zanchettin 2009, 187–89.

58. Thoenes 2009, 26–28, detected this technique in both the New Sacristy and St. Peter's drum. For St. Peter's, see also Zanchettin 2009, 188.

59. Subsequently, according to Saalman 1975, 404, Michelangelo considered the alternative of the hemispheric dome only for the inner shell (traced free hand on the sheet).

60. On the completion of St. Peter's after Michelangelo, see Wittkower 1952, 390–437; Orazi 1997.

61. Benedetti 2000, 86. On Michelangelo's sculptural conception of architecture, see also Ackerman 1986, esp. 37-52; Argan and Contardi 1990, 273–84.

Notes on the Oldest Sculpture of El Templo Mayor at Tenochtitlan

By Eduardo Matos Moctezuma

T he oldest stage of the Templo Mayor that we have discovered so far is the one we call Stage II (see Figure 8.1). According to our tentative chronology, this stage corresponds approximately to the year A.D. 1390, the period before the Mexicas liberated themselves from the rule of Azcapotzalco, under whom they were subjugated. In trying to find elements that would permit us more positively to elucidate our chronology—which we still consider subject to revision—it was proposed that we dig a trench in front of each one of the stairways that lead to the upper part of the Stage II area of the temple, where the *adoratorios* dedicated to Tlaloc and Huitzilopochtli are located. These trenches were two meters wide and were dug in the center of each stairway. The stones that formed the stairs were dismantled, numbered, and photographed, and were to be replaced once the excavation was finished.

I will not cover here the details of the work done during the months of January through April 1989, but rather will focus on a significant discovery that occurred when the trench on the Tlaloc side was dug. On January 20, 1989, the archaeologist Teresa Gracia Franco unearthed a stone head facing west, standing on the south end of a stone slab in the filling

FIGURE 8-1. An Early Stage of El Templo Mayor (Stage II. c.a.d. 1390). This is the northern side of the temple, ruled by Tlaloc.

of *tezontle* rock and mud that forms the nucleus of Stage II, just above the phreatic level. The head was attached to its base with stucco.

What immediately attracted our attention were the head's unusual features: The nose was contorted toward the left and the mouth had a marked grimace toward the right (see Figure 8.2), Immediately, it reminded us of some stone and ceramic faces that we had studied in 1970 and that were identified as possible representations of facial paralysis (see Matos 1970), an illness that occurs for various reasons, among them a traumatism or a severe chill. It affects the facial nerves and muscles, paralyzing half of the face. When the affected individual tries to eat, talk, or laugh, there is a very characteristic expression on one-half of the face. If the excavated head was made to represent a paralysis, it is important to describe, however briefly, some of the characteristics of illnesses and their relation to certain gods of the Nahua pantheon.

One of the studies that has shed bright light on the relations among the human body, illness, society, myths, cosmovision, and certain beliefs of the Nahuas, is without a doubt Alfredo López Austin's, *Cuerpo Humano e Ideolagia*. In Chapter 8, he writes of a debate with George Foster concerning whether the concepts of "hot" and "cold" forces in medical treatment were pre-Columbian or European. López Austin shows that the Mesoamerican world conceived of the dichotomy of "hot" and "cold" and made it part of its cosmovision prior to European contact. Foster believes that the hot/cold dichotomy is a derivative of the European world. I am inclined toward the position of López Austin because his arguments are solidly

FIGURE 8-2 Face with Possible Facial Paralysis

based in Mesoamerican evidence. It is in the discussion about the hot/cold dichotomy that archaeological representations of sicknesses and the contexts in which they are found can be of help, particularly in the case of the figure we are examining.

Let us look at the context in which it was found. The head, because of its characteristics, must have belonged to a chac-mool. The excavations of the Proyecto Templo Mayor, have taught us the significance of the place that these sculptures occupied. The chac-mool found in front of the adoratorios to the god Tlaloc in Stage II (see Figure 8.3) reveals an intimate relationship between this sculpted figure and the cult of water. The ritual and symbolic relationship between Tlaloc and chac-mool is obvious, and if there are any doubts, we also have the Mexica chac-mool found in 1943 (today in the Mexica Room of the Museo Nacional de Antropología), whose characteristics show a direct association with the water god.

But returning to the head we recently discovered: there is no doubt that it represents this type of sculpture. It has a striking similarity to the chac-mool of Stage II and was attached to the end portion of the slab that may have represented the body of chac-mool. Further, the pathological characteristics of the chac-mool head appear to be associated with the god Tlaloc. This is not unusual because some gods, according to their attributes, are related to determined illnesses; for example, Tlaloc, the water god, is linked to illnesses such as dropsy. Therefore, it would not be strange that he should also have a strong relation to an illness such as facial paralysis, which may be caused by a severe chill. It is reasonable to ask if this illness is

FIGURE 8-3. Detail of the Excavation. Note the positions of the two chac-mools

being represented. We believe so; such an obvious pathology and its causes would not have gone unnoticed by the Mexicas. Further research could compare this example with other representations of the same illness to search for similarities and differences.

On the other hand, the presence of a sick figure allied with the water god in the Templo Mayor is significant, in light of the fact that Huitzilopochtli, the god of war, who is also associated with a physical deformity, was found in the same building. Huitzilopochtli is a god with, as the chronicles say, a "skinny" foot—a foot that has suffered a real illness. The same pathology occurs with Nanahuatzin, the boil-covered god, who throws himself into a bonfire in Teotihuacan in order to become the sun at the creation of the Fifth Age. For a sick god to become the sun in one of the main Nahua myths illustrates that illness had a major religious significance in the Nahua world.

Again I would like to underline my support for the aforementioned position of López Austin in relation to the "cold" and the "hot," dual concepts that were present in the Templo Mayor. The northern half of the building is ruled by Tlaloc, who is associated with water, humidity, cold, and so forth—feminine characteristics. The opposite elements related to masculinity (the sun, heat, the sky, the eagle and so on), occur on the other side of the temple, which corresponds to Huitzilopochtli.

The purpose of these brief remarks is to share some ideas that emerged with the discovery of this sculpture, the oldest that has yet been found in the Templo Mayor. Further interpretation is ongoing and will be published in the future.

REFERENCES

López Austin, Alfredo
1984 *Cuerpo humano ideologia: Las Concepciones de los antiguos nahuas.* 3 vols. Mexico City: Universidad Nacional Autónoma de México.
Matos Moctezuma, Eduardo
1970 *Parlisis facial preispanka.* Mexico City: Instituto Nacional de Antropología e Historia.

NOTE

1. Funds for this work were provided by the Mesoamerican Archive and Research Project of the University of Colorado, Boulder, directed by David Carrasco. This chapter was translated with the assistance of Joseph Richey and Anne Becker.

Earth Reveries

Transcendent Responses

By Andrew Jay Svedlow

This essay is a search for understanding about the relationship between art, phenomenological practice, and the natural environment. It is an inquiry into the characteristics of some contemporary visual arts activities that are informed by environmental thinking and contemplation. It is at this intersection of artistic study and practice with ideas and issues as regards reflections on and about the cosmos where the author finds transcendent experiences and transactions.

In contemplating the deep issues and concerns about finding harmony in the cosmos, about climate change, energy and sustainability, environmental degradation, desertification, and the critically polluted air, water, and earth that people in all places across the globe are confronted with, how do some artists and aestheticians bring their practice to not only focus attention on this reality but bring themselves and their audiences to a place beyond the ordinary, to a transcendent understanding of oneself in the cosmos? It is not difficult to learn about and face firsthand the realities of the changing nature of our built and natural environment. Media outlets in almost every niche of our lives address

and debate the grave disposition of the situation in both the local community and the global situation. In what ways do artists and philosophers of art bring us outside of the world as we know it and into a place where we are confronted with a new vision about our surroundings and perhaps a place of discomfort in which to expand our horizons about the future?

Nature, in and of itself, has, in global aesthetic traditions, been a recurring platform by which to define and rejoice in the beautiful. The image of nature in human consciousness as a place of awe and grandeur, danger and delight, pleasure and pain, and the material embodiment of the existent of a transcendent unity of truth and goodness is also part of the perennial traditions of the work of artists. Umberto Eco finds this world view in the text "De Divinis Nominibus of Dionysius the Areopagite. It is a work which describes the universe as an inexhaustible irradiation of beauty, a grandiose expression of the ubiquity of the First Beauty, a dazzling cascade of splendours." (pg. 18) It is this "First Beauty" that is now under assault and in dire need of being reconstituted.

The artist Louis Le Roy has tapped into this tradition to look for the good and the beautiful through his poignant works of natural art. In Kantian terms, his art is "that, which goes beyond" or which transcends the possibilities of human knowledge and enters a meditative realm beyond language.

> In order to consider something good, I must always know what sort of thing the object is [meant] to be, i.e., I must have a concept of it. But I do not need this in order to find beauty in something. Flowers, free designs, lines aimlessly intertwined and called foliage: these have no significance, depend on no determinate concept, and yet we like them. (Kant 1987 4.2)

Le Roy, born in 1924 in the Netherlands, has been working for over thirty years on his everlasting environmental work *Eco-Cathedral* in Mildam, Holland. Le Roy's work represents a commitment to the temporal experience of nature. The work attempts to transcend human knowledge of time and the continuous nature of the *Eco-Cathedral* is intended to go beyond the work life of the artist. According to the artist, "The method's of today's planners will not prepare them for the enormous problems that they will have to face in the next century. One of the first things they have to do is accept infinite time within their thinking system." (www.slowlab.net/ecocathedral.html 7/2011)

This pursuit of a transcendent relationship with time may be viewed as the artist's attempt to seek refuge in the timelessness of nature as a barrier from the inhumane destruction of the natural environment that plagues the globe, which has placed humankind out of harmony with the Cosmos. Le Roy's work, therefore, is a heuristic tool to help place us outside of the normal practice and allegiance to time that is such an indelible part of transactions in the world, particularly in the workplace and the academy. The dominant paradigm that has informed most contemporary institutions is still a nineteenth century notion of time and competition, much like the development of the factory model during the industrial

revolution. Therein, organizations structure learning and work around units of time and rates or judges competency as a competition among workers and students. Thusly, in schools and in the work place today, as in the nineteenth century, if a person does not complete a standardized set of ideals within a set amount of time, they fail. Le Roy taps into a more pre-Socratic notion of time, one in which there is time to explore the construction of a new sustainability, one in which the pressures of time and competition are removed and there is a sensation of cosmic time.

This renewed way of knowing the world, this timeless way, may be, as Kant alluded to in *Critique of Pure Reason*, a transcendental knowledge, one in which "the way that we can possibly know objects even before we experience them." According to Kant, "the transcendent is that which lies beyond what our faculty of knowledge can legitimately know" yet, we somehow innately know of these things, these structures of time and place, otherwise how would we recognize them or know them again? (Kant 2007)

Artists such as Le Roy confront us with the relationship we have with the object oriented world and help us go beyond the sense of ourselves somehow separated from the other, from the world, from nature. Environmental unconsciousness inherently is a separation of the self from the other, from nature. The work of Le Roy and others helps us to exceed this limitation in order to come to a realization of the deeper connections we have with and as nature.

This, of course, is not a new idea. Pythagoras in theorizing about music with his notion of the *musica mundana* believed that the beautiful was "in the cycles of the universe, in the regular movements of time and the seasons, in the composition of the elements, the rhythms of nature, the motions and humours of biological life: the total harmony, in short, of microcosm and macrocosm." (Eco, pg. 32)

Ahmad Nadalian is another artist who helps us expand beyond the limits of our knowledge and experience of nature through his collaborative work with young people and adults in the communities he works in. An environmental artist, Dr. Nadalian's stone artworks seek to harmonize with their surroundings and, at times, feel as if they are natural outcroppings in the landscape as opposed to manmade objects. As stated on the greenmuseum.org website, his environmental art is informed by the iconography of his native Iran.

> According to a tradition in the north of Iran images of fish or snakes can be a sign of treasure. By carving simple fish shapes and other forms onto small stones and river rocks, artist Ahmad Nadalian seeks to repopulate the spirit of neglected streams and rivers in his native Iran and around the world and share these treasures with future generations. Over the past decade the artist has traveled to cities and remote regions in every continent (with the exception of Antarctica) to work with children and local residents to create countless treasures which are then tossed into rivers and buried under the earth, spreading his message on a scale that few artists have before. (http://greenmuseum.org/artist_index.php?artist_id=123)

Whereas Le Roy's work unfolds the artist's intuitive grasp of time, Nadalian's etched, incised, and colored rock art is a representation of an instinctive understanding of space outside of the continuum of time. Nadalian's work is infused with organic qualities that make the art intimately part of the natural environment. The beauty of the work is not in its placement in the artificial setting of the gallery or museum but in its synergy with and as nature.

Gary Snyder writes about this type of sense of place and the epistemology of place in *The Practice of the Wild*:

> A place on earth is a mosaic within larger mosaics – the land is all small places, all precise tiny realms replicating larger and smaller patterns. Children start out learning those little realms around the house, the settlement, and outward. (pg. 27)

Nadalian provides an opportunity to re-capture these small places with his seemingly random placement of simply etched and colored rocks in locations that re-annex the small for us. These works provide the opportunity for us to remind us that "recollecting that we once lived in places is part of our contemporary self-discovery." (Snyder pg. 28)

Gaston Bachelard captures this coming into Being of the beauty of place through our interaction in the landscape when he writes;

> The world asks to be seen: before ever there were eyes to see the eye of the waters, the huge eye of still waters watched the flowers bloom. And it was in this reflection-who will deny it!-that the world first became aware of its beauty. Just as, from the time when Monet first looked at a water lily, the water lilies of the Ile-de-France have been more beautiful, more splendid. They float now upon our streams with more leaves, in greater tranquility, sober and docile as pictures of Lotus-children ... Monet would have understood this immense charity toward the beautiful, this encouragement offered by man to all that tends toward beauty ... (Bachelard pp 5–6).

As with Bachelard's poetic interpretation of Monet's paintings of water lilies, the ancient Greeks also reveled in casting their eye upon beauty, albeit imposing a sense of unnatural symmetry on the subject of nature and beauty. The term for this idealized physical beauty that was also imbued with a moral sense of duty employed by the ancients was: Kalokagathia. Kalos meaning outward forms of beauty and agothos meaning to be worthy in a noble and courageous fashion. The Greeks found symmetry in this axiom of physical beauty and righteous thought. They portrayed an idealized harmonious Cosmos.

Like Le Roy and Nadalian, the artist Andy Goldsworthy works with natural materials to fashion experiences that are outwardly beautiful and gracious and splendid in their dignified approach within the natural environment.

According to Goldsworthy's official website,

> Goldsworthy deliberately explores the tension of working in the area where he finds his materials, and is undeterred by changes in the weather which may melt a spectacular ice arch or wash away a delicate structure of grasses. The intention is not to "make his mark" on the landscape, but rather to work with it instinctively, so that a delicate scene of bamboo or massive snow rings or a circle of leaves floating in a pool create a new perception and an ever growing understanding of the land. (http://www.rwc.uc.edu/artcomm/web/w2005_2006/maria_Goldsworthy/biography.html)

A noble intention is expressed in the work, "to create a new perception and an ever growing understanding of the land." The Kalos or external beauty of Goldsworthy's site specific installations appears obvious to me and the courage of the artist to hinge his oeuvre on the transient and insubstantial fits well with the work of other environmental artists and enlightened aestheticians attempting to connect audiences with a primal notion of oneself in the world.

Goldsworthy, Le Roy, and Nadalian, each from disparate regions of the world and diverse backgrounds, have expressed a universal desire, if not human need, to connect with the thus-ness of beauty and the complexity of the natural world. Their work can also be seen in light of the Greek term for virtue, arete. Plato, through Phaedo, equates arete as harmony as the accord between and of things, there rightness, their synchronization with the Cosmos. Through Cratylus, Plato uses the term to mean ever flowing, equating this moral stance as an unhindered goodness. The artists referred to in this essay fulfill this moral goodness through the acts of harmony with their place in the cosmos.

In Mules (2012) writing about Heidegger and his essay, The Origin of the Work of Art, he explains Heidegger's example of a stone lying on the ground and I see this case as a means to also understand the contemporary work of the three artists' work I've shared in this essay and their manifestation through their art of glimpses of harmony in the Cosmos.

> In appearing to us, the stone manifests withdrawal by pressing down on the earth. The stone "presses downward and manifests its heaviness. But while this heaviness exerts an opposing pressure upon us it denies us any penetration into it" (Origin 46). In lying there before us, the stone withdraws into the earth and in so doing, denies us any penetration into it. There is no question here that the stone *might* be penetrated; rather, penetration becomes fragmentation, dispersal, division and differentiation. Heidegger explains: "if we attempt such a penetration by breaking open the rock, it still does not display in its fragments anything inward that has been disclosed. The stone has instantly withdrawn again into the same dull pressure and bulk of its fragments (Origin 46-47).

By attempting to penetrate the stone, we have simply divided it into pieces, producing more stones withdrawing into the earth. The point Heidegger makes here is that the metaphor of innerness obscures the real mode of revealing of things; the breaking open of something does not reveal another thing inside the thing, but more things in different arrangements and dispositions. Things *are,* not because they have another thing inside them that makes them so, but because their being-a-thing is given to them as part of *physis* (physical emerging forth) as *poietic* becoming, which, in the case of the stone, redeploys the "penetrated" thing into different constellations of yet more thing-fragments.

Goldsworthy, Le Roy, and Nadalian all intuitively grasp this concept and work, poetically, to not fracture and fragment the stone they set before us but, to arrange that stone, metaphorically and literally, in order to find resolution and union.

REFERENCES

Bachelard, Gaston (1988) *The Right to Dream,* The Dallas Institute of Humanities and Culture. (1987) *On Poetic Imagination and Reverie,* Dallas: Pring Publications, Inc.

Eco, Umberto (1986) *Art and Beauty in the Middle Ages,* New Haven: Yale University Press.

Kant, Immanuel (1987) *The Critique of Judgment,* trans. Werner S. Pluhar, Indianapolis: Hackett. (2007) *Critique of Pure Reason* A12 trans. Marcus Weigelt, Penguin Books.

Mules, Warwick (2012) *Heidegger, nature philosophy and art as poietic event* in Transformations, Issue No. 21

Plato *Cratylus,* trans. Benjamin Jowett http://classics.mit.edu/Plato/cratylus.1b.txt *Phaedo,* trans. Benjamin Jowett http://classics.mit.edu/Plato/phaedo.1b.txt

Snyder, Gary (1990) *The Practice of the Wild,* San Francisco: North Point Press.

WEB REFERENCES

www.slowlab.net/ecocathedral.html 7/2011

http://greenmuseum.org/artist_index.php?artist_id=123

http://www.rwc.uc.edu/artcomm/web/w2005_2006/maria_Goldsworthy/works.html

http://wwwebart.com/riverart/fish/index.htm

http://www.rwc.uc.edu/artcomm/web/w2005_2006/maria_Goldsworthy/biography.html

Hegel and the Sea of Ice

By Andrew Jay Svedlow

I n *Phenomenology of Spirit,* Hegel postulates that the perceptions of the qualities of things in the world are expressions of deeper drives. Some interpret this to mean that "Hegel believed that knowledge is not wholly separate from our religious, moral and political practices; he believed that it is a social, interpersonal enterprise—the work of 'spirit' or of the 'I that is a we and the we that is an I'. "[1] With this in mind, the following interpretation of Casper David Friedrich's painting, *The Sea of Ice,* is an effort to capture the spirit of the author's transaction with the artwork.

Friedrich's painting is approximately 3 feet by 4 feet (38" × 49.9") and was completed in 1824. It now resides at the Kunsthalle in Hamburg, Germany. Categorized as a German romantic, Friedrich first exhibited the painting at the Prague Academy in 1824, under the title *An Idealized Scene of an Arctic Sea, with a Wrecked Ship on the Heaped Masses of Ice.* The painting portrays a shipwreck lost in the midst of the shattered ice flows of the Arctic Sea. The ship is often identified as the HMS Griper, which was part of William Edward Parry's arctic expeditions of 1819 and 1824; the ship was destroyed in 1868. Parry's expeditions to the arctic in search of a Northwest Passage were publicized in the European press and, no doubt, Friedrich had become familiar with the heroic efforts of the expedition.

Andrew Jay Svedlow, "Hegel and 'The Sea of Ice,'" The Cosmos and the Creative Imagination (Analecta Husserliana, Volume CXIX), ed. Anna-Teresa Tymieniecka and Patricia Trutty-Coohill, pp. 345-350. Copyright © 2016 by Springer Science+Business Media. Reprinted with permission.

Considered one of the most prominent of the German Romantics, Friedrich was born in 1774 and died in 1840. Friedrich was predominantly a landscape painter whose many allegorical works feature Gothic ruins and the menacing awesomeness of the natural world. As with many of the 19th century Romantics on the Continent, Friedrich embedded in his landscapes the presence of man, albeit normally in a diminished presence in the vastness of the landscape. His contemplation of nature brought to light the transcendent qualities of the experience of the gaze upon nature itself. Friedrich studied as an artist in Copenhagen and later in Dresden at a time when German intellectuals were, in part, shifting their worldview away from a rationalist dominant perspective to one that began to embrace the personal and the spiritual.

In Isaiah Berlin's classic text, *The Roots of Romanticism*, he characterizes this period in intellectual history as being about "the primitive, the untutored, it is youth, the exuberant sense of life of the natural man, but it is also pallor, fever, disease, decadence, the *maladie du siècle*, La Belle Dame Sans Merci, the Dance of Death, indeed Death itself."[2] Certainly, Friedrich's painting in question in this essay has an "exuberant sense of life" even if it is life in the balance. Death, so much an intimate partner of Berlin's definition of Romanticism, is also an ever present scythe hanging over the head of the crew of the HMS Griper as they struggle, trapped in the ice. The potential tragedy of the Griper is frozen in the moment imagined by Friedrich in his painting. Berlin's discussion of tragedy as an element of romanticism is relevant to what may have been an error on Parry's part in placing his mission and crew in such a precarious situation:

Previous generations assumed that tragedy was always due to some kind of error. Someone got something wrong, someone made a mistake. Either it was a moral error, or it was an intellectual error. It might have been avoidable, or it might have been unavoidable. For the Greeks, tragedy was error which the Gods sent upon you, which no man subject to them could perhaps have avoided; but, in principle, if these men had been omniscient, they would not have committed those grave errors which they did commit, and therefore would not have brought misfortune upon themselves.[3]

Friedrich takes the role of the omniscient manipulator of the scene as he constructs the stage on which the action he has visualized takes place. In some respects, the power of the moment, the true tragedy of being trapped in the ice in the dangers of the Arctic Ocean, is framed by the artist in a way that removes the intensity of this calamity. We can observe the frozen action set at an aesthetic distance and luxuriate, in a way, in the luminosity masterfully employed by Friedrich. The artist as all knowing controller of action has softened the sense of the tragic. The iciness of his palette does not in any physical way bring us into the reality of misfortune that the crew of the ship may have confronted. The well-balanced composition, the proportioned and measured angles of the ice floes, the quiet light, and the harmony of the artist's range of color allay our sense of emergency and immediacy.

Tragedy is a contradiction of actions, as Hegel asserted, as the tension between an individual's righteous actions that violate another equally righteous position, as in the tragedy of

Antigone. According to Roche[4], tragedy for Hegel "is the conflict of two substantive positions, each of which is justified, yet each of which is wrong to the extent that it fails either to recognize the validity of the other position or to grant it its moment of truth; the conflict can be resolved only with the fall of the hero." In Friedrich's painting the two positions are, a) the artist's creative decisions in framing the scene of the trapped ship through the technical craft of painting; and that of viewers, unfolding their own meaning of the experience with the work of art. Certainly, Friedrich was aware of potential viewer reaction to his work but, most likely, he was swept up in completing the commission that was the impetus for creating the piece. The viewers' position is, perhaps, looking to validate their own reconciliation of their aesthetic response with an interpretation of the artist's intentions, and the historical placement of the painting in the codified characteristics of German Romanticism. The viewer, therefore, sacrifices all other meanings of the painting for the particular creation of meaning revealed during the transaction with the artwork. The temporal experience of viewing the painting, contemplating the painting, and the intellectual and emotional construction of personal meaning at that moment of the transaction with the painting, must, in a minor tragic sense, sacrifice all other meanings.

The viewer not only sacrifices all other meanings during that transaction, but due to the limitations of the viewer's ability to know all inherent or historically constructed meanings for the work, sets up an internal conflict that is a debate carried on in the interior consciousness of the viewer. It is instructive to inquire into the historical dialectic that informs Friedrich's construction of the tragedy of the ship locked in a sea of ice, and to attempt to construct the context in which the painting is rooted.

The painting may be a representative of an artistic revolution in its stylistic counterpoint to the neo-classicism prevalent in the academy at the time of its creation. It may also correspond to the intellectual paradigm shift characterized by Hegel's discourse on the significance of tragedy. Friedrich's work, like Hegel's philosophy, moves away from the rootedness in the rationalistic classicism of the past, to a transitional period on the way to realizing the heroic power of the individual. Friedrich's struggle to make the Romantic ideal of the tragic hero visual is akin to Hegel's postulations about the revelation of truth through personal and universal struggle:

> Through them a new world dawns. This new principle is in contradiction with the previous one, appears as destructive; the heroes appear, therefore, as violent, transgressing laws. Individually, they are vanquished; but this principle persists, if in a different form, and buries the present.[5]

Friedrich's painting, and the artist hero whose toil works to present a new principle of art, is an art that persists in struggling against the old order in pursuit of principles that elevate the individual's path to outsized proportions.

In 1805, Johann Wolfgang von Goethe organized a wide-ranging artists' competition in Dresden. Friedrich won one of the numerous prizes at the competition and this elevated his

status as a significant artist of his time. Goethe wrote, "We must praise the artist's resourcefulness in this picture fairly. The drawing is well done, the procession is ingenious and appropriate."[6] Shortly after this praise from the highly respected Goethe, Friedrich began to receive critical success and was elected a member of the Berlin Academy in 1810.

Friedrich's commissions during the first decade of the 19th century take on a religious tone and have a sublime quality that has come to be the hallmark of his work. In *Philosophy of Art*, Hegel writes, "The beauty of art is beauty born of the spirit and born again, and the higher the spirit and its productions stand above nature and its phenomena, the higher too is the beauty of art above that of nature."[7] In the second volume of the *Philosophy of Art*, he writes that "we must … look for the real sublime in the fact that under this view the entire created world is limited in time and space, with no independent stability or consistency, and as such an adventitious product which exists solely to celebrate the praise of Almighty God."[8]

In light of Hegel's concept that "everything spiritual is better than any product of nature. Besides, no natural being is able, as art is, to present the divine Ideal,"[9] Friedrich's painting *The Sea of Ice* is the artist's journey to, and representation of, the spiritual. The artist's process of creation is, in itself, a form of a spiritual journey and the product of this quest is the painting, which provides the opportunity for a viewer to interact with the work in such a way that it may create an internal co-creative process that captures the sublime. The truth of the artist's spiritual drive is realized through the substance of the painting, and that passage is made available to the viewer.

The Sea of Ice is not merely a historic depiction or a simple seascape, but rather, in its totality, it is an expressive and emotive work. In 1938 the historian Hermann Beenken wrote about Friedrich's ability to create a "die romantische Stimmungslandschaft,"[10] or a special romantic feeling, as if the viewer were in the drama of the painting, not merely external to the frame of the work. Even the popular publication Time Magazine wrote of *The Sea of Ice* in 1974: "Friedrich was inspired, at first, by reports of early expeditions to the North Pole, all of which failed. But the image he produced, with its grinding slabs of travertine-colored floe ice chewing up a wooden ship, goes beyond documentary into allegory: the frail bark of human aspiration crushed by the world's immense and glacial indifference. 'The ice in the north must look very different from that,' Friedrich Wilhelm III of Prussia is said to have grumped on viewing this picture. He was right, though it scarcely matters. Friedrich's shipwreck survives as one of the most remarkable images of 'sublimity' in all 19th century painting."[11]

The bleak icescape of the painting is not so much an austere rendering of the drama of the shipwreck as it is a rich rendering of the hues and dynamic angularity of the abstract forms of the ice floes. While the object of the artist's focus is the complete and total harshness of the arctic sea and its crushing power to overwhelm the slightness of Man's adventurism, the finished painting chiefly represents a masterful, craftsmen-like arrangement of a fugue of geometric forms, and the subtle shifts of light through, within, and across those forms. This aesthetic distancing makes it difficult to feel the emotional content of the subject matter at

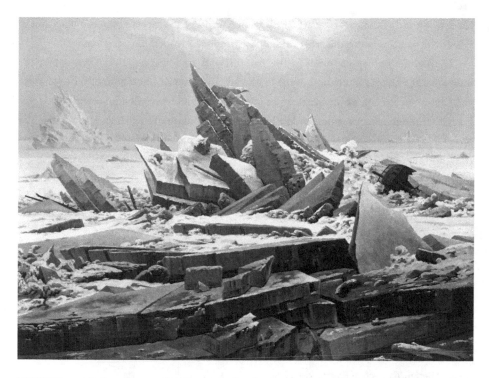

FIGURE 10-1. Caspar David Friedrich, https://commons.wikimedia.org/wiki/File:Caspar_David_Friedrich_-_Das_Eismeer_-_Hamburger_Kunsthalle_-_02.jpg, 1824. Copyright in the Public Domain.

hand and, in counterpoint, allows for a gratifying sensual experience of the virtuosity of the artist's ability to entertain the perceptual sense.

One of the painting's strongest elements is the thrusting upward mass of ice making a diagonal slash from the mid-point of the canvas toward the open sky on the left hand side of the picture, above the open horizon. This pointing to the transcendent, the nothingness above the tragedy of the doomed vessel, holds out hope where none seems to exist. The seascape may be littered with seeming confusion and randomness of the broken ice, but the artist's arrangement of forms, colors, and strong line direct the viewer's eye upward into a relatively calm and quiet sky. This sense of clarity in the midst of chaos evokes Hegel's views on tragedy, as mentioned earlier in this essay. The moment of truth is within this conflict.

It is obvious from the masterfully depicted objective reality of the ice floes, and the awareness of the arctic environment, that Friedrich observed nature first hand and used his analytical skills as an astute observer of the natural environment to call to the viewer's mind the depth of cold and graveness that lies in the path of the voyager, or metaphorically of the pursuer of truth. Of course, Friedrich is not merely or slavishly imitating nature; he is taking his well-honed close observations of the physical world to play out the drama of the tragedy of humanity. He has not simply mimicked nature, he has created an object of nature. The rigor and seriousness of his pursuit of this romantic cause produced this harsh and sober,

yet exciting and vibrant, work of art. The dynamic thrust of the ice caught in the snap shot of Friedrich's painting is also the artist's attempt to produce a work that is in dynamic flux.

The heroic journey captured in the painting can be interpreted as representing the individual search for genuineness in the unaltered physical environment in order to glimpse veracity in oneself. The wild yet pristine state of nature provides individuals with the legitimacy to through off convention and to witness the unfolding of their own true nature. The *Sea of Ice* was produced later in Friedrich's life, after the peak of public interest in his work. A decade after completing the painting, the artist suffered a debilitating stroke that severely restricted his ability to paint.

NOTES

1. Nicholas Bunnin and E. P. Tsui-James, editors, *The Blackwell Companion to Philosophy*, (Blackwell Publishers, Inc., 1996) 609.

2. Isaiah Berlin, *The Roots of Romanticism*, 3rd ed., (Princeton: Princeton University Press, 2001), 16–17.

3. Berlin, *The Roots of Romanticism*, 29.

4. Mark W. Roche, "Introduction to Hegel's Theory of Tragedy" *PhaenEx* 1, no. 2 (Fall/Winter 2006) 11-20, accessed December 2011, www.phaenex.uwindsor.ca/ojs/leddy/index.php/phaenex/.../398 11–12.

5. Georg Wilhelm Friedrich Hegel, *Lectures on Fine Art*, two volumes, trans. T. M. Knox, (Oxford: Oxford University Press, 1998) 18:515.

6. Linda Siegel, *Caspar David Friedrich and the Age of German Romanticism*, (Boston: Branden Publishing Co, 1978) 43–44.

7. Hegel, 2.

8. Hegel, 100.

9. Hegel, 29.

10. Hermann Beenken, "Caspar David Friedrich", *The Burlington Magazine for Connoisseurs*, 72 no. 421 (April, 1938) 171–175, accessed December 2011, *The Burlington Magazine for Connoisseurs*, .

11. "The Awestruck Witness", Time Magazine, 104 no. 18 (Oct. 28, 1974) http://www.time.com/time/magazine/article/0,9171,908926,00.html

CHAPTER 11

The Borderland

By Andrew Jay Svedlow

I n the heart of central Kharkiv, Ukraine's second largest metropolis, a university, and once thriving manufacturing city on the Russian border, is Shevchenko Park. In the winter of 2010, the park was an icy and windblown landscape whose zoo and other entertainment establishments bespoke of earlier times. For me, the outstanding feature of the park is the monument to Taras Shevchenko, Ukraine's beloved and renowned early nineteenth century poet and artist.

Shevchenko was born on March 9, 1814, in the village of Moryntsi, Ukraine, then part of the Russian Empire. A talented draughtsman at an early age, Shevchenko was recognized for his visual art and he entered the Academy of Arts in St. Petersburg, Russia in 1938. In 1840, Shevchenko published his first set of poems, *Kobzar*, and in 1841 he published the epic poem *Haidamaky*. He continued to paint and write throughout his life.

Opposition to the social and national oppression of the Ukrainian people grew in Shevchenko. Tsarist Russian censorship deleted many lines from his works, and created problems for the printing of the writer's poetry. In 1843, the poet left St. Petersburg, and at the end of May he was in

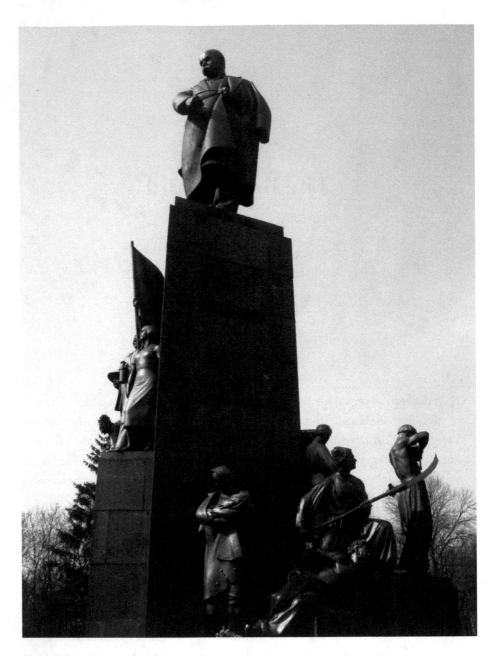

FIGURE 11-1

Ukraine. In Ukraine, Shevchenko did many pencil studies for a projected book of engravings to be called Picturesque Ukraine. In Ukraine, the poet had seen the heavy social and national yoke borne by the working people and the inhuman conditions of life of the peasants. This evoked new themes in Shevchenko's poetry. In the spring of 1846, the poet lived for some time in Kiev, where he met the members of the Kyrylo-Methodius Society. In

1847, arrests began of the members of the Kyrylo-Methodius Society and Shevchenko was arrested on April 5 on a ferry crossing the Dnipro River near Kiev. The next day, the poet was sent to St. Petersburg. He arrived there on April 17, 1847, and was imprisoned. Here he wrote the cycle of poems *In the Dungeon*. He was exiled as a private with the Military Detachment at Orenburg. Russian Tsar Nicholas I, in confirming the sentence, wrote "Under the strictest surveillance, with a ban on writing and painting." On June 8, 1847, Shevchenko was established at distant Orenburg, and later he was sent to the fort at even more distant Orsk. In 1848, Shevchenko was included as an artist in the Aral Sea Survey Expedition. In 1850, Shevchenko was arrested for violating the Tsar's order. Then he was sent to a remote fort in Novopetrovsk. Once again, strict discipline was imposed, and the poet was subjected to more rigorous surveillance. It was not until 1857 that Shevchenko finally returned from exile. On August 2, 1857, having received permission to travel to St. Petersburg, Shevchenko left the fort at Novopetrovsk. In Nizhniy Novgorod, he learned that he was forbidden to go to Moscow or St. Petersburg, on pain of being returned to Orenburg. In May 1859, Shevchenko got permission to go to Ukraine. He intended to buy a plot of land not far from the village of Pekariv, to build a house there, and to settle in Ukraine. In July he was arrested on a charge of blasphemy, but was released and ordered to go to St. Petersburg without fail. The poet arrived there on September 7, 1859. Nevertheless, to the end of his life, the poet hoped to settle in Ukraine. Taras Shevchenko died in his studio apartment in St. Petersburg at 5:30 a.m. on March 10, 1861. At the Academy of Arts, over the coffin of Shevchenko, speeches were delivered in Ukrainian, Russian, and Polish. The poet was first buried at the Smolensk Cemetery in St. Petersburg. Then Shevchenko's friends immediately undertook to fulfill the poet's Zapovit (Testament), and bury him in Ukraine. The coffin with the body of Shevchenko was taken by train to Moscow, and then by horse-drawn wagon to Ukraine. Shevchenko's remains entered Kiev on the evening of May 6, and the next day they were transferred to the steamship Kremenchuh. On May 8 the steamship reached Kaniv, and Taras was buried on Chernecha Hill (now Taras Hill) by the Dnipro River.

(http://www.infoukes.com/shevchenkomuseum/bio.htm)

The massive sculptural array in Kharkiv provides insight into Shevchenko's role in Ukrainian history and of socialist realism public sculpture in Kharkiv and its environs, as manifested by Soviet artists between the two world wars and afterwards. This work incorporates evidence both of the forces that shaped the Soviet political environment of the time, and

of the internal dynamic of the Ukrainian struggle to capture and define a national identity. The function of Soviet political monumental sculpture was to manifest official state values and to play a role in the control of ideas and images. While much of the earlier official Soviet art was proffered as a refutation of older norms, the period of this monument from the mid 1930s also recognized a need to shore up Ukrainian allegiance by using a strong nationalist icon such as Shevchenko, in light of the imposed famine in Ukraine, the Holodomor, in 1932-33, as instigated by Stalin. While the invented and often repeated motifs of the Soviet revolution, such as the hammer and sickle, the red star, and the heroic laborer and solider are not the focal point of this monument, the elements of the piece still unfold the orthodox posturing and standards of official socialist realism. Socialist realism became state policy in 1932, when Stalin disseminated the declaration *On the Reconstruction of Literary and Art Organizations*. The following text is drawn from the publication of this decree with a translation by Bowlt (Harrison & Wood 1992 pg. 417):

> The Central Committee states that over recent years literature and art have made considerable advances, both quantitative and qualitative, on the basis of the significant progress of Socialist construction. A few years ago the influence of alien elements, especially those revived by the first years of NEP, was still apparent and marked. At this time, when the cadres of proletarian literature were still weak, the Party helped in every possible way to create and consolidate special proletarian organs in the field of literature and art in order to maintain the position of proletarian writers and art workers. At the present time the cadres of proletarian literature and art have managed to expand, new writers and artists have come forward from the factories, plants, and collective farms, but the confines of the existing proletarian literature and art organizations are becoming too narrow and are hampering the serious development of artistic creation. This factor creates a danger: these organizations might change from being an instrument for the maximum mobilization of Soviet writers and artists for the tasks of Socialist construction to being an instrument for cultivating elitist withdrawal and loss of contact with the political tasks of contemporaneity and with the important groups of writers and artists who sympathize with Socialist construction. Hence appropriate reconstruction of literary and artistic organizations and the extension of the basis of their activity was needed. Following from this, the Central Committee of the All-Union Communist Party decrees: 1. Liquidation of the Association of Proletarian Writers. 2. Integration of all writers who support the platform of the Soviet government and who aspire to participate in Socialist construction in a single union of Soviet writers with a communist faction therein. 3. Execution of analogous changes with regard to the other arts. 4. Charging

of the Organizational Bureau with working out practical measures for the fulfillment of this resolution."

As an intended art of the people, the imagery used in the Shevchenko monument was accessible and easily comprehensible to residents and visitors to Kharkiv. This mode of clearly depicted hero or icon was consistent throughout the era. Bold, toiling, muscular, selfless workers, rising up and looking forward, comprise the armature that structures this piece. During Stalin's reign in the early 1930's, Soviet monumental sculpture and other art forms under official sanction began to not only depict the heroic worker, but also put forth images of the great leader. Of course, Stalin himself begins to appear in settings across the Soviet Union, as do sculptures and images of Lenin. In some respects, under Stalin's drive for collectivization and the construction and propagandizing of the heroic and forwarding thinking Soviet Man, the Shevchenko monument adds to this norm a deeper connective tissue in the Ukrainian psyche. Here the nationalist forward thinking hero artist and poet of the nineteenth century is a stand-in for the progressive Soviet Man.

The concept of the new Soviet man or person (*novy novetsky chelovek*) may be best exemplified in Vladimir Mayakovsky's 1924 "Vladimir Ilyich Lenin: A Poem":

> Who needs a "1"?
> The voice of a "1"
> is thinner than a squeak.
> Who will hear it?
> Only the wife...
> A "1" is nonsense.
> A "1" is zero.

(University Press of Hawaii, Vladimir Mayakovsky)

The substantial sculpture on Sumska Street, not far from Kharkiv's famously large Svobody Square, is a highly stylized response to the realities of the Soviet dominated and biased cultural imperative, as well as an idealized depiction of the contradictions involved in trying to capture, within the dynamics of public art, the heartfelt nationalism exemplified in Shevchenko's life and work. The Stalinist cultural imperative was a view that looked to art as a propaganda tool; a means of political persuasion and indoctrination. This non-violent method of persuasion still had the same intention as more coercive forms of control to have power over the thoughts and ideas of the populace. Monumental art was a manipulative tool under Stalin, and also undermined the ideas of opponents and previous cultural imperatives, such as those derived from the church.

Noteworthy for its projected physical strength and sweeping arrangement of archetypal Ukrainian characters, as typified in Shevchenko's writing, the sculpture relates its narrative in a

panoramic approach that engages the viewer in a circular walk around the structure. The sixteen subjects depicted in this grouping are as diverse, yet no less subtle in their depiction than the commanding central and dominating figure of Shevchenko himself. Shevchenko's visual art and poetry depicted the harsh reality of life he saw around him, and can be seen as an unfolding of a distinctly Ukrainian national character. He was certainly cognizant of the injustices perpetrated upon the Ukrainian people. His own life history made him particularly aware of the struggle for personal freedom, and his revolutionary spirit and distaste for the oppression of the Ukrainian people made the use of his image for Soviet propaganda the ideal appropriation.

The artist Matvey Manizer, at the time a sculpture teacher at the Leningrad Institute of Proletarian Visual Arts formed in 1932, captured the potent force of Shevchenko's character and nature, and shaped the monument out of powerful collective memories, observations of the human form in dynamic movement, and imaginative thinking. He built upon traditions that Soviet era authorities accepted as the language of public art. The tenets of socialist realism mandated that the work of art be straightforward and clear to viewers, that relevant subject matter be chosen, that the artwork should be in the realm of subjective realism and not abstract or non-objective, and that the sculpture serve the purposes of the State.

Manizer was born in St. Petersburg in 1891 and studied sculpture at the Academy of Arts in St. Petersburg. He produced numerous portrait sculptures and monuments of Lenin, which were erected in many cities across the Soviet Union. His portrait of Lenin in the revolutionary's birthplace of Simbirsk, formerly known as Ulyanov, is particularly notable for its heroic realism.

The Shevchenko monument in Kharkiv is one of a series of Shevchenko sculptures Manizer created in Ukraine. The Kharkiv monument is his most famous, and he worked with the architect Iosif Langbard on the landscaping and pedestal. Langbard, of Jewish heritage, was born in Bielsk, Belarus (now in Poland) in 1882 and during the 1930s he was quite active in architectural projects in his native Belarus where he was named, in 1934, "Honorary Worker in the Arts and Architecture of Belarus."

Later, in the 1930s and 1940s, Manizer produced sculpture for the Moscow Metro.

In 1958 he was named the People's Artist of the USSR and he was Vice-President of the Academy of Arts of the USSR from 1947 until his death in Moscow in 1966.

Manizer and the monument's architect, Langbard, created a tribute to Shevchenko that allows the viewer to be disposed to reverie. At times their visionary quest to capture the spirit of the poet and his place in the Ukraine patriotic landscape results in hackneyed characterizations. On the other hand, a dreamy utopian world is exemplified. Even if the sculpture is intended to represent objective reality, Manizer appears to make references to people that are somehow not quite real. It is in this imaginal space that an awareness of Manizer quest takes place. The focus may be one that works to reveal an idiosyncratic journey, a quest for a unifying identity.

The quality of this state is the tendency toward harmony, accord, and oneness. Approaching the sculpture, it can be noted that the artist made significant choices about

what is to be captured and translated into bronze. In this process, the exploration of both the ordinary and awe inspiring in Shevchenko's poetry is transformed into a tamed and accessible world. Manizer seems to be searching for continuity, and deviations in nature are subjected to the control of his modeling. The diverse parts of this naturalism are ordered for an effect of wholeness and togetherness. The solidarity of the derived elements exerts an influence that implies a cooperative spirit between the figures and the viewer. This union is captured by the artist as an effort to project an integrity that stands in contrast to the chaos that thrived in the period of its execution. The investigation of the national character of Ukraine through this monument, by the artist, can be almost scientific, wherein close observation and depiction thereof is of primary concern. However, the pursuit also involves a bit of adventure to a place of dreamlike proportions.

Heroic sculpture such as this, as seen in the light of a quest for unity, is not so much an imitation of nature, but it is a response to a reverence and deference to the sweep of the patriotic landscape. Whether in close study of the human figure in motion or a subdued arrangement of forms in space, the artist joins in a spirit of cooperation with his subject.

The monument stands sixteen and a half meters high and the Shevchenko element stands five and a half meters tall. The sixteen bronze figures, fabricated in Leningrad, spiral along a massive raw labradorite podium. At the dedication ceremony on March 24, 1935, the following was reported:

> A great holiday in Kharkov: the unveiling of the monument to the great son of the Ukrainian people Taras Shevchenko (1814–1861), the revolutionary democrat, the ardent fighter against Tsarism and serfdom was taking place. Red banners decorated the city. People filled in Sumska Street, adjacent streets and Dzerzhisky square
>
> 2 o'clock p.m. The trumpets sound. The veil goes down. All who gathered see the monument's multifigured sculptural composition crowned by the Kobzar statue. The sounds of "International" are heard. Then a large chorus sings Shevchenko's "Will" ... The meeting begins. Greetings and addresses are read. Yanka Kupala, a national poet of Byelorussia recites his poetry dedicated to the national poet of the Ukraine ...

http://www.kharkov.ua/about/shevchen-e.htm

The reference to "Kobzar" in the above address brings forth the Ukrainian folk tradition of the itinerant bard or balladeer. The Kobzar was someone who played the kobza, a stringed instrument similar to a lute. Shevchenko brings forth in his poetry and artwork this reverence for the nationalist ideal of the Kobzar, and published a collection of poems titled *Kobzar* (*http://www.infoukes.com/shevchenkomuseum/articles.htm#Doroshenko*) in

1840 in St. Petersburg. Interestingly enough, the demise of the Kobzar tradition came about at the same time as the inclusion of Ukraine as a republic of the Soviet Union. Referring to this very Ukrainian folk tradition may be interpreted as a means to tacitly incorporate the nationalist sentiments into feelings of allegiance to the communist state. Kupala read from his Shevchenko series at the monument's dedication:

> In 1909, Yanka Kupala wrote two poems: The Memory of Shevchenko (February 25, 1909), and Shevchenko's Memory that started the Byelorussian Shevchenkiana poetic series. In the first of these impassioned creative tributes, the Byelorussian bard acknowledges the truly boundless influence of the Kobzar's revolutionary Muse on vast social strata and expresses heartfelt admiration of this impact as a son of the Byelorussian people: "In the north, in the south, in the east, in the west, where the sun sets, The Kobzar plucks the strings of human souls. In a cabin, a palace, a prison cell, a tavern, He stirs hearts as a warden does with his bells. His verse reaches us every time, We listen happily to our neighbor, We add our flowers to his garland. Brother, dear, Byelorussians salute you." This motif is stressed even more in the second poem. Kupala refers to the Kobzar as the father of not only Ukrainians but also Byelorussians. Shevchenko's image prompted Kupala to write the epic poem *The Fate of Taras*. It turned out as a kind of life story of the great Ukrainian bard, full of charming lyricism, a soft poetic narration. The meter of *The Fate of Taras* is characteristic of Shevchenko's kolomyka—a lively Western Ukrainian folk song or dance. Maxim Gorky, the great Russian author, noted at one time that he knew of no other poet, except Yanka Kupala, who had so completely and profoundly utilized the Kobzar's creative principles.

(http://bestreferat.com.ua/referat/detail-8872.html)

Beneath the sculpture of Shevchenko, the Kobzar, at the pinnacle of the spiral monument in descending order are a female student, signifying the youthful spirit of Kharkiv as a center for higher education in the Soviet Union, a young farmer raising the flag, symbolizing forceful and youthful revolutionary laboring on behalf of the state, and just behind the figure of the farmer, stepping onto the penultimate pillar is the figure of the miner. Actors from the local Kharkiv theatre scene posed for the sculptor, allowing him to capture the naturalistic poses of each character.

The first sculpture at the foot of the monument is named "Katerina" and was inspired by the Shevchenko poem of the same name. The young mother clutches her baby in a protective and caring fashion. While somewhat melancholy, the figure of Katerina is symbolic of the strength of the mother as a metaphor for the state's ability to lead and protect, as well as the

anti-Tsarist sentiments as expressed in the original poem published in 1838. In the poem, Katerina is an unwed mother rudely abandoned by her lover, a soldier in the Tsar's army.

The next figure in line is a powerful and expressive characterization of the "Dying Haidamaka." Again, the figure is drawn from a Shevchenko poem of the same name and symbolizes the fighting spirit of the revolutionary to fight and die for his country. The poem depicts a peasant uprising and the artist has captured the tense moment of the physical and emotional pain of the dying peasant. The figure above the dying Haidamaka is of another esne using his scythe as a weapon, and the next figure positioned in the crux of the first spiral upward is breaking his chains to fight for his freedom.

The name Haidamaky was given by the Polish gentry to the peasant rebels that operated together with the Cossacks in the region of Ukraine that was under Polish rule during the eighteenth century. The word is of Turkish origin and means "unruly ones." The Haidamaky movement, known as Koliyivshchina, was at its strongest in the late eighteenth century and was the inspiration for Shevchenko's poem.

> My sons, my Haidamaki brave!
> The world is free and wide!
> Go forth, my sons, and make your way—
> Perhaps you'll fortune find.
> My sons, my simple-minded brood,
> When you go forth to roam,
> Who will receive my orphans poor
> With warmth into his home?
> So fly, my fledgling falcons, fly
> To far Ukraine, my lads—

(http://www.infoukes.com/shevchenkomuseum/poetry2.htm#link10)

The next figure is of a seated Cossack, or Zaporochet, bound at his hands and feet. Passive in his body language, the figure, sometimes referred to as a representation of Taras Bulba *(http://kharkov.vbelous.net/english/shevchen/zaporozh.htm)*, is a symbol of defiance. Like Gogol's "Taras Bulba," this figure is the epitome of strength and sorrow.

Zaporozhci were Cossacks who lived in the central Ukrainian region of Zaporozhia. The Zaporozhci became a political force that sought a Ukrainian identity and opposed the Ottoman, Polish-Lithuanian, and Russian empires.

As one makes the next turn around the sculpture the second major grouping of figures comes into view. The figure of a woman and then a man hunched over, weighted down by a millstone on his back, are both symbols of the oppression of the people under tsarist rule. The woman holds the tools of a farmer in a defiant gesture, as she seems to be protective of the fate

of the laborer burdened by the pressure of his oppressive stone. The next figure up the spiral is of an indentured soldier in the Tsar's army, his heavy coat wearing down his spirit.

As the figures twist their way up the monument, another set of young people and heroic soldiers makes their way along the pedestal. First a young boy, perhaps a student, behind the image of a revolutionary clutching his banner, followed by a sailor raising his hat, and then a worker striding forward with his rifle at his side. The next in line is the upright figure of a Red Army soldier proudly standing guard.

Reaching to the top of spiral are the figures of the coal miner, the farmer, and the female student. From the depiction of Shevchenko's "Katerina" at the base of the monument, to the compelling portrayal of the woman student gripping a book, the monument captures the narrative of the characters of Shevchenko's writings, about the peasant revolt and the heroic nature of the underclass in opposition to the tsarist regime, forward and through the Bolshevik revolution, into the modern spirit of the Soviet man and woman, looking forward to the predicted bright future of Stalin's Soviet Union.

The irony of the position of this monument in contemporary Ukraine is that it is honored and acknowledged not as a symbol of Stalinist Socialist Realism, but as a testament to the valor and persistence of the Ukrainian people and state. Unlike the Soviet military medals and Lenin lapel pins that are traded in the street markets of Ukrainian cities along with other memorabilia and kitsch items, Manizer's monumental public sculpture provides an authentic experience that helps the visitor unfold something of Ukrainian history and soulfullness, as well as connect the viewer to universal conditions of humanity.

REFERENCES

Bonnell, Victoria. *Iconography of Power: Soviet Political Posters Under Lenin and Stalin.* University of California Press, 1997.

Bowlt, J. *Russian Art of the Avant-Garde.* (London and New York, 1988).

Harrison, C., and P. Wood,, eds. *Art in Theory 1900–2000: An Anthology of Changing Ideas.* Malden, MA: Blackwell Publishing, 1992.

Lindy, Christine. *Art in the Cold War: From Vladivostok to Kalamazoo, 1945–1962.* New York: New Amsterdam Books, 1990.

Luckyi, George S. N. *Is Shevchenko a Symbol of Universal Freedom?* in Comparative Literature Studies. Edited by Thomas O. Beebee. Vol I, No. 2 143–151, Penn State University Press, 1964.

Mayakovsky, Vladimir. *Vladimir Ilyich Lenin: a Poem.* University of Hawaii Press, 2003.

Shevchenko, Taras) *The Haidamaks*, Translated by Michael M. Naydan, in Ukrainian Literature: a Journal of Translation Vol. I. New York, Shevchenko Scientific Society, 2004. Lines 1–10.

Encyclopedia of Ukraine: http://www.encyclopediaofukraine.com/picturedisplay.
asp?linkpath=pic\S\H\Shevchenko Taras Kateryna 1842.jpg

http://membres.multimania.fr/mazepa99/ENG/art-shevch.htm

Ukrainian Poetica: http://poetry.uazone.net/english.html

Ukrainian Poetry in English: http://membres.multimania.fr/mazepa99/ENG/UPOETS/
up-eng.htm

Yanka Kupala: http://bestreferat.com.ua/referat/detail-8872.html

Belous, Valerie: http://kharkov.vbelous.net/english/shevchen.htm

Answers.com: http://www.answers.com/topic/iosif-grigor-yevich-langbard

http://www.answers.com/topic/matvey-genrikhovich-manizer

Encyclopedia of St. Petersburg: http://www.encspb.ru/en/article.
php?kod=2804029999

Encyclopedia of Irish and World Art: http://www.visual-arts-cork.com/history-of-art/
socialist-realism.htm

Taras Shevchenko Museum: http://www.infoukes.com/shevchenkomuseum/monuments.
htm

CHAPTER 12

Visual Culture/Visual Studies

By James D. Herbert

"Visual culture" has emerged of late as a term meant to encompass all human products with a pronounced visual aspect—including those that do not, as a matter of social practice, carry the imprimatur of art. "Visual studies" (which I select from a number of cognate designations currently in use) serves as a convenient name for the academic discipline that takes visual culture as its object of study. The day has passed, however, when a nascent discipline such as visual studies can justify itself simply by gathering more goodies behind its disciplinary parapets: art ... and much more! Practical considerations aside (and such considerations are far from trifling in the modern university), the exercise smacks of unreasonable acquisitiveness, of academic hubris. Visual studies, rather than engaging in the science of accounting for a massive collection of fresh data points, must embark on the historical and social analysis of the hierarchies whose formation and operation have generated—and will continue to generate, even under the aegis of visual studies—greater interest in some artifacts than in others. To enlarge the compass of the study of visual artifacts beyond art does not force scholars to homogenize away the differences between art (or other favored categories) and things not thus endowed. Visual studies, rather than leveling all artifacts into the meaningless

commonality of "the visual," treats the field of the visual as a place to examine the social mechanisms of differentiation.

Let me, then, offer an abbreviated sketch of the expanded territory—the necessarily and self-consciously artificial territory—across which visual studies hopes to chart the production of hierarchies among artifacts. I will do this by plotting out the new discipline's moves in relation to the field of art history along three trajectories.

First, visual studies democratizes the community of visual artifacts. However defined and however assigned, the concept of art bestows a type of privilege on a select few objects. The great mass of common items that visually address real or potential viewers tend to attract attention from art historians only when they set the context, in some fashion or another, for works of art. For the most part, humanists lack even a rudimentary system of classification to make sense of this bounteous supply of things (although James Elkins has ingeniously fashioned a preliminary typology for them, using semiotic categories derived in part from Nelson Goodman). Visual studies promises to pay heed to these relatively neglected objects. While not questioning the importance of art objects, the new discipline entertains the possibility that other visual artifacts may be equally capable of aesthetic and ideological complexity—and accordingly can reward scholarly investigators with nontrivial results. Visual studies, as it were, extends to this broad class of artifacts the franchise of scholarly analysis, welcoming them into the society of objects worthy of study.

To phrase it thus anthropomorphizes, and—realizing the metaphor—it is tempting to draw a rough parallel between social and aesthetic hierarchies. Historically, social elites do seem to have certain affinities with high art. Nevertheless, in terms of the rank of their creators, that which they depict, their intended audience, or the types of viewers that actually engage them, visual artifacts hardly need correlate with any given class in relatively similar position along the social scale. Sometimes they do, and sometimes they don't. Visual studies can make that ever changing interplay between social and aesthetic forces one of its principal concerns—without presupposing the placement of any privileged set of artifacts or class of people at the center of the discipline.

A curious by-product of this broadening of attention beyond the precincts of art is that visual studies in practice can take on a distinctly modern aspect. In part this is the result of the attraction exerted on the field by technologically advanced new media (about which more in a moment), which have not yet secured solid standing as works of art. But it also stems from the fact that simple, everyday objects that have survived from distant times tend to assume, in our own day, the mantle of high art. Any potsherd miraculously preserved from ancient Egypt or classical Greece, any fragment of medieval tapestry or even simple cloth not destroyed during the rugged course of intervening centuries, today receives royal curatorial treatment and elicits no clucking when displayed at the Metropolitan Museum of Art or published in *The Art Bulletin*. In order to distinguish itself from a discipline that already claims most of the past as its own, visual studies often takes recourse to featuring objects of recent and abundant manufacture—films and photographs, advertisements and commercial goods—not yet

valued for their rarity (with distressing regularity, a valuation confounded with aesthetic distinction). It is important to recognize that this tendency toward the modern is the result more of current academic jostling than of disciplinary imperatives internal to visual studies. Visual studies need not let go of the past.

Second, in addition to expanding the range of domestic visual artifacts under consideration, visual studies also broadens the study of visual artifacts potentially to all corners of the world. Such global mindfulness is not without precedent: Euro-American art history departments in the postwar period have generally responded to the recognition (by Western scholars) of cultural activity in a previously underacknowledged part of the world by appointing a specialist to cover the area—or at least by bemoaning the lack of funds that prevents them from doing so. Nonetheless, the Eurocentric origins of that established discipline, emerging as it did in the Continental nationalist movements of the nineteenth century, has repeatedly raised the specter that the discovery of art in societies outside the Occident entails the projection of a concept of great cultural specificity and considerable political charge—namely "art"—onto distant peoples among whom that idea of art may hold little or no currency. Consequently, historians of that thing called "art" frequently find themselves in a double cul-de-sac of the discipline's own making: no one would wish to insist that artifacts outside the Occident should conform to European aesthetic standards (that would be Eurocentric, if not indeed culturally imperialistic), yet neither would anyone want to suggest that such societies lack the capacity to perform at an aesthetic level comparable to the Occident (that would be condescending).

Visual studies somewhat sidesteps this sort of impasse by defining its scope not in terms of a loaded cultural concept but rather according to a physiological characteristic of seeming transcultural application: the fact that people from all parts of the world have eyes, and those eyes have the capacity to see. Not that visual studies would wish to assert some solid biological foundation to its activities. Different societies conceive of that basic ocular faculty—and use it as a metaphor for knowledge and other cultural practices—in radically different manners. For example, during European antiquity and the Middle Ages, sight frequently assumed the active character we now tend to associate with touch. Consequently, seeing and being seen frequently required strict social or religious regulation: fear of the piercing Evil Eye, for instance, prompted the wide dissemination of prophylactic talismans (a recent volume edited by Robert S. Nelson [2000] explores such variations in underlying assumptions about the visual). Nevertheless, the fact that any term used to designate a field of inquiry necessarily carries with it a certain cultural relativity hardly implies that all terms are culturally relative to an equal degree. And in some rather obvious sense the category of the visual breaks beyond the markedly Eurocentric—indeed postromantic—notion of art. Specifically, it opens up the field to a comparative study of the origins and functions of the aesthetic criteria of modern Euro-America—and also of other typologies and hierarchies generated by humans for the management of sight and of things seen.

To engage the material culture of distant cultures and to forsake the object-privileging concept of art, however, may drive visual studies into the fold of yet another discipline, anthropology (or, earlier, ethnography), and more than one critic has faulted the initiative for thus selling its soul to the social sciences. Various complaints against visual studies may be hiding under this general accusation of anthropologizing (including the worry that the academic study of culture thereby loses its historical dimension, a misgiving only reinforced by the modernist tendencies of the practice). But it seems that a principal reservation held by a number of detractors concerns means and ends. Anthropology—literally, an "account" of "man"—regards material artifacts principally as supporting evidence contributing to an understanding of the varied ways of the human species. To thus regard the artifact as a sign of something else is to overlook its specificity as a material object, its brute recalcitrance to incorporation into some story about "man."

The concern is justified, as far as it goes. To the extent that "art" history would like to use evidence of human social practice to understand the work of art rather than using the work of art as evidence of human social practice, the anthropologization of cultural analysis may well put the cart before the horse. Whereas anthropology treats "culture" as the totality of human activity in a given society (and would regard the art world as an elite subcultural practice), art history often would like to maintain the possibility that "culture" (as in the phrase "high culture") operates somewhat independently of social practice broadly perceived—perhaps even serving as a point of material resistance to the sort of larger social forces that anthropology might call "culture."

Yet visual studies cannot be so easily reduced to anthropology. Because visual studies suspends itself somewhere between art history and anthropology, it does not close down the question concerning the potential autonomy (or semi-autonomy) of the art object but rather props it permanently open. Is the work of art, when treated only in its signifying capacity with disregard to its material aspect, merely a means toward understanding the social sphere; or is the work of art an end in itself, which the social sphere may encounter as some indigestible kernel of material incongruity? Visual studies offers the possibility of maintaining an analytic balance between the primacy of social "man" and that of material "art," examining the constant and productive tension (productive both for social practice and for aesthetic activity) between these two underlying, governing conceits.

Dematerialization may take other forms than reduction to the sign. Hence the third trajectory of visual studies: it frees the study of visual culture from the limitations imposed by the material object—and does so in two new senses. In the first sense, it can shift the focus of analysis away from things seen toward the process of seeing. Here the ideas of Michel Foucault on the panopticon and Jacques Lacan on the gaze and the screen have proved especially helpful in recasting vision primarily as an issue of identity formation and social interpolation. (Others, including Margaret Olin [chapter 22 in this volume], have explored these methodological developments in much greater depth; I give them only summary treatment here.) Generally, film studies has tended to tackle these issues earlier and with greater

rigor than has art history; accordingly, that discipline has contributed enormously to the analytical tools available to visual studies.

In the second sense, visual studies happily embraces new forms of image production that, increasingly over time, no longer manifest themselves in material form: from photography (which can be treated principally as it materializes itself in the photograph), to film (the study of which has seldom fetishized the celluloid carrier of the image in the way that the study of photography has celebrated the precious print), to television and video (whose names abandon reference to the material carrier), to digitalized computer images (which reside in the material box of the computer but could never be mistaken for the computer itself), to digitalized images transmitted across the World Wide Web and other electronic networks (which cannot, in any meaningful sense, even be located in one material place). The last of these, abetted by hyperbolic claims and excitement circulating throughout the mass media over the past several years, has become a special darling of scholars in visual studies and serves well to exemplify the new discipline's enthusiasm for the disembodied image.

The Web, however, has changed its stripes in the several decades since its inception. What began as an esoteric electronic medium for the ostensibly disinterested transmittal of scientific information among researchers in universities and the national defense apparatus has evolved into a shining new vehicle for the rapid hawking of commodities to potentially just about everybody. Indeed, the further we work our way down the list above of disembodied media, the more the visual image appears caught up in the world of commerce. For some critics of visual studies, the terms "dematerialization" and "commodification" function as virtual synonyms. Mainstream Hollywood movies, the television networks, and now the Web all are tinctured by the making of big money.

And here we get to the crux of the matter, the point at which visual studies may most clearly distinguish itself from earlier forms of cultural analysis in the humanities. In one scenario, the scholar imagines that the world of commodity capitalism exists as a hegemonic behemoth busily striving to transform all concrete things into abstracted market values and any remaining traces of real life or experience into the superficialities of the mass spectacle (as characterized with great effect by Jean Baudrillard). In that case the responsible scholar—operating from either the political left or right, moreover—need search for some material practice, such as art, marginalized by or (even better) operating outside of the hegemony of commerce, which can therefore embody resistance to it. (Many arguments along these lines are really just extensions or permutations of Clement Greenberg's formulation, dating from the late 1930s, of the artistic avant-garde as a safe haven for the preservation of the last remnants of revolutionary consciousness in a reactionary age.) Alternatively, the scholar questions (explicitly or implicitly) the internal coherence and consistency of the capitalist hegemony and considers that meaningful—even progressive—cultural work can be performed from deep inside the machine, operating its devices to incongruent effect. Is it possible, for example, to watch television or surf the Web against the grain? More: could

it be that the multiplicity of manners in which commodified imagery can be appropriated and redeployed by its users is such a decisive characteristic of cultural consumption that it doesn't even make sense to talk about operating "against the grain" (or, for that manner, about hegemonies) because commodities don't possess the power to carry the hegemonic "grain" along as part of their ideological baggage? Scholars who answer both questions in the negative (and subscribe to the first alternative above) will tend to emerge as defenders of the basic tenets of art history and insist on the special preserve and characteristics, such as materiality, of art. Scholars who answer both in the positive (and sympathize with the second alternative) may well find the area of scholarship laid out by visual studies to provide the more accommodating forum for the pursuit of their interests.

This third trajectory of dematerialization qua commodification inflects the first two, globalization and democratization. While art history may strive to study cultures from around the globe, it tends to shy away from cultural artifacts and activities from outside Euro-America that have been tainted by the capitalist markets. Japanists don't tend to analyze the Sanrio menagerie, and Indianists risk professional isolation (at least from art historians) if they study recent movie posters from the subcontinent. The concern seems, at least in part, to be that commodification, as an Occidental (and hegemonic) import, dilutes the cultural specificity—or perhaps the ostensibly pure, unchanging authenticity—of the region. Given the current ubiquity of commodity culture, an obvious consequence of this scholarly tendency is to render art history of the non-Occident as decidedly premodern in emphasis as visual studies appears rooted in the modern. In a similar fashion along the axis of class, much of the cultural activity of the mass audience—watching television and glimpsing billboards, visiting Disneyland and inhabiting the mall—takes place at the very heart of the markets that have triumphed in the commodification of the image. To dismiss the world of the commodity as unworthy of serious cultural analysis or to hand that realm of investigation over to the social scientists while the humanists study objects more pure in their construction is to forsake the study of most of the production and consumption of visual images around the globe and across the social spectrum.

Opening the floodgates to let in the vast sea of commodities, however, threatens visual studies with a peculiar problem: scholarship may become inundated by simply too much stuff to analyze. Not just too much stuff (art history has no shortage of unpublished paintings to uncover and minor artists to resuscitate); too many categories of stuff, too many genres of pictorial production, too many semiautonomous cultural communities trafficking in their own idiosyncratic images. To redirect scholarly analysis toward the formation of hierarchies provides only a partial solution to managing this unlimited abundance, both because it somewhat forces the issue of dematerialization (since one is principally studying dematerialized social categories rather than singular material things) and because it only postpones the moment of choice until one must select which of innumerable hierarchies to study and which specific items are thereby ranked. How then should visual studies, as an emerging discipline, attempt to make sense of this fantastic proliferation? How can a discipline predicated on a

certain inclusiveness go about selecting from within its extensive field those exemplary objects, necessarily limited in number, that will, along with their social orderings, receive scholarly treatment?

These are questions that, much to the detriment of visual studies, have not been adequately addressed by its practitioners. Some tactics—the discipline lacks anything resembling a clear strategy—have emerged. One is to plunge to the deep center of commodity culture (to the extent that that center can be located) to demonstrate the presence even there of cultural complexity and conflicting agendas among actors. Expect a study of the new Las Vegas, perhaps, or of the variegated viewing habits of the habitués of *Friends*. Another is to seek out odd corners of the cultural landscape to locate places where groups on the underprivileged side of various categories of race, class, and gender use visual artifacts to formulate marginalized identities. Judith Butler's much-read essay on the film *Paris Is Burning*, which features "Voguing" in Harlem by impoverished black gays and transsexuals, well exemplifies this approach. Still another is to chose instances where established works of high art interact in interesting ways with visual artifacts of different (from the perspective of art, lower) standing. In essence, this final gambit rides the coattails of art history's already executed, though always evolving, processes for the selection of its objects of study.

These are divergent mandates, and no one object of analysis may succeed in satisfactorily exemplifying all three. Nonetheless, the American flag might serve our purposes. Certainly

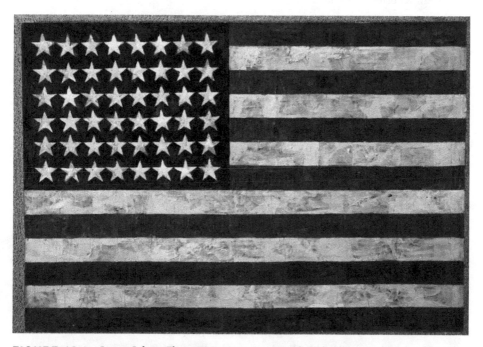

FIGURE 12.1 Jasper Johns, *Flag,* 1954–55. Encaustic, oil, and collage on fabric mounted on plywood, 42 ¼ × 60 ⅝. The Museum of modern Art, New York. "Gift of Philip Johnson in honor of Alfred H. Barr, Jr. Photograph

the bunting and banners of Independence Day circulate abundantly as commodities each early July, and more than one enthusiastic waver of the red, white, and blue would stoutly declare the celebration to be all about the political institutions that allow capitalism to flourish. The ubiquitous use of the flag following September 11 has only multiplied such commercial opportunities. It is a greater stretch (again, especially after September 11) to cast patriotic Americans as a marginalized subculture, yet flag idolatry at its chauvinistic extremes does contribute to the self-definition of subgroups that are feared and despised as much as admired. And the American flag has repeatedly furnished the scenic backdrop for the stage of art, toward which a significant number of paintings and sculptures have made gestures of reference and against which they have struck their poses of difference. Perhaps the most famous of these artworks is Jasper Johns's *Flag* of 1954–55 (Fig. 12-1). With a large debt to the perspicacious writing of Fred Orton on this painting, I will use *Flag* as a means of approaching the nonart objects, those banners of the masses, that it engages—and that engage it.

Johns's *Flag*, as Orton would have it, is a complex object indeed. With its ostensibly simple subject (an American flag) and its patently complex facture (bits of newsprint and other detritus embedded in tinted encaustic), *Flag* over and again confounds any proposition concerning its purport by immediately offering evidence of its opposite. After exploring in rich detail each of the following antinomies, Orton concludes with the following explicitly Derridean set of formulations:

> As an "undecidable" *Flag* ... cannot be securely located within any of the oppositions or antinomies that make it and which are used in its accounting. ... Neither original or unoriginal, it is both original and unoriginal; neither personal nor impersonal, it is both personal and impersonal; neither masculine nor not-masculine, it is both masculine and not-masculine; neither celebration nor criticism, it is both celebration and criticism; ... neither simple-minded nor recondite, it is both simple-minded and recondite; neither patriotic nor unpatriotic, it is both patriotic and unpatriotic; neither ground nor figure, it is both ground and figure; neither collage nor painting, it is both collage and painting; neither texture nor textuality, it is both texture and textuality; neither subject nor surface, it is both subject and surface; ... neither representation nor abstraction, it is both representation and abstraction; neither life nor art, it is both life and art; ... neither sign nor referent, it is both sign and refer-ent; neither flag (standard, colours or ensign) nor painting (or something that is neither painting nor collage but both painting and collage), it is both flag (standard, colours or ensign) and painting (or something which is neither pant-ing nor collage but both painting and collage). Mute and eloquent, opaque and lucid, *Flag* works in the space of difference where it articulates well-rehearsed oppositions and disarticulates them. (Orton 1994, 145–46)

This is, as an account of Johns's singular object, brilliant and deeply satisfying. It is art history of the first order. And consequently it is also visual studies of the first order, to the extent that visual studies gladly accepts within its compass the analysis of that subset of artifacts that go by the name of art. But visual studies might push yet further in exploring the visual artifact, or rather multiply produced artifacts, to which *Flag* makes reference, namely, the Stars and Stripes (Orton's convenient manner of referring to that which in any other context would be referred to as "the flag").

To be sure, Orton does address the nature of that object. Twice, with exemplary thoroughness, Orton launches into the sort of contextual description that might be said to characterize the social history of art. He reports, for instance, that

> it was not until an executive order of President William H. Taft, issued on 24 June 1912, that the design of the flag was laid down as a standard set of relative proportions. Taft's order made available a blueprint plan, obtainable on request from the Navy Department, which could be used to determine the precise location and size of the, by then, forty-eight stars for flags in any of the twelve official sizes whose dimensions were determined by the measure of the hoist, or vertical width, in relation to the fly, or horizontal length, in the ratio of 1:1.9. These specifications were, and still are, regularly ignored; the most common proportions used by manufacturers are not 1:1.9, which is mandatory for flags displayed by Government departments, but either 2:3 or 3:5. (Orton 1994, 90)

Or Orton connects the artist's interest in flags to the social setting of his southern origins: "[Johns] was ... named for Sergeant William Jasper. ... Jasper (1750 –1779), who served in the 2nd South Carolina Infantry under William Moultrie, distinguished himself during the British bombardment of Fort Sullivan, Charleston—known afterwards as Fort Moultrie—on 26 June 1776 by recovering the fort's flag after it had been shot down and, under heavy fire, remounting it" (Orton 1994, 104, 106). Orton, then, does examine the cultural life—"cultural," this time, in the anthropological sense—both public and personal, of the Stars and Stripes.

Yet, like much art-historical analysis that sets its art objects into a context, the context assumes a certain stability that allows it to serve as the foundation for the historical placement of art. Johns's *Flag* may twist and turn against any possibility of historical determination: that is certainly part of Orton's point. Art has that capacity to trope. Art-historical analysis has a tendency to assume that art alone has that tropological capacity—or at least that analysis does not concern itself with the tropes executed within, as opposed to against, the context. We can see this clearly in the one formulation in Orton's list that requires the subordinating device of parentheses: "Neither flag (standard, colours or ensign) nor painting (or something that is neither painting nor collage but both painting and collage), it is both flag (standard, colours or ensign) and painting (or something which is neither panting nor collage but both painting and

collage)." *Flag* as a painting is metadiscursively both "painting and collage," whereas the Stars and Stripes, lacking that metadiscursivity, is simply "standard, colours or ensign."

Orton is surely justified in this stabilization of the external referent: his task is to provide an account of *Flag*, not of the Stars and Stripes, and any tactical simplifications he may make in the description of the Stars and Stripes are legitimate as long as they do not distort his arguments about *Flag*. A practitioner of visual studies, however, might, place different emphasis. He or she might direct the analytical spotlight, usually reserved for the painting, onto the objects that make up its context.

Specifically, a visual studies approach could take Orton's insights about *Flag*'s undecidability and query the Stars and Stripes on similar lines. What after all, does a flag mean? To whom does it belong? Does it appertain to the individual (like *Flag*, read in a certain manner, does to Jasper Johns) or to the collective (as again does *Flag*, read in relation to its historical context)? Consider the simple phrase, which could be voiced by many a patriotic citizen: "It's my flag." In an obvious sense, a flag signifies a nation, and a nation consists of an entity greater than any individual. We might say that the nation exists only to the extent that its citizens are willing to recognize it as the embodiment of a special supraindividual identity—despite its familiarity, quite an abstract notion—that unites a people. For someone to say "It's my flag," then, is actually a rather odd utterance, for it declares singular proprietary interest in a piece of cloth that can only represent a collectivity. The Stars and Stripes is neither singular nor collective, but both singular and collective. It performs, in a masterful ideological stroke, the suspension of that basic contradiction as a truth—a patriotic truth of such compelling force that a significant number of soldiers (including Sergeant Jasper, in a subsequent battle) have willingly died for it. We are now on a stage where the flag, more than simply serving as art's backdrop, becomes an upstage figure active in the formation of ideology—a role for it explored within a French context both by Roland Barthes in *Mythologies* and by Raoul Girardet in Pierre Nora's monumental *Realms of Memory* (both publications, replete with essays that discern complexity in mundane visual artifacts, stand as useful precursors to, or participants in, the work of visual studies).

The flag then is as much an undecidable as is *Flag*. Yet this brief foray into the analysis of what had been the art-historical context for *Flag* and is now a text of visual studies has, in a sense, forced me to let go of the object. I have not been presenting an argument about a single flag, a specific scrap of cloth with a particular date of origin and a history of use and misuse that may register—spots, tears, and so forth—across its surface. I have been discussing flags as a class of things, that great collection of items manufactured and sold over the years at the improper ratio of 2:3 or 3:5. Without the individual object at hand, the analyst can hardly execute the careful and detailed visual analysis (beautifully exemplified by Orton's scrutiny of the minute material idiosyncrasies of *Flag*) that the discipline of art history can rightly claim as one of its proudest achievements. Art history is loath to abandon that commitment to the single object: even Orton, in order to dwell with precision on *Flag*, must play down that fact this singular painting was also a part of a large group of canvases that Johns painted of flags.

Must visual studies forsake the use of this particular tool for the analysis of particularities? (Accusations that visual studies may involve a "de-skilling" of its students may amount to this—although the indictment begs the question of how well traditional programs in art history have actually been in imparting this skill.) Not necessarily. Visual studies can recuperate it by choosing instances where a single specimen from a class of things can be examined in its individual history as a means of illustrating a more generalized social use of that class: the flag salvaged by Sergeant Jasper in 1776, for example, had it survived. Or it may exercise the same degree of visual precision in analyzing characteristics shared by multiply produced items—the composition of a specific frame of a film, say—rather than the idiosyncrasies that distinguish the individual artifact—the visual scratches and aural pops on a given print of that film. Sentimental attachment to a given mode of analysis, in any case, should hardly be allowed to dictate the range of artifacts we select for study. If a certain manner of scholarly looking requires singularity and singularity remains an attribute more closely linked with objects of art than with mass-produced commodities, then to insist on the type of close visual analysis that focuses on individuating particularities would be to leave the discipline fundamentally blind to the social and aesthetic history and function of singularity itself. In an age when tension between unique items and reproducible types plays an integral part in many of our most important ideological struggles, that is no minor loss. Far from a settling of the question of what to analyze and what to analyze it with, visual studies—in recognition of new and newly rediscovered constellations of visual objects in use—proposes that we leave ourselves open to improvisation and surprise.

REFERENCES AND SUGGESTED READINGS

Barthes, Roland. 1972. *Mythologies.* Translated by Annette Lavers. New York: Hill and Wang.

Baudrillard, Jean. 1988. *Jean Baudrillard: Selected Writings.* Edited and translated by Mark Poster. Stanford: Stanford University Press.

The BLOCK Reader in Visual Culture. 1996. London: Routledge.

Bryson, Norman, Michael Ann Holly, and Keith Moxey, eds. 1994. *Visual Culture: Images and Interpretations.* Hanover, N.H.: Wesleyan University Press.

Butler, Judith. 1993. "Gender Is Burning: Questions of Appropriation and Subversion." In *Bodies that Matter: On the Discursive Limits of "Sex."* London: Routledge.

Elkins, James. 1999. *The Domain of Images.* Ithaca: Cornell University Press.

Foucault, Michel. 1977. *Discipline and Punish: The Birth of the Prison.* Translated by Alan Sheridan. New York: Pantheon.

Goodman, Nelson. 1976. *Languages of Art: An Approach to a Theory of Symbols.* 2d ed. Indianapolis: Hackett.

Jenks, Chris, ed. 1995. *Visual Culture*. London: Routledge.

Lacan, Jacques. 1978. *The Four Fundamental Concepts of Psycho-analysis*. Edited by Jacques-Alain Miller, translated by Alan Sheridan. New York: Norton.

Mirzoeff, Nicholas, ed. 1998. *The Visual Culture Reader*. London: Routledge.

Mitchell, W. J. T. 1994. *Picture Theory: Essays on Verbal and Visual Representation*. Chicago: University of Chicago Press.

Nelson, Robert S., ed. 2000. *Visuality before and beyond the Renaissance: Seeing as Others Saw*. New York: Cambridge University Press.

Nora, Pierre, director. 1996–98. *Realms of Memory: The Construction of the French Past*. English version edited by Lawrence D. Kritzman; translated by Arthur Goldhammer. 3 vols. New York: Columbia University Press.

October. 1996. "Visual Culture Questionnaire" (and related articles by Hal Foster and Rosalind Krauss). *October* 77.

Orton, Fred. 1994. *Figuring Jasper Johns*. Cambridge, Mass.: Harvard University Press.

Walker, John A., and Sarah Chaplin. 1997. *Visual Culture: An Introduction*. Manchester: Manchester University Press.

Two Encounters

By Jack Flam

Matisse was far older than Picasso, and a serious and cautious man. He never saw eye-to-eye with the younger painter. As different as the North Pole is from the South Pole, he would say, when talking about the two of them.

— FERNANDE OLIVIER

The Stein family later gave different accounts of it, but they agreed they had trouble deciding whether to buy the picture, a roughly painted, brightly colored portrait of a woman wearing an absurdly large hat (Fig. 13.1). They were intrigued but put off by its sheer, aggressive ugliness. "It was … a thing brilliant and powerful," Leo, who probably first saw it, later recalled, "but the nastiest smear of paint I had ever seen." Gertrude—as was her habit—later claimed to have discovered the picture on her own, but at the time it was her brother Leo who had the better and more adventurous eye. She was a quick study, though, and in the end they decided to buy it precisely because they

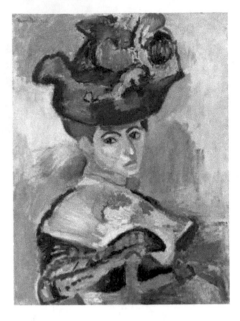

FIGURE 13-1 Matisse, *The Woman with the Hat*, 1905. 80.6 × 59.7 cm.

Henri Matisse, 1905. Copyright in the Public Domain.

found it so disturbing. Its very ugliness made it paradoxically appear to be an important artistic statement.

In the fall of 1905, Gertrude, an aspiring but as yet unpublished writer, who described the picture as "very strange in its colour and in its anatomy," must have been especially struck by the way the richness of the formal language was able to make a rather banal subject seem fresh and new, and by the original way the painting depicted the image of a woman. It was at once something more than a portrait of a specific woman, and yet it was also a portrait, and a raw one at that—very different from the sweet and often sentimental depictions of "femininity" that characterized women's portraits at the time. This was a notion that Gertrude was struggling with in her own writing, and it struck a chord.

Although the painting seemed to be all on the surface, it also laid bare the woman's inner state of mind—and it did so not by a dramatic facial expression or elaborate gestures but because of the way it was painted.

The woman is posed conventionally, seated in an armchair, her head exactly in the center of the canvas. But the viewer is immediately unsettled by the degree to which her face is overwhelmed by everything around it—the fan she holds, the bright orange belt she wears, and especially her enormous and extravagantly decorated hat. And when we finally do focus on her face, we are struck by how determined and yet how vulnerable and sad she looks. She seems to peer out from behind an elaborate network of physical and psychological shields, her masklike face concealing more than it reveals. It is the radical rendering that evokes these contradictions, the dissonance of the colors and the rough way the paint is laid down.

The psychological ambiguity of the picture is intensified by an equally strong sense of physical uncertainty. The rhythmic brushstrokes suggest an overall sense of fragmentation, as if the image we are looking at is on the verge of physical disintegration; or paradoxically, as if we see it in the process of coming into existence. The fluidity of the rendering and the way the forms are set against large areas of blank canvas owe a good deal to Cézanne. So does the subject, which recalls Cézanne's portraits of his wife, of which Leo and Gertrude already owned a first-rate example. But *The Woman with the Hat* took the expressive distortions of

Cézanne considerably further, and its raw aggressiveness was a far cry from Cézanne's austere, almost classical humanism.

In studying this picture by Henri Matisse, an artist at the time unknown to them, the Steins sensed that something new was happening to the art of painting, and to human character. A new and undiscovered territory was opening up—a vast terrain in the Land of the Ugly, in which traditional aesthetic values seemed to be reversed, and in which ugliness seemed to be replacing beauty as the most essential element in art. Or maybe it was that from within the depths of this apparent ugliness, a terrible new beauty was being born. Was that what Matisse was suggesting in *The Woman with the Hat*? Was it possible that the picture the Steins watched crowds come to laugh at, and that critics were deriding as depraved, would within a few years come to be seen as beautiful? Would pictures such as this one, which critics were calling "barbarous and naive" and which were held to reflect a "sick imagination"—would such pictures, which were scorned as the worst things Matisse had painted, come to be considered some of his very best? It seemed that the very nature of aesthetic judgment was changing, and that the idea of looking at the world in a radically new way was much more important than the traditional notion of beauty as a criterion of excellence.

When Matisse exhibited *The Woman with the Hat*, the Salon d'Automne was a newly founded annual exhibition of progressive art, initiated only a couple of years before as a complement to the well-established Salon des Indépendants, which took place in the spring and had no jury. The new autumn Salon was juried, which in principle ensured a greater control of quality. It also featured retrospective exhibitions by major modern masters—in 1905 the works of Ingres and Manet were shown. But the significant event of that autumn Salon turned out to be the paintings by Matisse and his colleagues. People came to laugh and jeer at them, and they became the target of outraged moralists, who called the artists "Incoherents" and "Invertebrates." The wild way a picture like *The Woman with the Hat* was painted seemed more appropriate to savages than to civilized people. Serious, right-minded people associated it with anarchy and the breakdown of social values.

At the time, Matisse, a thoughtful and impecunious thirty-five-year-old father of three children, was as horrified by the public's reaction as the public was by his painting. To add insult to injury, a group of conservative artists sent him a woman hideously "painted with chrome oxide green stripes from forehead to chin," as if to say, here was a model appropriate for his kind of painting. After his first visit to the Salon d'Automne, Matisse decided not to return, and he urged his wife, the subject of the controversial portrait, to stay away completely.

Matisse was therefore somewhat surprised, just a week before the show closed, to hear that an offer had been made for the painting, for which, after a brief negotiation, the Steins paid the respectable asking price of 500 francs. It was through this purchase that Matisse came to know the family of American expatriates who would be his first major patrons: Leo, his sister Gertrude, their brother Michael, and his wife Sarah. Leo was a collector and amateur painter who had studied Renaissance art with Bernard Berenson in Florence and was passionate about the art of Cézanne. He had settled in Paris in 1903, at the rue de Fleurus on the Left

Bank, and Gertrude had joined him there shortly afterward. Michael, the eldest of the three, had stayed in San Francisco to run the family's cable car company. But he, too, came to realize that he had no taste for commerce and followed his siblings to Paris, where he and his wife found an apartment on the nearby rue Madame.

The sale of this painting was an important event for Matisse. It not only brought him an infusion of much-needed cash but also reinforced his confidence in what he was doing and provided an entrée into another corner of Parisian society. Soon Matisse and his wife were invited to Leo and Gertrude's Saturday night salon, where *The Woman with the Hat* held pride of place on their studio wall. Gertrude especially liked Amélie Matisse, a clear-featured, dark-haired woman from the south of France, whom she admired for her practical, matter-of-fact manner and simple strength. In a rush of energy, as if inspired by the hideously painted woman the conservative artists had sent him, Matisse created a second, even more intensely colored portrait of his wife—this time with a bright green stripe running down the center of her face. That painting, in which Amélie Matisse looks as tough as nails and ready to take on the world, was immediately purchased by Michael and Sarah Stein and hung at their apartment on the rue Madame.

The Steins discovered that the man who had produced those wild paintings did not quite look the part of a revolutionary or a madman—or even an artist. Quite the opposite. They found Matisse to be a reflective, medium-size man with a well-trimmed reddish beard and wire spectacles. Although he radiated a strong sense of energy, which suggested inner turmoil, it was held in check by an outward manner of great reserve. The persona he presented to the world was carefully composed. He dressed neatly and spoke with a measure, gravity, and lucidity that reflected his early training as a lawyer. "The professor," his friends called him, affectionately, but with an edge of irony. Though he moved slowly and with deliberation, his blue eyes were quick and alert, penetrating, full of curiosity. But as he stared out through his gold-rimmed spectacles, he seemed always to be holding something back, as if the thick lenses that shielded his myopic eyes were a visible reminder of the psychological distance from which he observed the world around him, as if he were looking out at the world from behind a mask.

According to both Gertrude and Leo, they discovered Picasso shortly after the purchase of *The Woman with the Hat*. But a good deal of evidence suggests that they misremembered the sequence of events and that Leo had bought a painting by Picasso, and had even met him, through the writer Henri-Pierre Roché, in spring 1905. Leo saw the Picasso painting, which had an oddly poetic subject and was rendered with exquisite skill, in Clovis Sagot's gallery in Montmartre and found it compelling, perhaps because of its odd affinities with Renaissance art. It showed a family of traveling performers seated together with their infant child and a monkey (Fig. 13.2). In it the father, dressed as a harlequin, leans toward his wife and gently watches the child that squirms on her lap, while the monkey—apparently part of their circus act, but also clearly a member of the family—watches with intense curiosity and concern.

The Acrobat's Family with a Monkey delicately balances a number of opposing thoughts and feelings. It is at once lyrically tender, almost sentimental, and yet full of wicked irony. The soft colors and delicate rendering create a mood of deep sympathy and compassion, which is reinforced by the way the monkey is made part of the human family: The animal's sympathetic attention, like that of the parents, is concentrated on the robust child who occupies the center of the picture and around whom everything in it revolves. In a surprising touch, we are positioned at the eye level of the monkey, so we see the scene as if through its eyes. Our gaze is led up to the child's face by the mother's hand; and along this same axis, the lines of sight of the father and the monkey meet—the father's glancing down and the ape's staring up. In addition

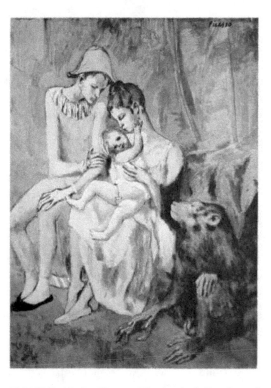

FIGURE 13-2 Picasso, *The Acrobat's Family with a Monkey*, 1905. 104 × 75 cm. Pablo Picasso, 1905. Copyright in the Public Domain.

to the subtle psychological interactions this picture depicts, it is fraught with ironic historical references. The overall composition and the child's pose evoke the theme of the infant Christ in the arms of the Madonna—a reading reinforced by the elaborate contrapposto of his body and the broad sweeping arcs of the rendering, which recall High Renaissance representations of that theme by Leonardo da Vinci and Raphael. This reference in turn suggests a parallel with representations of the Holy Family and St. John the Baptist, who is frequently dressed in an animal skin.

Leo Stein was intrigued by this mixture of tenderness and mockery, by the way a clearly profane scene was charged with sacred overtones that would have been openly blasphemous had they not been depicted with such subtlety, human warmth, and technical mastery. "The ape looked at the child so lovingly," Leo remembered, "that Sagot was sure this scene was derived from life." Leo correctly believed otherwise, and when Picasso later told him that the monkey was pure invention, Leo saw it as "proof that he was more talented as a painter than as a naturalist."

<p style="text-align:center">***</p>

It wasn't until after the purchase of *The Woman with the Hat* that Leo took his sister to see more Picassos. At first Gertrude didn't like what she saw. In fact, she so hated the "monkey-like

feet" in Leo's second Picasso purchase, *Girl with a Basket of Flowers*, that she threw down her knife and fork and refused to eat when he told her he had bought it. Leo himself seems to have been pulled in opposing directions: Whereas the Matisse painting seemed to be on the cutting edge of modernity, the Picassos he was interested in, from the Blue and Rose Periods, were comparatively provincial and still employed the language and sensibility of late-nineteenth-century Symbolism. If Leo later misremembered the sequence of his first purchases of paintings by Matisse and Picasso, it might well have been because he was still uncertain about the direction his collecting was going to take.

Eventually Gertrude came around, and late that year the Steins made their way across Paris to the odd little building on the Butte Montmartre where the twenty-four-year-old Picasso had his studio. The ramshackle building at 13 rue Ravignan was known as the Bateau-Lavoir, named for its resemblance to a dilapidated Seine laundry barge. From the entrance on the rue Ravignan, the building seemed to be a wide, low, single-story shack with a number of angular skylights perched on the roof. But what appeared to be the ground floor from outside was actually the top floor, since the structure was built on a steep hill and extended down to the street behind in a sprawling warren of irregularly shaped rooms inhabited mostly by artists and writers.

To reach Picasso's studio, the Steins had to make their way up and down a rickety wooden staircase into a mazelike space full of intersecting corridors. The walls were damp, the dark hallways stank of mildew and cat, and a single fountain in the stairwell provided the only source of water for the whole building. The building's many skylights, which made it unbearably hot in the summer, also invited the cold of winter, so that a bowl of soup or coffee left overnight would be frozen in the morning. Picasso's studio was at the end of a long corridor on either the top or the ground floor, depending on whether the visitor counted from the street out back or from the rue Ravignan.

The studio was a medium-size room with dingy walls and massive exposed beams. Apart from an iron stove, it was sparsely furnished: a wooden paint box, a small round table in a vaguely Second-Empire style that had obviously been picked up at a junk shop, a couple of chairs, and a sagging sofa that served as a bed. At the far end of the room was a small alcove with a mattress, which intimate friends referred to as "the maid's bedroom." There was no gas or electricity in the building, and a small oil lamp stood on the table. Picasso preferred to paint at night, and he used the lamplight to work by or to show his canvases to visitors such as the Steins. At times when he could not afford oil for the lamp, he painted with a candle in his left hand, squatting over his canvas. Although the room had little furniture, it looked quite full. The artist seemed never to have thrown anything away, and the floor was littered with paints, brushes, rags, an array of jars and bottles, and a vast assortment of junk.

The Steins could hardly have imagined a place more different from their comfortable, tastefully furnished apartment, full of Renaissance furniture, Chinese sculptures, and Japanese prints—or, for that matter, from Matisse's modest but brightly lit and orderly apartment on the quai Saint-Michel, overlooking the river and Notre-Dame. There, "every chair,

every material or object showed a personal touch and most careful selection." In Matisse's immaculate studio, there was "a place for everything and everything in its place," as Leo remarked, "both within his head and without."

Picasso, by contrast, seemed to revel in a calculated disorder—both around him and within him. Even physically, he was the opposite of Matisse: short, with a compact but virile body, given to quick movements, dressed in workman's clothes. Though not especially handsome in any ordinary sense, he was striking to look at—and to be looked at by. His large dark eyes had a riveting, magnetic stare—they fixed you with their unnaturally large pupils, which were always dilated as if he were staring not quite at you but into you, or through you, or beyond you. "When Picasso had looked at a drawing or a print," Leo recalled, "I was surprised that anything was left on the paper, so absorbing was his gaze." He had enormous presence and what the Steins understood to be a Spanish way of interacting with the world. His regard was bold, aggressive, sexual—a striking example of what the Spanish call *mirada fuerte*, or "strong gazing." In Andalusia, where Picasso grew up, it has been said that the eye "is akin to a sexual organ ... looking too intently at a woman is akin to ocular rape."

If the Steins were surprised to find that Picasso was smaller than they had expected, it was in some measure because the woman he was with, a full-hipped, heavy-lidded beauty, was nearly a head taller than he—"a large, placid woman, with a beautiful complexion and great almond eyes, sleepily sensual. ... She was remarkably idle, and she ... would lie in bed watching Picasso do whatever housework was done." This was Fernande Olivier, whom Picasso's friends called "La Belle Fernande." She had only recently moved in with him, but he had been in love with her for more than a year, from the time the previous summer when he first saw her returning to the building from the small square in front of it and playfully tried to block her way. Picasso was so smitten that shortly after their first meeting he had done a drawing of her, which he used as the center of a mock-serious altar fashioned as a kind of ex-voto of his cult of devotion to her, in which the portrait was mounted in a frame covered with blue cloth taken from one of her chemises and set up between two bright blue vases filled with artificial flowers.

The two appear to have had a brief affair at this time, and not long afterward he did a watercolor of himself watching her sleep. It was then that the predominant tonality of his pictures shifted from blue to dull pink, the beginning of the so-called Rose Period, and that his subject matter shifted from the crippled and the abject poor to amorous couples and traveling performers, as in the picture the Steins had just acquired. Fernande had at first resisted getting involved with him. She had not found him particularly attractive, despite his remarkable eyes and his rather dainty hands and feet, and he was too poor, too inarticulate, too Spanish. She worked as an artist's model and had endured many difficult times with men, starting with the middle-aged man who had raped her when she was only seventeen and who, after having been forced to marry her, submitted her to repeated brutality and sexual degradations. On leaving that monstrous relationship, she had been caught up in one unhappy love affair after

another. She wanted to do better, but eventually circumstances and Picasso's persistent ardor had worn her down.

Picasso and Gertrude Stein felt an immediate bond. In part it was a kind of chemical, almost sexual attraction. She appealed to him as a woman who had a powerful physical presence but who at the same time was de-eroticized by her masculine bearing and her homosexuality. It was therefore possible for Picasso to consider her as intensely feminine and at the same time paradoxically possessed of what to him were the masculine virtues of independence, intelligence, and artistic ambition—qualities that were in direct opposition to the more traditional femininity of Fernande, whom Stein herself characterized as being concerned with little else than perfume and hats. Whereas Matisse appeared eminently respectable and resembled a doctor—or, even worse, a college professor, such as those she had vainly attempted to study medicine with back at Johns Hopkins—Gertrude found in Picasso a true bohemian, like the acrobats and actors he hung around with and depicted in his works. He was a kind of rebel who lived on the fringes of society and who seemed to make his own laws.

Picasso, moreover, was surrounded by interesting types, in contrast to Matisse whose daily life was centered on his family. Picasso lived in a veritable artists colony. The poets Max Jacob and André Salmon lived at the Bateau-Lavoir, and during the five years Picasso resided there, its inhabitants included such notables as the composers Edgar Varèse and Erik Satie; the painters Kees Van Dongen, André Derain, Maurice Vlaminck, Georges Braque, Juan Gris, and Amadeo Modigliani; the mathematician Maurice Princet, one of the early theorists of fourth-dimensional geometry; and writers such as Pierre MacOrlan and Maurice Raynal. Unlike Matisse, who was essentially a loner, Picasso was firmly entrenched within a milieu: first one of fellow Spaniards, then of French artists and writers, later of prominent artists and public figures in all fields. He was like a magnet that drew people to him, whereas Matisse, for all his surface sociability, never fully participated in a group.

The friendship between Picasso and Gertrude was no doubt given further impetus by their outsider status within French society. Gertrude's French was only marginally better than his, and she spoke it with a manner and accent that were in their own way as awkward and abominable as his own. Although he would spend the rest of his life in France, Picasso never mastered the language, and during those early years he was especially self-conscious about how bad his French was. When the Steins brought Matisse and Picasso together for the first time, Picasso was intensely aware of how much more articulate the older painter was. Matisse "had an astonishing lucidity of mind," Fernande Olivier remembered, "precise, concise and intelligent," and he was masterful in his ability to "argue, assert and endeavor to persuade." On the occasion of a Manet and Redon exhibition at the Durand-Ruel gallery, Matisse, who was friendly with Redon, told Leo that he thought Redon was even better than Manet, and that he had said so to Picasso, who had agreed with him. When Leo Stein later expressed his astonishment about this to Picasso, he replied with exasperation, "Of course I agreed with

him. Matisse talks and talks. I can't talk, so I just said *oui oui oui*. But it's damned nonsense all the same."

In fact, Picasso had a complex relationship to language generally. He was born in Malaga, but his family moved to Corunna (Le Coruña), on the northwestern coast of Spain, when he was only nine. In Corunna, his Andalusian accent would have been quite conspicuous, and the local people used the Galician dialect as well as Castilian. Four years later, his family moved to Barcelona, where Catalan was widely spoken, especially in the *catalaniste* circles he frequented. Two years after that, Picasso went to study in Castilian-speaking Madrid, and it was not until the summer of 1898, when he went to the mountain village of Horta de Ebro with his friend Manuel Pallarès, that he became comfortable speaking in Catalan.

When he first visited Paris in October 1900, Picasso's French was virtually nonexistent, and his circle of friends included primarily Spaniards. When he returned to Paris the following year, his French was still so poor that he and his new friend, the poet Max Jacob, had to communicate largely with gestures. Throughout his life, Picasso continued to speak French with a marked Spanish accent and to employ an idiosyncratic form of spelling, no matter which language he was writing. Some idea of how his speech, and his views about women, appeared to the French can be had from reading Guillaume Apollinaire's novel *La Femme assise*, in which the madly jealous Picasso-like painter Pablo Canouris implores his mistress, "*Elbirre, écoute-moi oubbre-moi jé te aime, jé te adore et si tu né m'obéis pas, jé té touerrai avec mon rébolber*" (Elbira, listen to me, obben the door, I lova you, I adora you and eef you do not obey me, I will sheeoot you wif my rebolber). Earlier in the book, Canouris remarks, "*Pour aboir braiment une femme, il faut l'aboire enlébée, l'enfermer à clef et l'occouper tout lé temps*" (To breally hab a woman, you have to kidnab her, lock her ub and take care ob her all de time).

During most of his formative years, Picasso used language as an outsider. Thus, even before he arrived in Paris, he was already a "vertical invader"—a maverick who was able to occupy a place at the center through the sheer magnetism of his personality. (In Montmartre, his French artist and writer friends came to be known as members of *la bande à Picasso*. In the Spanish manner, he made himself the center of a *tertulia*, or circle of cronies.) Picasso's sense of dislocation and his fluid relationship to language must have given him an extremely strong sense of the arbitrariness of all systems of communication, including visual ones, and was no doubt a contributing factor to his extraordinary freedom from self-censorship—in his speech, his actions, and his art.

The Steins' interest in Picasso complicated Matisse's relationship with them. Although Matisse was twelve years older than Picasso and better established, he had little time to savor his newfound patronage before paintings by his young rival began to appear on the walls next to his own. This was the beginning of a pattern that would persist well into the future: Each time Matisse seemed on the verge of carrying the day, Picasso would somehow arrive on the scene and sour the situation, sometimes giving it a distinctly bitter edge (and at each turn, Picasso would greatly profit from what he in turn was able to take from Matisse). In a

typical gesture, shortly after Picasso met the Steins, he underscored his feeling of sympathy for Gertrude—and got one up on Matisse—by asking her to sit for a portrait. This was a turning point in the relationship between the Steins and Picasso and in the relationship between Picasso and Matisse.

<div align="center">***</div>

At the time they were taken up by the Steins, Matisse and Picasso had not yet met, and they had only a passing acquaintance with each other's work. Though their paintings had sometimes been handled by the same dealers, there was no particular reason for either to have paid much attention to the other's works before the Steins started to collect them. Picasso's work was not well known, and for all its poetical verve and precocious technique, it was considerably less advanced than that of Matisse and would not have impressed him much. Matisse's paintings were better known, since the older artist had been exhibiting at the progressive Salons for the past few years, and his work was regularly mentioned in newspaper reviews. But Picasso, who refused to exhibit at the Salons, evidently did not go out of his way to see the Salons, either. In any event, most of the works that Matisse had previously exhibited were still lifes and landscapes—neither of which would have held much interest for Picasso.

Picasso's first significant exposure to Matisse's work seems to have been at the same 1905 Salon d'Automne where Matisse was discovered by the Steins—and where by coincidence Picasso's Catalan friend Ramon Pichot, who painted with a colorful palette, had a picture hanging in the same room as paintings by Matisse. These were the works in which Matisse was beginning to come into his first real maturity and to assert his originality—the brightly colored and freely brushed works that would be called Fauve. Matisse showed eight oil paintings at that Salon, mostly landscapes and figures in landscapes. All were boldly painted, but Picasso's attention would naturally have been drawn to *The Woman with the Hat*. His own painting at the time was centered on the human figure, and it was in *The Woman with the Hat*, with its emphasis on the portrait, that Matisse's audaciousness was most readily apparent. After all, if an artist colors a tree bright red, or moves a house or an outcropping of rocks a couple of yards, few will take him to task for it. But if he moves someone's nose a couple of centimeters, or colors it vivid green, there will be hell to pay. This was a lesson Matisse learned at the 1905 Salon d'Automne, where it was *The Woman with the Hat* rather than his figures in landscapes that set people's teeth on edge, and which was prominently reproduced in the popular weekly *L'Illustration*. Gertrude Stein was not far off the mark when she wrote, "if you do not solve your painting problem in painting human beings you do not solve it at all." In advanced French painting at the beginning of the century, the ultimate painting problem would focus on ways in which the human figure could be represented in a subjective, sometimes nearly abstract way and still have its human content be convincing.

The Woman with the Hat must have been like a slap in the face to Picasso. All his life he had been something of a boy wonder, and by the fall of 1905 he was getting enough notice to reinforce his convictions about the rarity and importance of his own talent. So far as he could tell, there was no real competition around. But seeing Matisse's work brought him up

short; it made clear that whatever virtues his own Symbolist-inspired work might have, it was distinctly provincial-looking and more than a bit old-fashioned. The Manet and Cézanne paintings that he saw at that same Salon d'Automne would have driven home the point even more. Matisse had been struggling for the past several years with the enormous implications of Cézanne's late paintings—such as their fragmentation, lack of finish, and overtly metaphysical ambition. Picasso had seen Cézanne's paintings at Vollard's gallery as early as 1901, but he had first been attracted to the violent—and often misogynistic—imagery of Cézanne's early work, as is evident in Picasso's drawing of a man strangling a woman, which appears to be based on Cézanne's *The Strangled Woman*. Picasso had only recently begun to look seriously at Cézanne's formal innovations, and he still had found no way to make meaningful use of them in his own work. Though he had a number of friends among French writers, his artistic milieu was based in the villagelike atmosphere of Montmartre and was still primarily Spanish.

When Picasso's paintings began to appear at the rue de Fleurus, Matisse could not have found them especially threatening from an artistic viewpoint. The Steins' expressed fondness for the young Spaniard, however, and the hold he seemed to have on Gertrude's loyalty during the winter he began to work on her portrait were another matter. These developments put Matisse in an awkward position. He was older and better-established than Picasso, and he was on his home turf. For a thirty-six-year-old artist to acknowledge that he was engaged in open competition with a twenty-five-year-old upstart would be demeaning—especially since Picasso's bohemian nonchalance seemed so unworldly. Yet as Matisse must have understood, Picasso began immediately to occupy as much terrain as he could, effectively ingratiating himself with the Steins. He had proposed doing the portrait of Gertrude right after his first dinner with them, and it turned into an arduous project for which she would sit some ninety times. A few months later, while he was still working on the large oil portrait of Gertrude, Picasso used his fluent technical facility to good advantage by doing a small, frontal portrait of Leo, his face lyrically rapt in a flattering mix of critical appraisal and aesthetic reverie. Around the same time, in order to please the Steins of the rue Madame, Picasso also did a handsome profile portrait of Michael and Sarah's son Allan. In this way Picasso was shrewdly able to accommodate virtually the whole family while still reserving pride of place for Gertrude, whose portrait was the largest, and done in oil on canvas rather than in gouache on cardboard as were the other two. In later life, Picasso was famous for his skill in playing people off against each other; clearly this was a gift that he had from the beginning.

Matisse, moreover, was not an artist to whom things came easily, and casual commissions such as the portraits of Leo and Allan Stein would have been virtually impossible for him to take on. He did not have the same fluency with the brush that Picasso had, and everything he worked on was a struggle. "All his pictures," as Leo noticed, "were to give him a lot of trouble. … He worked endlessly on his pictures, and wouldn't let them go till they were finished." To a large degree, this was because Matisse thought with his brush, and in a sense discovered his pictures in the act of painting them. Picasso, by contrast, always had a strong narrative gift, and his brush generally followed his preconceived idea of what the picture would look like.

It would be difficult to think of two gifted men whose temperaments and strengths were more different. It was only natural that from the moment the Steins first began to collect their work, the two artists would see themselves as rivals.

Contemporaneity Between Modernity and Post-Modernity

By Antonio Negri

C ontemporaneity: what does it mean to be "contemporary" between modernity and postmodernity? For me, the definition of "contemporaneity" raises problems. Perhaps I will be somewhat polemical in pursuing this question, but it will be worth the effort.

Looking back at the cultural history of recent years, we see that (generally speaking) we have been steeped in the construction of a concept—and an experience—of postmodernity that wished to remain in the direct lineage of modernity. Postmodernity was, in fact, constructed as exasperation with modernity and the sublimation of its qualities. The Frankfurt school was, from this point of view, the source of the gravest misunderstandings and mystifications about the linear, "hypermodern," and sometimes catastrophic configuration of modernity. The school derived this sense and destiny from the pessimistic, often desperate, and always critical perspectives of a certain brand of Marxism typical of the 1920s. These conceptions, which could all be assigned to a common critical matrix, led to the construction of a "hypermodernity" rather than to a realistic vision of the coming into being of postmodernity and of the "radical break" that it implies.

Antonio Negri, "Contemporaneity Between Modernity and Postmodernity," Antinomies of Art and Culture: Modernity, Postmodernity, Contemporaneity, trans. Giuseppina Mecchia, ed. Terry Smith, Okwui Enwezor, and Nancy Condee, pp. 23-29. Copyright © 2008 by Duke University Press. Reprinted with permission.

As often happened in various Marxist heresies, the concept of "trend" was used in a teleological sense, as if it alluded to a necessity. Yet already in Marx, the concept of trend denotes the contrary: a break, a scission, a discontinuity. A trend is not dialectical; it is not reconciliatory in character. It implies the objective contradictions of development, and these contradictions recompose and intersect the subjective mechanisms of class struggle through a complex play of transformations in the material conditions of consciousness.

This line of thought is paradoxical and tragic: it has determined a situation in which critical-catastrophic traditions (from Lukacs to Adorno, passing through Benjamin) and critical-reactionary traditions defining capitalist development and the imperialist state (from Max Weber to Carl Schmitt) ended up coinciding. At that point, Heidegger's synthesis found itself right at home.

Postmodernity, in contrast, when it is defined as the real subsumption of society into Capital, reveals that this subsumption is not linear with respect to modernity, but antagonistic in nature. Not only is it antagonistic with respect to modernity, it is also contradictory in itself. Contemporaneity (as you define it)[1] is situated in postmodernity, when postmodernity is understood as a field of forces that are not only new and orbiting the global circuit, but are also innovative and antagonistic. To be contemporary one has to confront the end of the 1900s, the historical upheavals that characterized it, and the counterreformation happening today (if the comparison were not too flattering, one could talk about Bush as another, "hypermodern" Cardinal Bellarmino). Being contemporary will, then, mean defining postmodernity as a break with modernity and as a field in which antagonism is expressed in the most radical way.

In the most recent debates, and in particular in the field of cultural studies and in the discussions taking place in the so-called underdeveloped countries, the categories of modernity have become associated with and opposed to anti-modernity. Similarly, modernity, in its constitution and in the forward movement that it implies, has been accompanied by a linear and rigid definition: the capitalist or the socialist model of development (we should never forget that socialism always had the skeleton of capitalism in its closet) triumphed in it.

But could "another" modernity exist? Another modernity, one that did not want to be, or better, did not want to construct itself either as a return to archaic forms of accumulation or as a reproduction of static (Eurocentric and Western) definitions of value, but that would determine alternative modes of development and a different material organization in the existing social and political forms? Another modernity, one that would not appeal to paradigmatic and utopian "use values" but would raise the question of acting differently and of transforming the world—starting from productive dimensions and established ways of creating commodities in our society? Debate about this possibility was extremely lively in some of the great developing countries (China, India, Latin America); nonetheless, the weight of a rigid postmodernity, fixated on Eurocentric or Western models of continuity with modernity, has neutralized all efforts to build something "other." More important, it also prevented the finding, within the process of development itself, of nondetermined alternatives

that would not be fallaciously considered necessary or constraining but that could be free, inventive, original.

The idea of another modernity arose in the debate that took place in China between the end of the Cultural Revolution in 1976 and the massacre at Tienanmen Square in 1989. On that square the demonstrators were not the defenders of the West, but people who were looking to another, original way toward development within and beyond underdevelopment.

We need to remember that a similar debate developed during the classical period, during the birth of modernity. The field of antagonism identified at that time was one on which the ontological power of the multitude was being expressed. Against the capitalistic seizing of power, an instance of liberation was posited. Both Hobbes and Spinoza commented, from different viewpoints, on these antagonistic tendencies. Alternatives of this type are often found within the debates and struggles typical of developing societies. Today, we will not find a balance, or a new hope, unless we break the teleology of modernity, that is, the command imposed by Hobbes and capitalistic transcendentalism.

When we insist, today, on the concept of "contemporaneity," I am not certain that we simply want to summarize, to find an abbreviation, a logo for the break with the teleological paradigm of modernity. If we do want to take this shortcut, I welcome the theories of "contemporaneity," but they will have to assume as their foundation that the break with the paradigm of modernity, the opening toward a spectrum of new possibilities, is based on a new potential of resistance and difference.

When we talk of contemporaneity, therefore, we have to consider it as the field of antagonism. But why is this antagonism powerful? We need to stress, first of all, that this antagonism has nothing to do with the one formerly described in modernity, because it is rooted in a new social, economical, and political context: the context of biopolitics. When we say "biopolitics," on the one hand we mean that capitalist power has invested in the entirety of social relations, but at the same time we also consider this context as a historical reality inhabited by new subjects and new political and social configurations. Empire is a biopolitical reality; it is not simply a new capitalist organization of work. It is the ensemble of forces that traverse this reality and that express the power of life.

We cannot fully assume contemporaneity if we fail to thematize it within the passage from modernity to postmodernity, within the simultaneous passage from modern to postmodern biopolitics, between the invasion and the colonization of existence by power and the antagonistic dimension of the powerful contradictions present in the biopolitical context.

This configuration implies certain consequences.

(1) We can define the biopolitical context as the place where labor antagonisms have become social. When we say "social," we mean that the paradigm of work, or better yet of productive activities, pervades the whole society while becoming immaterial and cooperative. Today, the capitalist invasion of society, its subsumption by capital, is accompanied and contradicted by the transformation of the paradigm of work. Modern biopolitics were disciplinary; postmodern biopolitics are founded on control. Our deconstruction of modernity,

therefore, revisits the material conditions of the totality of existence during the modern period in order to show contemporaneity as being the context for new contradictions.

If the social composition of contemporaneity has nothing to do, anymore, with social constitution within modernity, it is because innovative transformation is actually happening in the field of labor. We are talking about the passage from the mass worker to the social worker and from material to cognitive labor, as well as the transformation of the construction of value, which is no longer a measure of the time of production, but is, rather, the innovative construction of new mediations for the value of work. Here, the new technologies (new technological environments and new machines) are closely interwoven into a new social composition. The jump is decisive. As I noted before, understanding the present in terms of postmodern contemporaneity requires us to posit a new periodization in historical development. The change in the nature of work and of technology implies an anthropological mutation. Still—and this is the true meaning of a new historical periodization—these processes are not purely technical, nor are they simply anthropological (if anthropology is predicated on the individual); they are "social passages" tying the transformation of humanity to the facts of social cooperation. Work becomes linguistic in its very expression; it is cooperative, not simply because it includes cooperation but because it expresses it, determining cooperative innovations and producing a continuous excess of signification.

(2) In the philosophy of postmodernity we have witnessed a long and laborious philosophical effort that has tried to grasp the events that have ruptured the continuity and the teleology of modernity. It might be useful to remember three great lines of development.

The first was initiated by French philosophers of postmodernity when they insisted on the complete circularity of the processes that produced both commodities and subjectivity. So-called weak thought, aesthetic conceptions of life, and Marxist heresies about a production fully dominated by capital and therefore immeasurable and out of control, on its way to catastrophe—all of this did in fact reconfigure the field of analysis. At the same time, however, it also neutralized it. Between Lyotard and Baudrillard, it would be difficult to decide who was less responsible for this.

A second group tried to find, through the deconstruction of this context (precisely because they recognized it as being neutralized and insignificant), a point of rupture: a "marginal" point of true rupture that would allude to another form of existence or at least to a capacity to renew its meaning. From Derrida to Agamben, this line of thought developed its potential with force and intelligence. But the point of rupture remained and still remains marginal; the field and the horizon where this attempt at reversal takes place are extreme and become hardly viable. They are both frail and vulnerable to extremist tendencies. Critical theory here trumps practical reconstruction: the problem is recognized; the solution escapes our grasp.

The third line of development finds its inspiration in Foucault and Deleuze: it locates the powerful production of subjectivity at the center of the constitution of the real, rooted in a resistance to the insignificant self-enclosure of the world created by the production of

commodities. This conquest of a creative ontological space (also called a space of differ-ence) is crucial: this difference, this resistance, this production of subjectivity located in the center of the metropolis, in the center of cultures, in the center of intellectual and affective exchanges, in the center of linguistic and communicative networks, this center that is every-where—well, it is from here that an ontological alternative can be given. Not a desperate, but a constructive, one.

(3) When we implant ourselves in the biopolitical field, work becomes a social activity and vice versa. Social activity participates in the General Intellect. But the General Intellect, in a biopolitical context, is also Eros: this means, obviously, that our anthropological becoming, in contemporaneity, is a process of singularization that is pragmatic and intellectual, affec-tive and corporeal. The production of subjectivity accompanies an affective and a corporeal singularization. When we say "general intellect" we therefore indicate that ensemble of rela-tional, ethical, and affective activities that were once called "eros." I will give you an example: the processes of artistic innovation from Cézanne to Beuys can indicate the direction taken by the reconstruction of this ontological concretion, consisting of matter and spirit. Spinoza described this kind of process as a synthesis of complexity and ingenuity. Between material and immaterial labor, between the production of commodities and the production of ser-vices, the workforce infuses the totality of the life experience and apprehends itself as a social activity. Living labor, and therefore the production of value, presents itself as at once an excess and a by-product.

(4) Capital and state control of technological development, reacting against the struggles and the resistance of workers and citizens (of the worker-citizens), operates essentially through the attempt to reappropriate social cooperation, and therefore through the dissolu-tion of the commonality of life, through the colonization of affects and passions, through the commodification and the continual reduction to financial entities of the places of resistance and antagonistic cooperation. Nonetheless, the existence of apparatuses of resistance is becoming increasingly evident. Today, the expression of "living labor" is directly the "produc-tion of a residue": this expression is, therefore, in the anthropological terrain, a production of subjectivity, and, in the political terrain, a production of democracy.

I come now to my conclusion. We cannot get rid of the category of postmodernity: in fact, this category allowed us to identify—beyond the conceptions that envisioned postmoder-nity as a pure and simple description of the capitalist invasion of life—a field of struggle, of antagonism, of power. Postmodernity gave us the possibility of imagining contemporaneity as the place of the production of subjectivity. It made us discover, in the totality of subsump-tion, the permanence of antagonism. It made us imagine an ethical power that would be entirely immanent.

It is, therefore, the concept of multitude that brings us back to contemporaneity. Today, when we talk about multitude, we sometimes find ourselves in an ambiguous position: we define it as a multiplicity of singularities, but this reality of the multitude is fully inserted in the antagonistic context of postmodernity. We affirm, in fact, that the multitude is capable

of a reconfiguration of the sensible; we also affirm that the figure of imagination is capable of innovation and that, vice versa, innovation is capable of constituting a context capable of imagination.

On the other hand, the multitude appears to us within a catastrophic picture. Nothing is less terroristic than this affirmation—we should not be afraid of it; but nothing is less messianic either. We only want to emphasize that the emptying of meaning typical of capitalist development finds as an alternative (as an alternative to catastrophe) the power of the multitude. This is why, today, the multitude appears as the figure of a possible recomposition of the sensible, within the catastrophe of contemporaneity. The multitude appears as a liminal figure between biopower and biopolitics, or, better, between *pouvoir* and *puissance*. Could we, at this point, reformulate an old figure of the antagonism, as did those seventeenth-century English thinkers who distinguished between power[2] and multitude?

I would define contemporaneity in Spinozist terms: as the path that unfolds between the natural *conatus* toward cooperation, and the *amor* that constructs the sensible dimensions of social, institutional, and democratic process; as the cooperative opening of living labor and of every movement of renewal. Contemporaneity has to be reconsidered within the antinomies of postmodernity, that is, it has to be seen in relation to the new figure of the contradiction between capital and labor, between power and life, which appears in postmodernity. To live in postmodernity not as utopia but as "dis-utopia" (as the pragmatic tension that crosses real contradictions; that is capable of traversing its contradictory content without bypassing it, without dreaming of its beyond, but transforming the existing state of affairs) can be understood as the struggle to reclaim the meaning of contemporaneity. This dis-utopia is the contemporary apparatus operated by the collective will to resolve (in a revolutionary manner) the contradictions of postmodernity and to have done, once for all, with capitalists and bosses. In Spinozist terms, I want to say, this means that contemporaneity is the only way to express the eternal will to resistance and freedom.

NOTES

1. This refers to the concept of contemporaneity advanced at "Modernity ≠ Contemporaneity: Antinomies of Art and Culture after the Twentieth Century" by the symposium conveners and elaborated in the introduction to this volume.
2. In the original Italian essay, the word "power" appears in English.

The Art of Kara Walker

By Gwendolyn DuBois Shaw

I n the spring of 1997 I visited Kara Walker's exhibition "Upon My Many Masters" at the San Francisco Museum of Modern Art (SFMOMA). One of the works I saw that day was a physically imposing installation titled *The End of Uncle Tom and the Grand Allegorical Tableau of Eva in Heaven* (Fig. 15.1). It was a huge piece that spread across the gallery walls, like a shadow drama being played out by actors hidden behind a scrim of white fabric. Each of the work's many characters was presented in formally elegant profiles that froze the motions of their wildly gesticulating bodies in erotic, satiric, and violent poses that were both attractive and repulsive. Many of my fellow gallery visitors stood before the piece, jaws slack and eyes wide, staring in puzzled disbelief at what they were seeing, or at least at what they thought they were seeing. I, too, was stunned by the graphic nature of the piece, its violence and its hard-core sexual content, the way that it seemed to attack the clichés and stereotypes about plantation life that have become a part of the popular understanding of the past. It was a moment of communal visuality in which the act of viewing within the space of the gallery became a spectacular spectacle, a cyclical scopic activity in which museum patrons watched other museum patrons watching them back. The phenomenological effect of the installation, its very "thingness,"

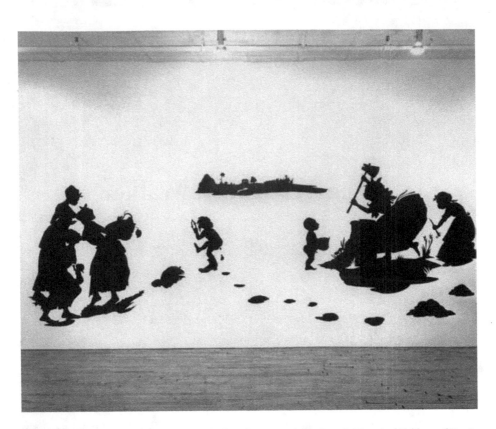

FIGURE 15-1 Kara Walker, *The End of Uncle Tom and the Grand Allegorical Tableau of Eva in Heaven*, 1995. Private Collection. Cut paper and adhesive on wall, 15 × 35 ft. (dimensions variable). Photo courtesy of Brent Sikkema Gallery, New York City.

following Martin Heidegger's 1936 essay "The Origin of the Work of Art," was like a physical blow to the observer; it rendered many viewers temporarily disoriented and speechless.

The experience of the power of the spectacle that Walker's silhouettes had created was profoundly exciting to me, but I was even more intrigued by the sophisticated references that the work made to antebellum history and to nineteenth-century American visual culture. This "Grand Allegorical Tableau," with its axe-wielding Little Eva, spike-brandishing Topsy, and eviscerated Uncle Tom praying for deliverance, evoked for me the restaging of an apocryphal episode from Harriet Beecher Stowe's 1852 sentimental novel, *Uncle Tom's Cabin*.[1] But I also saw piles of excrement, children being sexually assaulted, and babies being murdered, elements that didn't fit in with my memory of the book. Were these elegant black silhouettes actually doing the horrible and ghastly things that I imagined, or was I projecting my own nasty thoughts onto them? Like many of the other spectators around me that day, I, too, was confounded by the uncanny drama in which these life-size, cut-paper figures required me to participate. I was both bewildered and elated by the exciting, yet largely incomprehensible narrative of graphic violence and sexual depravity that spread before me in a great gothic panorama.

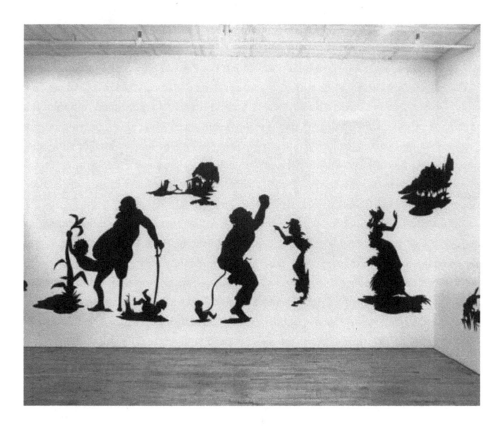

When I first viewed *The End of Uncle Tom* and the other artworks assembled in "Upon My Many Masters" I knew only a little of the controversy that preceded Walker's work to San Francisco. I had read about how her ideologically provocative art had drawn both vociferous critical condemnation from some senior African American artists and six-figure bids from many eager European American collectors. After my visit to the show, I read everything I could find on her work, which at the time was limited to a few newspaper and art magazine articles. I made repeated trips to the museum and had many heated, critical discussions with friends and colleagues. I attended receptions for Walker, the lectures and the gallery walkthroughs that she gave at sfmoma, and I even managed to talk John Weber, the museum's curator of education, into inviting me to lunch with her. Through this preliminary research, I started to see that there was something phenomenal going on in her images, something that was being overlooked by the various reactions of the so-called African American community and the mainstream art world.

Soon, *The End of Uncle Tom and the Grand Allegorical Tableau of Eva in Heaven* began to reveal itself as more than just a provocative artwork that used antebellum imagery. In it I saw that Walker was engaged in an artistic process of racialized signification. In her visual revision

of Stowe's written text the artist was signifying on the predictable horrors of historicized, fictionalized, and mythologized slavery in a uniquely African American way.[2] As the literary historian Henry Louis Gates Jr. has theorized about the slave narrative in his germinal book *The Signifying Monkey: A Theory of Afro-American Literary Criticism,* Walker was making "the white written text speak with a black voice, [which] is the initial mode of inscription of the metaphor of the double-voiced."[3] I became convinced that Walker was signifying on the predictable myths of antebellum plantation life using a combination of nostalgic silhouette imagery and a bold display of wildly corrupted social mores. She was skewering the mythologies of iconic texts like Margaret Mitchell's *Gone With the Wind* and historically remote documents like *Uncle Tom's Cabin,* so familiar to contemporary audiences.[4]

These revelations about the signifying power of Walker's art raised important questions about her historical influences and about her conceptual intentions. What was the nature of the antique silhouette format that gave it such an uncanny ability to express current American cultural and racial ideologies? What motivated a young African American woman artist to create a fantastically horrific narrative out of racial stereotypes, nostalgic themes, and historical mythology? Over the course of the next few years, the magnetic power of this artist's nostalgic postmodernism, her trenchant visual wit and fondness for allegorical obfuscation, and her ability to show what so many of her critics were unable to say fascinated me. I wanted to understand better how she could tap both the latent and the virulent racist icons of the visual and textual past in order to make her audience "see the unspeakable."

At first, my project was one of excavation. It was a search for sources and signs, for signifiers and silhouette history. I wanted to better understand Walker's place within the current artistic discourses on race, as well as her relationship to the nineteenth- and twentieth-century ideologies that her project so often critiqued. I came to understand the constant self-referentiality of Walker's work, her various personae, which included the "nigger wench" and the recurrent self-inclusion in titles and textual material ("Upon My Many Masters," for example), as symptomatic of her raced and gendered artistic conciousness (a sort of triple consciousness).[5] They were a part of the post-Warholian relationship that she had come to have with her own celebrity. I came to see her work as being about both artistic subjectivity and the subjection of history, and its varying modes of representation, to an artistic vision.

In a [...] study, I argue that the disturbing and often melancholic tone of Walker's art reflects, and offers up for critique, the problem of the broader culture's inability to come to terms with the past. Through a series of engagements that begins with an overview of the artist's career and the history of African American visuality with which her work engages, I examine Walker's brief mature artistic production and the process of signifying in which she is actively involved. To provide close examination of her artistic practice as a whole, [...] concentrate on interpreting the content of only four of Walker's paper cutout "pageant" installations, prints, and gouache drawings: *The End of Uncle Tom and the Grand Allegorical Tableau of Eva in Heaven, John Brown, A Means to an End,* and *Cut,* respectively. Each work proves itself an intricate web of historical, theoretical, and cultural contexts. They are potential sites of

meaning within which the collective terror of our shared legacies and our desires to transcend them through the use of cultural mythologies may be graphically foregrounded.

The [...] provides an overview of Walker's career and a general history of race and representation as it pertains to her artistic production. Here I discuss major sources for her work, the broad themes in which she is interested, and historical precedence for the use of silhouettes and profiles to image race and "otherness." I outline the way that her work confronts and addresses the ongoing battle to counteract negative images of the African American body in Western visual culture and in the United States in particular. She follows an avant garde tradition of African American artists who have chosen to sacrifice communal approval for their work in favor of the freedom to pursue independent and sometimes transgressive visions.

Walker's 1997 installation of *The End of Uncle Tom and the Grand Allegorical Tableau of Eva in Heaven* has the uncanny ability to haunt the spectator through its visualization of the "discourse of the unspeakable." It is a discourse made up of the horrific accounts of physical, mental, and sexual abuse that were left unspoken by former slaves as they related their narratives, the nasty and unfathomable bits of detritus that have been left out of familiar histories of American race relations. The "unspeakable" may be understood as a traumatic site, what literary historian Cathy Caruth has called "unclaimed experience," and it is the temporal nature of the slave narrative and its painful history that art historian and literary critic W. J.T. Mitchell has argued must be "rememoried" in order to be reconciled.[6] This unclaimed discourse of the unspeakable continues to impact the ability of many European Americans and many African Americans to confront the terrible impression that the legacy of slavery continues to have on our individual and collective psyches. In this [...], the work's psychological relationship to both the artist and her audience is examined, revealing a deeply embedded gothic culture of denial and repression at the core of contemporary society.

The 1996 gouache drawing *John Brown* allows an investigation of Walker's critique of a specific mythic construction of history that has sought to circumvent the visualization of the unspeakable by presenting an idealized aesthetic of martyrdom. Through an in-depth visual examination of the formative images for representing the executed radical abolitionist revolutionary John Brown made by nineteenth-century European American artists and the alternative twentieth-century traditions developed by their African American counterparts, I argue that Walker's *John Brown* deconstructs this doubly racialized and wholly patriarchal martyrdom aesthetic—an aesthetic that canonized and celebrated an executed white man as a secular saint for popular African American veneration. In the end, her image of Brown is one that is constantly degrading and decomposing in a process that follows Walter Benjamin's description of allegorical ruination in *der Trauerspiel.*[7]

The [...] discusses the difficulties that Walker's artistic production and various personae have presented to the African American and the general arts communities. It examines how her work within the "discourse of the unspeakable" has literally been "unseeable" for some spectators, due to its being protested against or having been pulled from exhibitions. By comparing the censorship of Walker's 1995 print suite *A Means to an End: A Shadow Drama*

in Five Acts by the Detroit Institute of Arts with an uproar at the University of Missouri, St. Louis, over the work of Robert Colescott, I demonstrate the way that her art transgresses certain ideas about the established decorum and suitable subject matter for an African American woman artist to engage. At issue here is not only the graphic nature of her work, but also the manner in which her artistic persona flouts an African American code of visual conduct that has traditionally been closely, and quite reasonably, guarded. This argument relies on elements of literary critical theory surrounding ideas of gendered and raced "otherness": in particular, cultural critic Michele Wallace's conception of the black woman artist as the "'other' of the 'other,'" and the way it reveals the complex structural relationship of the artist to society and to her own identity.

I read the 1998 silhouette Cut, a self-portrait of Walker, as revealing the artist's self-realization of her status as the "'other' of the 'other'" and one who dares to speak the unspeakable. Building on ideas developed in chapter 4, I use the idea of post-Negritude visual practice, recently set forth by film historian and cultural critic Mark Reid, as a way to frame Walker's work within a contemporary African American creative milieu. I show that despite its contemporary currency, the image in Cut of a mutilated woman propelled by veiled forces also has deep roots in the artistic roles that women of color inhabited during the nineteenth century. In this way, as a self-portrait, *Cut* visualizes Walker's personal experience as being in line with the treatment that African American artists have historically received in the mainstream art world.

The images that Kara Walker has created prove themselves to be detailed excavations of the visual history of multiple genres of American raced and gendered representation. They form a body of work that ultimately reveals the generational schism inherent in the work of a postmodern, post-Negritude, African American woman artist who was born after the major battles of the civil rights movement had been fought. By mapping the process of rewriting and revision, of active signification in which Walker was engaged between 1995 and 1998, I hope to show that her challenges are to both the middle-class African American culture in which she was raised and the liberal, white-dominated art world that currently supports her work.[8] I believe these are challenges that cannot be easily dismissed or even fully understood due to their constantly unfolding relationship to what might be called a "postblack" artistic practice.[9] She is shown to be a powerful young artist who is questioning, rather than accepting, the strategies and tactics of social responsibility that her parents' generation fought hard to establish. Kara Walker is an artist with the uncanny ability to make her audiences see the unspeakable.

NOTES

Introduction

1. Harriet Beecher Stowe, *Uncle Tom's Cabin* (New York: Norton, 1994; originally published Boston: John P. Jewett and Company, 1852).

2. By using the term "signifying" I mean to link Walker's work to the creative tradition of revision that Henry Louis Gates Jr. has identified as unique in African American literary culture. See Henry Louis Gates Jr., *The Signifying Monkey: A Theory of Afro-American Literary Criticism* (London: Oxford University Press, 1988).

3. Ibid., 131.

4. This is a general artistic strategy, sometimes referred to as parody, that was recently the subject of public debate in a controversy engendered by the lawsuits made to halt the publication of Alice Randall's book *The Wind Done Gone* (Boston: Houghton Mifflin, 2001). The Mitchell estate sued the book's publishers under intellectual property rights which, they argued, protect the estate's control of sequels. In a move that is similar to what we see Walker doing in her racially charged silhouettes, Randall's book offers the reader a retelling of Mitchell's *Gone With the Wind* from the perspective of Scarlet O'Hara's mulatto half-sister.

5. For a discussion of this sort of triple consciousness, see Adrian Piper's essay "The Triple Negation of Colored Women Artists," in *Out of Order, Out of Sight, Volume II: Selected Writings in Art Criticism, 1967–1992* (Cambridge, Mass.: mit Press, 1996), 161–173. Piper argues that "the ideology of postmodernism functions to repress and exclude cwas [colored women artists] from the art-historical canon of the Euroethnic mainstream. Correctly perceiving the artifacts produced by cwas as competitors for truth and a threat to the cultural homogeneity of the Euroethnic tradition, it denies those artifacts their rightful status as innovations relative to that tradition through ad hoc disclaimers of the validity of concepts such as 'truth' and 'innovation'" (161).This position of being a threatening and necessarily repressible body is one that is frequently visible/readable in Walker's work, and is discussed further in chapters 4 and 5.

6. Cathy Caruth, *Unclaimed Experience: Trauma, Narrative, and History* (Baltimore: Johns Hopkins University Press, 1996); W. J. T. Mitchell, "Narrative, Memory, and Slavery," in *Picture Theory: Essays on Verbal and Visual Representation* (Chicago: University of Chicago Press, 1994).

7. Here I refer to Benjamin's study of tragedy and human wretchedness in *The Origin of German Tragic Drama* (London: Verso, 1985; originally published 1928).

8. A note on terms: I use the terms "African American" and "black" in a popular sense to refer to peoples of African descent living in the United States. "European American" and "white" are used in a similar spirit.

9. Postblack is a term that was first coined by the artist Glenn Ligon and recorded by the curator Thelma Golden in her introduction to the catalogue for the exhibition *Freestyle* (Studio Museum in Harlem, 2001, 14): "Post-black was a shorthand for post-black art, which was shorthand for a discourse that could fill volumes. For me to approach a conversation about 'black art' ultimately meant embracing and rejecting the notion of such a thing at the very same time. ... It was a clarifying term that had ideological and chronological dimensions and repercussions. It was characterized by artists who were adamant about not being labeled as 'black' artists, though their work was steeped, in fact deeply interested, in redefining notions of blackness. In the beginning, there were only a few marked instances of such an outlook, but at the end of the 1990s, it seemed that post-black had fully entered into the art world's consciousness. Post-black was the new black." The term is rapidly gaining currency, propelled by ideas that the work of contemporary African American artists of "generations X and Y" have a vision that is unique from, and largely in opposition to, the one that came out of the Black Arts Movement of the 1960s and 1970s, the movement that shaped the artistic discourse of their parents' generation.

Resources

Chapter 1 Caves and Art: Initiation and Transcendence by L. G. Freeman, University Press of Colorado (2005)

Web Sites:
http://www.lascaux.culture.fr/?lng.=eng
Books:
Cave Art by Dr. Jean Clottes, Phaidon Press, 2010
Palaeolithic Rock Art in Western Europe by Andrew J. Lawson, Oxford University Press, 2012

Chapter 2 Architectural Art in Ancient Egypt by Leo Hansen, Cognella

Web Sites:
http://www.sca-egypt.org/eng/SITE_GIZA_MP.htm
Books:
Great Pyramids of Giza: Measuring Length, Area, Volume, and Angles by Jane Levy, Rosen Publishing Group 2009
Building the Great Pyramid by Kevin Jackson, Jonathan Stump, Firefly Books, 2003

Chapter 3	Evolution and Development of Greek Sculpture by William H. McNeill, University of Chicago Press (1986)

Books:
The Discobolus by Ian Jenkins, British Museum Press, 2012
Archaic and Classical Greek Art (Oxford History of Art) by Robin Osborne, Oxford University Press, 1998

Chapter 4	The Arts of China by Andrew Jay Svedlow

Web Sites:
http://www.unesco.org/en/list/441
Books:
China's Terracotta Warriors: The First Emperor's Legacy by Yang Liu, University of Washington Press, 2012
The Arts of China, 4th edition, by Michael Sullivan, University of California Press, 1999

Chapter 5	The Medieval Aesthetic Sensibility, in Art and Beauty in the Middle Ages by Umberto Eco, pp. 4–16, Yale University Press (1986)

Web Sites:
http://www.sacred-destinations.com/italy/ravenna-galla-placidia
Books:
The Mausoleum of Galla Placidia in Ravenna by Angiolini Martinelli, Franco Cosimo Panini 2009
Byzantine Mosaics by Nano Chatzidakis, Athenon 1994

Chapter 6	What is the Gothic Look by Robert A. Scott, University of California Press (2011)

Web Sites:
http://www.cathedrale-chartres.org/en/,143.html
Books:
Universe of Stone by Phillip Ball, Random House, 2008
High Gothic Sculpture at Chartres Cathedral by Anne McGee Morganstern, The Pennsylvania State University Press, 2011

Chapter 7	Describing Art by Marco Ruffini, Fordham University Press (2011)

Web Sites:
http://www.giottodibondone.org
http://www.leonardoda-vinci.org
http://mv.vatican.va/3_EN/pages/CSN/CSN_Main.html
Books:
Storytelling in Christian Art from Giotto to Donatello by Jules Lubbock, The British Library, 2006
Leonardo Da Vinci by John Malam, Heinemann Raintree 2009
Michelangelo and the Sistine Chapel by Andrew Graham-Dixon, Sky Horse Publishing 2009

Chapter 8	Notes on the Oldest Sculpture of El Templo Mayor at Tenochtitlan by Eduardo Moctezuma, University Press of Colorado

Web Sites:
http://www.denverartmuseum.org/collections/pre-columbian-art
http://www.worcesterart.org/Collection/precolumbian.html
Books:
Guide to Pre-Columbian Art by Jean Paul Barbier 1998
Pre-Columbian Art by Esther Pasztory, Cambridge University Press, 1998

Chapter 9	Earth Reveries: Transcendent Responses

Web Sites:
www.slowlab.net/ecocathedral.html 7/2011
http://greenmuseum.org/artist_index.php?artist_id=123
http://www.rwc.uc.edu/artcomm/web/w2005_2006/maria_Goldsworthy/works.html
http://wwwebart.com/riverart/fish/index.htm
http://www.rwc.uc.edu/artcomm/web/w2005_2006/maria_Goldsworthy/biography.html

Chapter 10	Hegel and the Sea of Ice by Andrew Jay Svedlow, in The Cosmos and the Creative Imagination, Springer International Publishing, Switzerland (2016)

Books:

The Roots of Romanticism by Isaiah Berlin, Princeton University Press, 2001

Caspar David Friedrich and the Age of German Romanticism by Linda Siegel, Branden Publishing, 1978

Chapter 11 The Borderland by Andrew Jay Svedlow (previously published in Cultural of Ukraine, Scientific Papers, Kharkiv State Academy of Culture (2016))

Web Sites:

http://www.infoukus.com/shevchenkomuseum/monuments.htm

Books:

Iconography of Power by Victoria Bonnell, University of California Press, 1997

Art in the Cold War by Christine Lindy, New Amsterdam Press, 1990

Chapter 12 Visual Culture/Visual Studies by James D. Herbert, University of Chicago Press (2015)

Web Sites:

http://fondation-monet.com/en

Claude Monet: Water Lilies by Ann Temkin, Museum of Modern Art, 2009

Van Gogh: The Life by Steven W. Naifeh, Gregory White Smith, Woodward/White, 2011

Chapter 13 Two Encounters by Jack Flam, Basic Books

Web Sites:

http://www.pablopicasso.org

Books:

Pablo Picasso by Victoria Charles, Confidential Concepts, 2011

Chapter 14 Contemporaneity Between Modernity and Post modernity by Antonio Negri, Duke University Press (2008)

Web Sites:

http://warhol.org

http://www.jackson-pollock.org

Books:

The Philosophy of Andy Warhol: From A to B and Back Again by Andy Warhol, Houghton Mifflin Harcourt, 1977

Jackson Pollock by Evelyn Toynton, Yale University Press, 2012

Chapter 15 The Art of Kara Walker by Gwendolyn Shaw, Duke University Press

Web Sites:

http://www.pbs.org/art21/artists/kara-walker

Books:

Seeing the Unspeakable: The Art of Kara Walker by Gwendolyn Shaw, Duke University Press, 2004

About the Editor

By Andrew Jay Svedlow

Currently Professor of Art History and formerly Dean of the College of Performing and Visual Arts at the University of Northern Colorado, Dr. Svedlow was previously the Dean of the College of Visual and Performing Arts at Winthrop University, President of the New Hampshire Institute of Art, and Assistant Director of the Museum of the City of New York. Dr. Svedlow received his Ph.D. from the Pennsylvania State University and has taught Asian art history, art appreciation, arts administration and museum leadership, aesthetics, art education, and studio art at University of Northern Colorado, Winthrop University, Penn State, Bank Street College of Education, Parsons School of Design, University of Massachusetts-Dartmouth, University of Massachusetts-Lowell, University of Kansas, New York University, University of Southern Mississippi, the New Hampshire Institute of Art, and the University of New Hampshire. Dr. Svedlow was a 1991 International Council of Museums/USIA exchange partner in Australia, was a 1994 Research Fellow with the Smithsonian Institution, and in 1998 he participated in a cultural exchange between business and civic leaders in Niigata, Japan. In 1996, Dr. Svedlow was presented the Distinguished Service to the Profession of Art Education Award by the New Hampshire Art Educators' Association and in 1998 he

completed the MLE Program in the Harvard Graduate School of Education's Institute for Higher Education. He was a member of the American Association of State Colleges and Universities' Millennium Leadership Initiative 2002. He has directed and administered museum and education programs for the Smithsonian's National Museum of Design, the Museum of the City of New York, and the Mulvane Art Museum at Washburn University. He was a 2007 Fulbright Scholar for the Japan-US International Education program and was a 2010 Fulbright Scholar to Ukraine.

Dr. Svedlow has published on art appreciation, Japanese art, phenomenology, aesthetics, art history, art education, museum education, and arts administration. His publications include articles on lifelong learning, reveries on aesthetics, and the history of art museums in America. His art criticism has appeared in such journals as American Artist, the New Art Examiner, and the Kansas Quarterly, which honored him with an award for his writing. He published a chapter on Japanese aesthetics for the book *Teaching Asian Art* and, just out in 2016, the revised edition of his textbook *Thirty Works of Art Every Student Should Know* is now available. A painter and printmaker, Dr. Svedlow's artworks have been exhibited in galleries and museums in Colorado, North and South Carolina, New York, Connecticut, Massachusetts, Pennsylvania, New Hampshire, Kansas, Missouri, and in Ukraine. His exhibition titled *Fragments* opened in January 2013 at Artworks Loveland and his works titled *Remembrance* were included in two concurrent one-person exhibitions in April 2015 at the Mizel Museum in Denver, and the Loveland Museum/Gallery. In December 2008 he was an artist in residence at the Banff Centre in Alberta, Canada, and he returned to the Banff Center in May 2015. In 2012 he was an artist in residence at the Stonehouse Residency in Miramonte, CA. He had a one-person exhibition titled "Illumination," forty works on paper, inspired by medieval Hebrew manuscripts, which opened in November 2009 at the Mari Michener Gallery and his exhibition *Fragments* was held in May 2010 at the L'viv Academy of Arts in Lviv, Ukraine. One of his works devoted to environmental concerns was recently exhibited in the lieutenant governor's office in the Colorado State Capitol. He is currently a studio artist in residence at Artworks Loveland, an urban artists' community in Loveland, CO.

Dr. Svedlow is a Senior Fellow of the American Leadership Forum, and is a graduate of the 1997 Leadership New Hampshire program, a 1994 graduate of Leadership Manchester, NH, and was appointed by the Governor of New Hampshire as Chairman of the Commission of the Christa McAuliffe Planetarium. He participated in the 2007 Aspen Institute Executive Seminar and was an Aspen Institute Environment Forum Scholar in 2009. Dr. Svedlow was one of the founding college presidents of the New Hampshire Campus Compact and he is an active supporter of service learning in higher education. In 1997 he was awarded the Good Samaritan of the Year Award from New Hampshire Pastoral Counseling Services and was selected, in 1998, by Change Magazine, as one of the country's Top Forty Young Leaders in Higher Education. He has served as a grant panelist for the National Endowment for the Arts, the Fulbright Program, and numerous regional and state granting agencies.

Credits

Caves and Art: Rites of Initiation and Transcendence

L. G. Freeman, "Caves and Art: Rites of Initiation and Transcendence," Anthropology without Informants: Collected Works in Paleoanthropology by L. G. Freeman, pp. 329-341. Copyright © 2009 by University Press of Colorado. Reprinted with permission.

Architectural Art in Ancient Egypt

Leo Hansen, "Architectural Art in Ancient Egypt," Art and Architecture, pp. 181-191. Copyright © 2015 by Cognella, Inc.

Evolution and Development of Greek Sculpture / Leaders of Antiquity

William H. McNeill, "Evolution and Development of Greek Sculpture / Leaders of Antiquity," History of Western Civilization: A Handbook, pp. 119-128. Copyright © 1986 by University of Chicago Press. Reprinted with permission.

The Arts of China

The Medieval Aesthetic Sensibility

What is the Gothic Look?

Describing Art

Marco Ruffini, "Describing Art," Art Without an Author: Vasari's Lives and Michelangelo's Death, pp. 104-136, 201-208. Copyright © 2011 by Fordham University Press. Reprinted with permission.

Notes on the Oldest Sculpture of El Templo Mayor at Tenochtitlan

Eduardo Matos Moctezuma, "Notes on the Oldest Sculpture of El Templo Mayor at Tenochtitlan," Aztec Ceremonial Landscapes, ed. David Carrasco, pp. 3-8. Copyright © 1999 by University Press of Colorado. Reprinted with permission.

Hegel and "The Sea of Ice"

Andrew Jay Svedlow, "Hegel and 'The Sea of Ice,'" The Cosmos and the Creative Imagination (Analecta Husserliana, Volume CXIX), ed. Anna-Teresa Tymieniecka and Patricia Trutty-Coohill, pp. 345-350. Copyright © 2016 by Springer Science+Business Media. Reprinted with permission.

Caspar David Friedrich, https://commons.wikimedia.org/wiki/File:Caspar_David_Friedrich_-_Das_Eismeer_-_Hamburger_Kunsthalle_-_02.jpg, 1824. Copyright in the Public Domain.

The Borderland

Andrew Jay Svedlow, "The Borderland," Culture of Ukraine (Scientific Papers), pp. 147-155. Copyright © 2016 by Kharkiv State Academy of Culture. Reprinted with permission.

Visual Culture/Visual Studies

James D. Herbert, "Visual Culture/Visual Studies," Critical Terms for Art History, ed. Robert S. Nelson and Richard Shiff, pp. 452-464. Copyright © 2003 by University of Chicago Press. Reprinted with permission.

Jasper Johns, 2000. Copyright © 2000 by Museum of Modern Art, New York (MOMA).

Two Encounters

Jack Flam, "Two Encounters," Matisse And Picasso: The Story of Their Rivalry And Friendship, pp. 9-22. Copyright © 2003 by Perseus Books Group. Reprinted with permission.

Henri Matisse, 1905. Copyright in the Public Domain.

Pablo Picasso, 1905. Copyright in the Public Domain.

Contemporaneity between Modernity and Postmodernity

The Art of Kara Walker

CPSIA information can be obtained
at www.ICGtesting.com
Printed in the USA
FSHW022154130120
66049FS